CHANEL

FINE JEWELLERY

SOUS LE SIGNE DU LION

BROOCH IN WHITE GOLD AND DIAMONDS

www.chanel.com

Johnen Galerie
—

ROBERT STURM
KERAMIK 1969–1993
MARCH 11–APRIL 16, 2016

MARTIN HONERT
APRIL 26–MAY 28, 2016
—
JOHNEN GALERIE
MARIENSTRASSE 10, D–10117 BERLIN
WWW.JOHNENGALERIE.DE

ARCO MADRID
FEBRUARY 24–28, 2016
STAND 7E06

ART BASEL HONG KONG
MARCH 24–26, 2016
STAND 1B13

MIART
APRIL 8–10, 2016

ISA MELSHEIMER
ÜBER DIE DÜNNHÄUTIGKEIT VON SCHWELLEN
MARCH 11–APRIL 16, 2016

TOMÁS SARACENO
APRIL 26–MAY 28, 2016

ESTHER SCHIPPER
SCHÖNEBERGER UFER 65, D–10785 BERLIN
WWW.ESTHERSCHIPPER.COM

ARCO MADRID
FEBRUARY 24–28, 2016
STAND 7E06

ART BASEL HONG KONG
MARCH 24–26, 2016
STAND 1B13

MIART
APRIL 8–10, 2016

B E N D I X H A R M S

A N T O N K E R N G A L L E R Y

Anton Kern Gallery 532 West 20th Street New York NY 10011 T: 212.367.9663 F: 212.367.8135 antonkerngallery.com

JULES DE BALINCOURT

13 APRIL – 14 MAY 2016

Victoria Miro

16 Wharf Road · London N1 7RW

Fondazione Prada

TO THE SON OF

MAN WHO ATE

GOSHKA MACUGA
4.2 – 19.6.2016

THE SCROLL

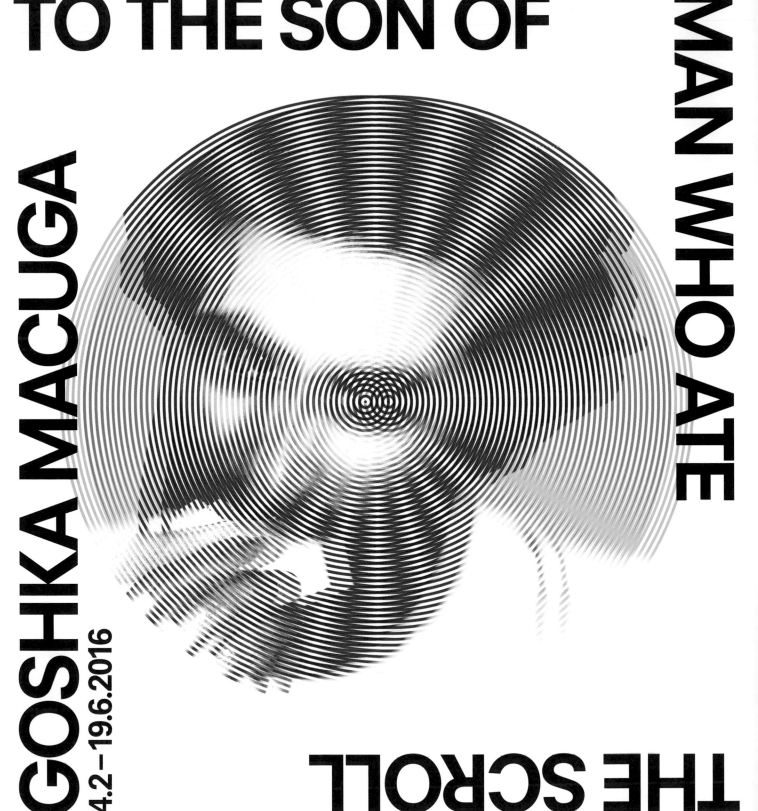

LARGO ISARCO 2
MILANO
FONDAZIONEPRADA.ORG

Milano

ELEPHANT

Editor-in-chief
Marc Valli
marc@elephantmag.com

Editor
Robert Shore
roberts@elephantmag.com

Web Editor
Emily Steer
emily@elephantmag.com

Editors at Large
Charlotte Jansen
Katya Tylevich
Robert Urquhart

Contributing Editors
Astrid Stavro

Art Direction
Astrid Stavro
Pablo Martín

Design
Atlas

Communication Manager
Molly Taylor
molly@elephantmag.com

Proofing
Sarah Batten

Intern
Ellie Howard
Lucy Martin

For all editorial enquiries
Elephant Magazine
C/O Magma
117-119 Clerkenwell Road
London EC1R 5BY

Publishing Directors
Robert Thiemann
robert@frameweb.com
Rudolf van Wezel
rudolf@frameweb.com

Marketing & Sales Director
Margreet Nanning
margreet@frameweb.com

Circulation Director
Benjamin Verheijden
benjamin@frameweb.com

For ad sales enquiries
Molly Taylor
molly@elephantmag.com

Subscription rates
1-year €69
1-year student €59

How to subscribe?
Visit frameweb.com/elephant
or call +31 20 4233 717

Postmaster
Send address changes to
Elephant Magazine
701C Ashland Ave
Folcroft PA 19032

Front cover
Luke Butler
Landing Party II, 2009
Courtesy of the artist and
Jessica Silverman Gallery
Photo credit Jessica Skloven
See page 62

Elephant
(ISSN 1879-3835,
USPS No. 025-545)
is published quarterly
by Frame Publishers NL
and distributed in the USA
by Asendia USA
17B S Middlesex Ave
Monroe NJ 08831

Periodicals postage paid
New Brunswick, NJ and
additional mailing offices

Queries
Frame Publishers BV
Laan der Hesperiden 68
1076 DX Amsterdam
The Netherlands
T +31 20 4233717
F +31 20 4280653
service@frameweb.com
www.frameweb.com

ELEPHANT BY CAMILLE ROUSSEAU

Lyles & King

Chris Hood

106 Forsyth Street New York

www.lylesandking.com

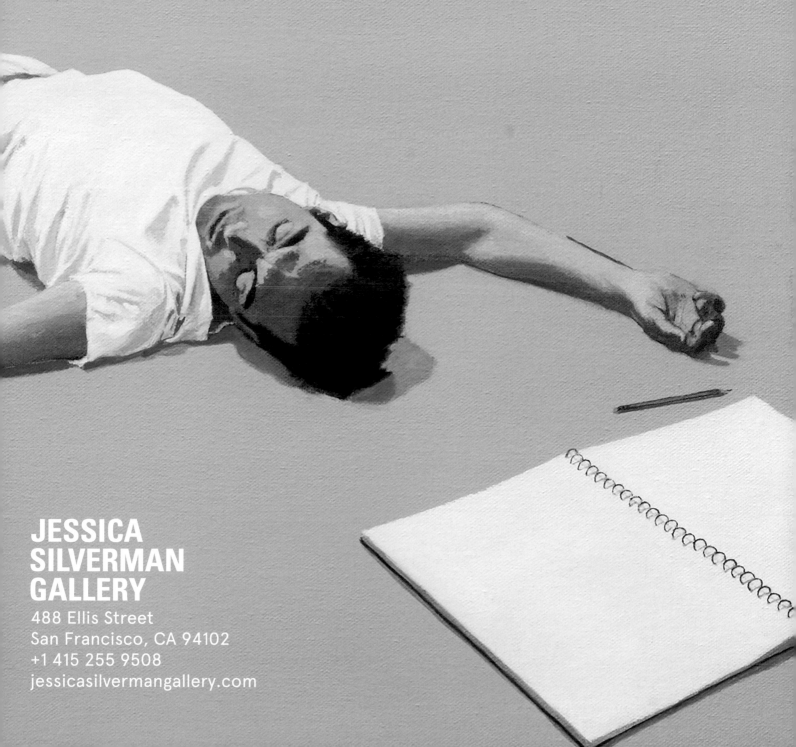

Dashiell Manley, Sean Raspet,
Suzanne Blank Redstone, Ian Wallace
The Armory Show
March 3 – March 6, 2016

Luke Butler
March 10 – April 16, 2016

**JESSICA
SILVERMAN
GALLERY**
488 Ellis Street
San Francisco, CA 94102
+1 415 255 9508
jessicasilvermangallery.com

KunstHalle
by Deutsche Bank

On view
2016

April 29 — July 3, 2016
Basim Magdy
Deutsche Bank »Artist of the Year« 2016

July 21 — October 10, 2016
Common Affairs

November 18, 2016 — March 5, 2017
Bhupen Khakhar: You Can't Please All
In Koopertation mit Tate Modern

Deutsche Bank KunstHalle
Unter den Linden 13/15
10117 Berlin
10 am — 8 pm, Mondays admission free

Details on the exhibitions and supporting programs
deutsche-bank-kunsthalle.com

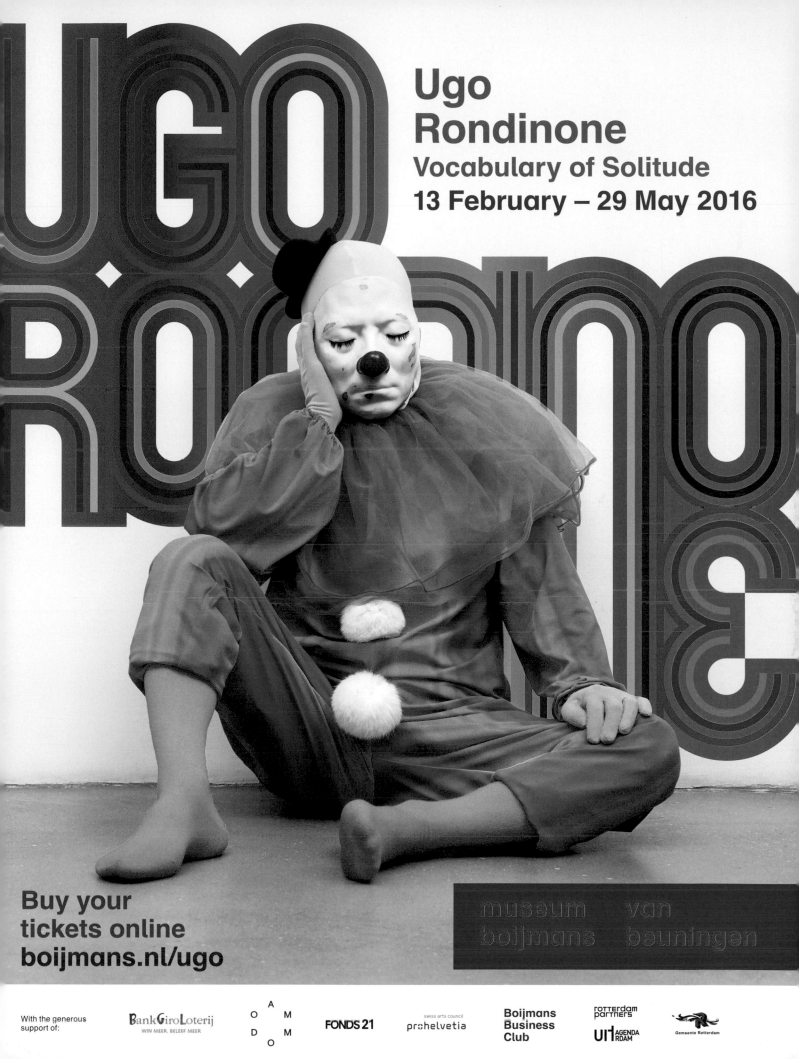

RICHARD GASPER

March 15th - April 20th

MIART MILAN 2016

Peter Sutherland, Maximilian Schubert, Hanae Wilke

April 8th - 10th

GUY PATTON

April 30th - June 1st

Ellis King

Ellis King, Unit 7, White Swan, Donore Avenue, Dublin 8, Ireland
+ 353 (0) 1 453 7605 | office@ellisking.net

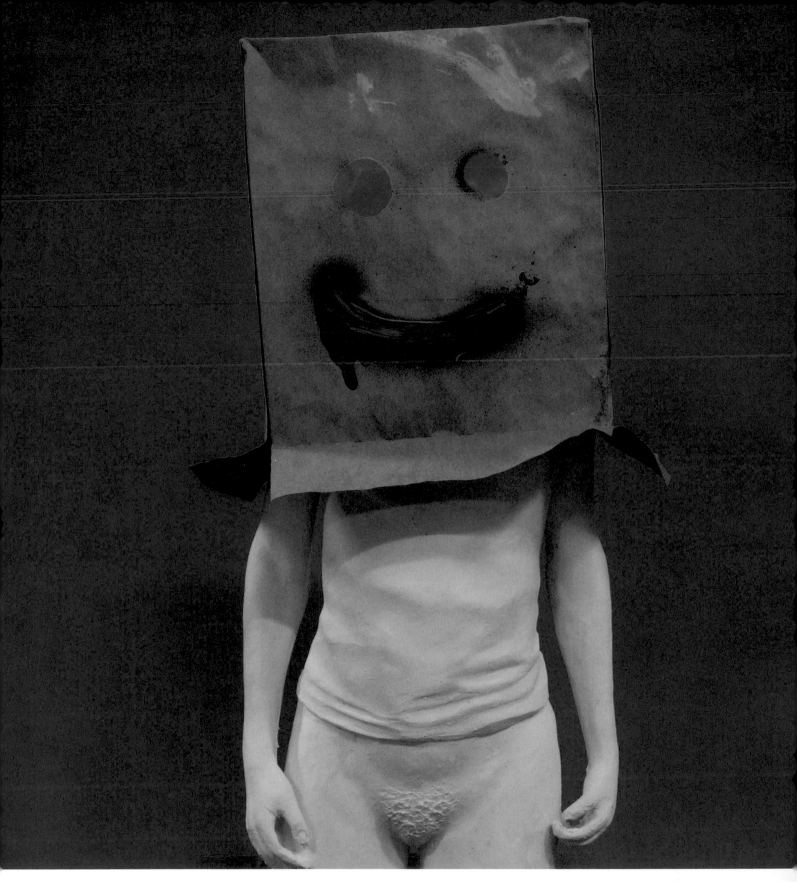

Amir Chasson | Fredrik Raddum | Sverre Bjertnes

SKJERP DEG!
12 Feb - 19 Mar 2016

KH

Kristin Hjellegjerde

533 & 364 Old York Road, SW18 1TG, London, UK | +44 (0)20 8875 0110 | www.kristinhjellegjerde.com

MARCH
3–6
2016
AT
PIERS
92
& 94
IN
NEW
YORK
CITY

THE ARMORY SHOW

THEARMORYSHOW.COM

ARIANA
PAPADEMETROPOULOS
3/12/16 – 4/23/16

JAMES
GEORGOPOULOS
4/30/16 – 6/11/16

REN
HANG
6/18/16 – 7/23/16

MAMA GALLERY
1242 PALMETTO STREET
LOS ANGELES, CA 90013
WWW.MAMA.GALLERY

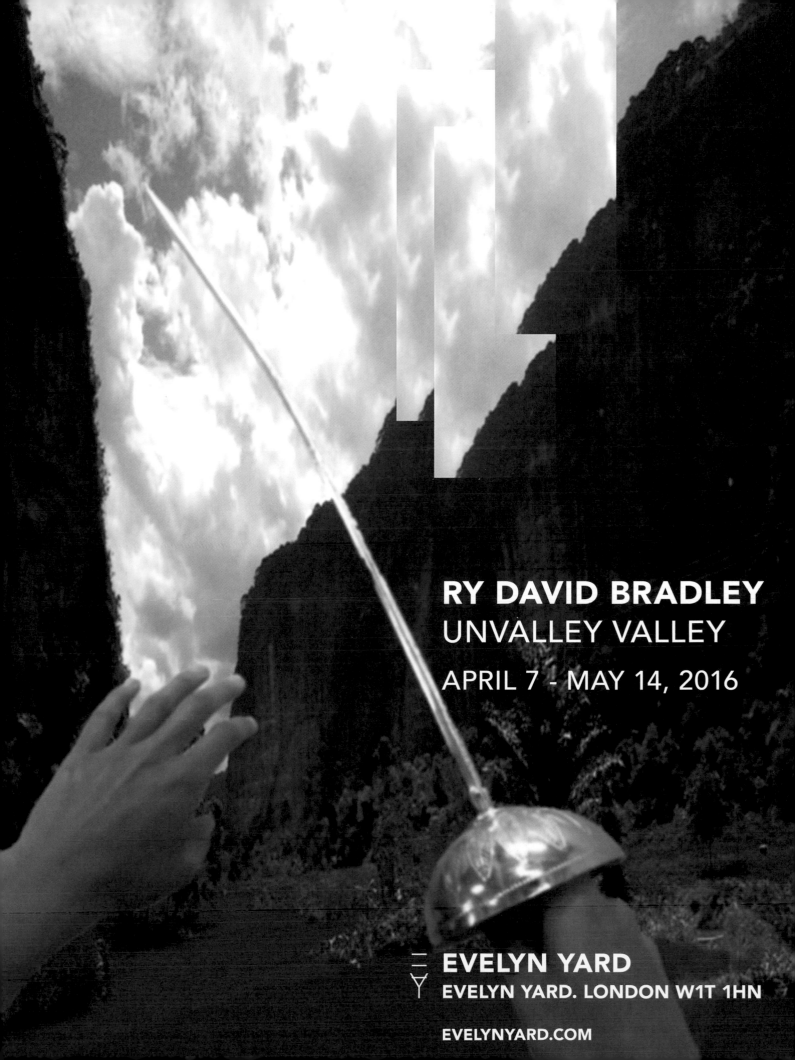

RY DAVID BRADLEY
UNVALLEY VALLEY

APRIL 7 - MAY 14, 2016

EVELYN YARD
EVELYN YARD. LONDON W1T 1HN

EVELYNYARD.COM

RUTTKOWSKI;68

PARRA (NL) 15/4/2016 - 29/5/2016

RUTTKOWSKI;68 / BISMARCKSTR.70 / 50672 COLOGNE / RUTTKOWSKI68.COM

*Wipe that Simile
off your Aphasia*

Koen Delaere

10 March
— 16 April 2016

Rod Barton
67 rue de la Régence
Brussels 1000

SABRINA⅄MRANI

WAQAS KHAN
Solo show

ART BASEL HONG KONG
24-26 March 2016

ART COLOGNE

50. INTERNATIONALER KUNSTMARKT 14. – 17. APRIL 2016

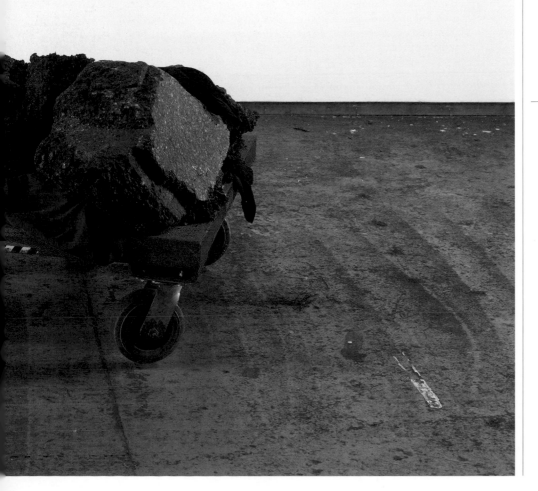

MAVERICK
MANOEUVRES

Not playing by art-world rules, not to mention declaring the art audience 'the worst audience in the world', appears only to have increased **DAVID HAMMONS'S** mystique and appeal. **FISUN GÜNER** appraises the long career of a master nonconformist ahead of a new show at Mnuchin Gallery.

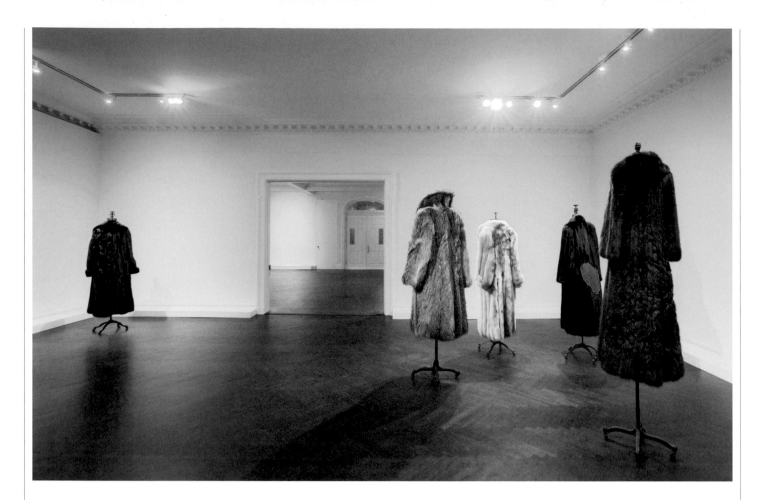

'I decided a long time ago that the less I do the more of an artist I am.'

If you've come across the work of David Hammons, it probably won't be the first time you've come across this quote. It comes from a rare interview he gave to *New Yorker* critic Peter Schjeldahl in 2002. Since then he's remained tight-lipped. He no longer talks to journalists and indeed remains a shadowy figure in the art world he appears so reluctant to inhabit: the artist, who's now 72, has so far resisted museum directors eager to give him a retrospective. This, of course, only adds to the intrigue.

It also means that the few quotes that have been gleaned over a career spanning five decades—first as a young artist making his way in LA, where he was influenced by West Coast conceptualists Bruce Nauman and Chris Burden, then in New York, where he became involved in the avant-garde black art scene centred around the pioneering gallery Just Above Midtown—tend to get quite a bit of recycling.

But it's a telling quote all the same, and not only because it shows affinity with the modernist creed Less Is More, but because, like the Adolf Loos mantra Hammons is riffing on, his work has frequently re-enacted seminal works by other artists. *Bag Lady in Flight* (1982) is a concertinaed paper wall relief that alludes to Duchamp's *Nude Descending a Staircase No. 2*; an untitled 1990 installation of urinals on trees in a forest in Ghent is a more obvious Duchampian reference; his body imprints, which have

featured throughout his career—one of the earliest is *The Door (Admissions Office)* (1969), with the artist's ink-blackened splayed hands and body pressing up against the frosted glass of one of those old-fashioned, dark wood office doors (a symbol of bureaucratic officialdom which might as well have the words 'no entry for the likes of you' written across it)—more than hint at Jasper Johns's intimate body casts and canvas imprints; and his 2002 *Concerto in Black and Blue*, consisting of gallery rooms in pitch darkness where visitors light their way with tiny blue flashlights, is a work that brings to mind Yves Klein's 1958 *The Void*. One might think of the French artist's trademarked International Klein Blue in those luminous flashes of blue.

But the work for which he is perhaps best known, probably because it draws together and perfectly encapsulates the multifarious themes and allusions that have occupied him for decades, is *Bliz-aard Ball Sale* (1983). Here the artist turns street vendor, hawking snowballs during a frosty New York winter. And if the artwork looks deceptively slight, that's part of its enduring appeal. It is, after all, a work about ephemera, ephemera naturally being what the conceptual art scene of the time largely traded in. It's also work about being had—art, and particularly the art world, as a scam, for what kind of trickster-conman could sell you snowballs?

Most pressingly, it's a work about social exclusion, though with a poetically lighter touch

than *The Door (No Admissions)*; and finally, connected to that, it's a work about colour—the black street hustler in his shabby coat, pork-pie hat and improvised stall-blanket on which he's presented his pure white wares—neatly arranged, delicate, untouchable, innocent and ultimately uncommodifiable wares. This all chimes neatly with another one of Hammons's oft-repeated quotes, the one where he declared his hatred of art. 'I can't stand art actually. I've never ever liked art.'

Hammons, then, is, or at least sees himself as, an outsider-street hustler of sorts, albeit one with a blue-chip profile and whose international status just keeps growing. Most recently he exhibited at London's White Cube Hoxton, and this coming spring an exhibition will open at New York's Mnuchin Gallery (formerly, the L&M Gallery), his third solo show to date at that plush East Side venue. However, he doesn't have a dealer as such—his work has largely sold on the secondary market—and he prefers to put together his own shows without curatorial intervention. And he always likes to surprise.

This is just what he managed to do for his first, 2007 show at Mnuchin, a gallery he approached himself with the idea of using it as a stage to present new work and which he also financed himself—that is, he paid out of his own pocket to hire the gallery space.

When it came to the exhibits, he surprised everyone with a paintings show—though the

Previous pages
David Hammons
A Movable Object
2012
Steel, asphalt, fabric
108 x 167.6 x 96.5cm

Opposite
Hammons
L&M Arts, New York
18 January–31 March 2007
Installation view

This page
David Hammons
Orange Is the New Black
2014
Glass, wood, nails, acrylic
63.5 x 40.6 x 33cm

"THE FUR COATS DIRECTLY ADDRESSED WHAT I WOULD CALL OUR TYPICAL CLIENTELE, IN A TONGUE-IN-CHEEK WAY"

joke was that the paint was splattered on five expensive full-length fur coats draped on mannequins, the kind of coats you'd see floating into a chic gallery on the backs of Upper East Side ladies. The furs—mink, sable, chinchilla—all looked shop-new, until you examined the backs and found that they'd been scorched as if with a blowtorch, then aggressively swiped with strokes of thick paint and thickly varnished. You had to hand it to him for sheer chutzpah, though he had no trouble attracting exactly the sort of crowd he was sticking it to. The show was, predictably, a sell-out.

'I think the fact that the fur coats directly addressed what I would call our typical clientele, in a tongue-in-cheek way, that's what I think really appealed to him much more than a downtown space,' says Sukanya Rajaratnam, curator and now senior partner at Mnuchin. Rajaratnam wasn't working at the gallery at the time of that show, but that changed once she saw it.

'It was such a brilliant show,' she says. 'Having the sort of trust in the artist to make such an institutional critique was so brave of the gallery, and that's what made me want to join the gallery, which I did in 2008.' That gave Rajaratnam plenty of time to work on Hammons's second show in 2011. And she freely admits to being taken aback as he unveiled his proposal for it back at his studio.

'Robert [Mnuchin, the gallery founder] and I looked at each other and we didn't know what to say to David,' she explains. 'So we took the car home in complete silence. And at the end of the ride Robert said, "So, what should we do? Is the world going to appreciate this from David?" And I said, "I don't know. But if we don't do the show we'll be the biggest idiots in the world. We have to do it." But we had no idea what the reception would be for the works because they were so unexpected and it was a huge leap of trust for us.'

For an artist known for hawking snowballs, and who'd previously turned lumps of elephant dung into sculpture, years before Chris Ofili caused controversy by using them to prop up his paintings, you might wonder what could possibly have so shocked a high-end gallery. They were just paintings—huge canvases covered in bright abstract expressionist swirls but which were then raggedly covered in tarp, so that some of the painting still peeped through round the peeling edges of the plastic sheets.

Like the furs, they were definitely paintings, but they were also a negation of painting—canvases that looked set for the rubbish dump. To a gallery used to dealing in paintings from the era of high modernism—the de Koonings and the Klines, the transcendent Rothkos and even the abject Gustons, this may have looked like another attempt to piddle on the art-world establishment (there's a photograph from 1981

of Hammons urinating on a Richard Serra public sculpture). Anyway, shock turned into thrills. 'We walked in on Monday,' Rajaratnam says, 'and the whole show was installed. And it took our breath away. Seeing them in context, and as a group, made them coalesce as a message.' What's more, the show had 500 visitors a day, 'which had never happened before'. After almost 50 years of steady work and maverick manoeuvres, Hammons was quickly turning into a cult figure. And, as Rajaratnam says, context is, of course, everything. Hammons has shown that he's brilliant at using it to make his message 'coalesce'.

In 2004, in an audacious coup de théâtre, the artist staged what you might call his most 'context and culturally appropriate' work, at the Dak'Art Biennial in Dakar. Away from the main art spaces, Hammons organized a sheep raffle. Ordinary citizens gathered each day around makeshift stages in the hope of winning an animal. Over the course of the week a dozen sheep were given away. This was 'institutional critique' turned on its head. It was also 'relational aesthetics' put to properly useful ends, but it was hardly a gesture of earnestness. This was 'giving something back to the community' delivered as a deadpan, defiant joke, and it must certainly have raised a few eyebrows. Perfect.

Five Decades *runs at Mnuchin Gallery, New York, from 15 March to 27 May.*

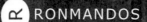

Konrad Wyrebek

NEW WORKS
April 9—May 14, 2016

Galerie Ron Mandos

Prinsengracht 282
Amsterdam, The Netherlands
www.ronmandos.nl

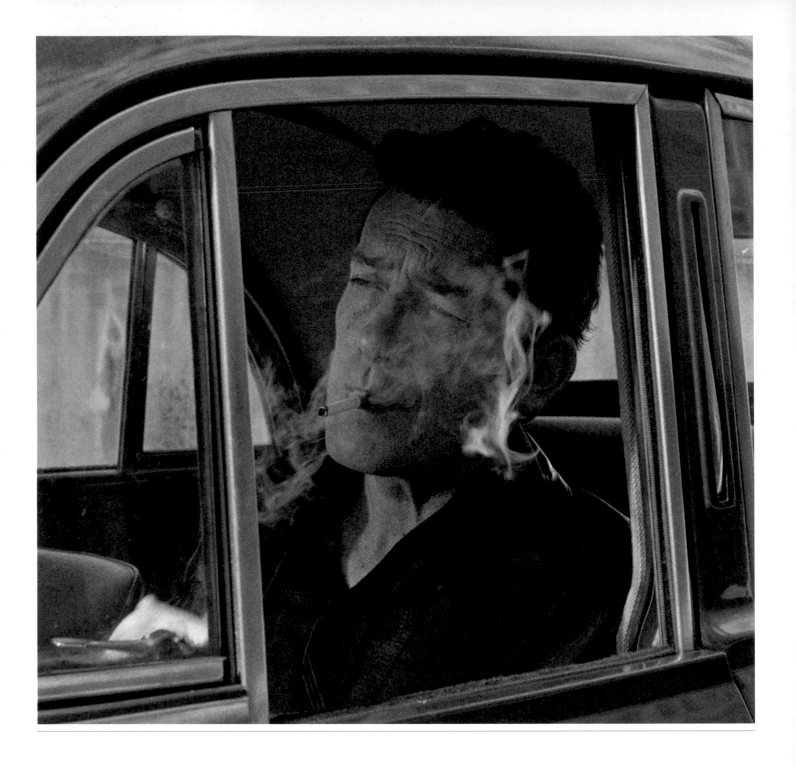

NOW SHOWING

STAN DOUGLAS

VICTORIA MIRO · UNTIL 24 MAR
DAVID ZWIRNER · 31 MAR—30 APR

Stan Douglas's latest exhibition runs at London's Victoria Miro before going on to David Zwirner in New York, and combines historical facts, rumour and fiction to create an alternative documentation of transitional moments within history. The celebrated Canadian artist restages the plot of Joseph Conrad's *The Secret Agent* in his new multi-screen film set in Lisbon in 1974, post-'Carnation Revolution' (a military coup in Lisbon to overthrow Estado Novo). The large-scale, digitally rendered photographic works that comprise the second half of the exhibition nod to classic Hollywood thrillers and the anxieties of a post-war generation by creating vivid mise-en-scènes filled with the disenfranchised, the drunk and the gambling-addicted.

Bio: Douglas's combination of semi-fictitious plots and unusual historical facts—often melded to question political and social realities on a global landscape—have earned the artist a huge following since 1980. He has exhibited both in group and solo shows internationally, including (from 2015 alone): Museu Coleção Berardo, (Lisbon) Wiels Centre d'Art Contemporain (Brussels) and the Irish Museum of Modern Art, (Dublin).

Quote: 'Maybe we can get closer to the truth by telling a fictional story instead of an obsessive search for strictly factual events. Perhaps exaggeration enables you to portray a time period more accurately than historical precision.'
www.victoria-miro.com
www.davidzwirner.com

Opposite and below
Stan Douglas
The Secret Agent
2015
Six-channel video projection with sound

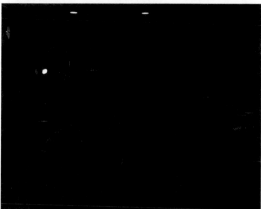

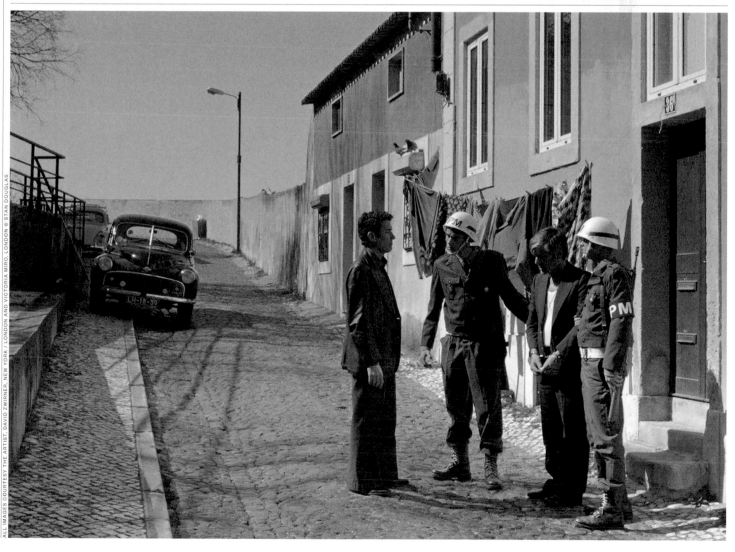

ARIANA PAPADEMETROPOULOS
12 MAR—23 APR

Exhibition: Ariana Papademetropoulos's enchanting paintings have recently whipped up quite a media storm, resulting in a series of shows in her native LA.

Papademetropoulos is best known for her *Watermark* series. Using found imagery as a reference, this is a suite of large-scale works featuring opulent interiors (seemingly the last bastions of faded '70s décor) that bear the illusion of a watermark, leaving inky pools of psychedelic colour streaked across the canvas. Visually seductive, the works expose the true colour spectrum and latent patterns that lie underneath the surface—giving the painting agency as a recorded moment. Concerned with illusions, façades and the unseen, Papademetropoulos's paintings read like ablutionary acts in revealing hidden repositories of daydream contemplations.

Bio: Papademetropoulos was awarded a bfa from CalArts in 2012 and also studied at Universität der Künste in Berlin. She participated in *To Hide To Show*, MAMA Gallery, Los Angeles (2015). Among her solo presentations are *Wallflower* at the Orgy, SADE LA (2015) and *Palimpsest*, Lookup Gallery (2015).

Something else you should know: Papademetropoulos worked as a professional 'bubble fairy' for a number of years under the name Opal Desdemona. She was also sometimes hired as a mermaid, a role she preferred as she was immobilized and paid simply to lounge.

Quote: 'My high school senior quote was "If you're having a terrible day, just pour a bag of glitter in front of a fan and live in paradise". Although I no longer do this, it's a good sentiment to live by.'
www.mama.gallery

Top left
Tree Hugger
2015
Oil on canvas

Top right
A Boy in a Room
2015
Oil on canvas

Left
Steeped
2015
Oil on canvas

GLASGOW, SCOTLAND

GLASGOW INTERNATIONAL
8—25 APR

Exhibition: This celebration of Scotland's creative capital is now in its seventh year. Steered towards cultivating the city's status as a centre for contemporary art, it unfolds over 18 days. This year's theme focuses on Glasgow's heritage, its industrial legacy and its artists' relationships with ever-evolving cycles of production, manufacture, artisanship, craft and industry. With over 200 artists participating across 57 venues, this iteration of the annual art festival, led by Sarah McCrory, is set to be the best yet.

Keep an eye out for: Lawrence Lek's site-specific video project that imagines a fictional account of the Glasgow-built QE2 ocean liner returning home from Dubai, realized in a monumental artwork. Further afield, David Dale Gallery will commission a permanent site-specific work by Venezuelan artist Sol Calero.

Something else you should know: Visitors can pop into the Fireworks Pottery, where Erica Eyres and Garnet McCulloch will be presenting an entirely dysfunctional fruit and vegetable stand. Inspired by Claes Oldenburg's *The Store*, the exhibition features ceramic works and drawings of produce, offering a delightfully novel way to do your groceries.

Quote: 'The importance of the wealth of artistic talent in Glasgow both emerging and established is well represented, alongside exceptional international artists, as part of a timely and important discourse'—Sarah McCrory, director of Glasgow International.
www.glasgowinternational.org

DAVID ALTMEJD
4 MAR—9 APR

Exhibition: Canadian-born artist David Altmejd continues to prove himself a master of material processes, with his fourth solo exhibition at Brussels-based gallery Xavier Hufkens.

Blurring the lines between exterior and interior and veering between modes of representation and abstraction, Altmejd's approach to art-making and his treatment of materials are key to understanding his sculptural works. Experimenting with a diverse range of materials and objects—polystyrene, chains, fur, crystals and resin casts of his hands and of exotic fruits—Altmejd poses as a renegade scientist, generating meaning through connections and juxtapositions of material elements, manipulating the decaying cadaver of sculpture to sublime effect.

Bio: Altmejd's career has been internationally recognized with solo exhibitions throughout America, Canada and Europe. Recent successes include a major survey exhibition entitled *Flux* at the Musée d'Art Moderne de la Ville de Paris, France (2014–15). He represented Canada at the Venice Biennale in 2007 and his first public sculpture *The Eye* was unveiled in 2012.

Quote: 'I think about decay not in a negative way, but in the sense of creating a space for things to start growing.'
www.xavierhufkens.com

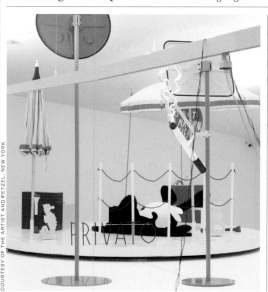

Above
Tessa Lynch
Raising, Generation 25
2014
Installation View
Jupiter Artland
Edinburgh

Left
Cosima von Bonin
HIPPIES USE SIDE DOOR. THE YEAR 2014 HAS LOST THE PLOT
2014
Installation View
Mumok, Vienna

Right
David Altmejd
Untitled 2 (Bronze Bodybuilders)
(edition of 3 + 2 AP; this is 1/3)
2015
Bronze, patina
203.2 x 57.8 x 57.8cm

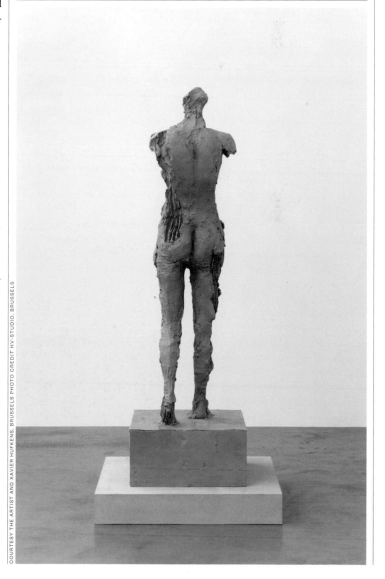

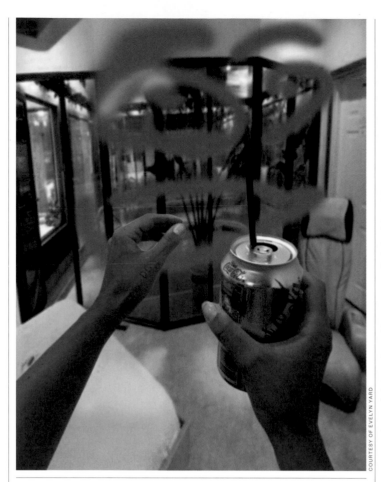

DECORATIONS NEAR THE HOUSE
ANTOINE ESPINASSEAU
20 MAR—31 APR

Exhibition: The young Parisian artist Antoine Espinasseau makes his UK solo exhibition debut in *Decorations near the House* at the up-and-coming Chelsea gallery The Dot Project.

Concerned with the processes of individual projection onto natural environments, Espinasseau has an incredibly strategic approach to image-making. In a series of elegantly composed photo-collages, watercolours and sculptural works, the artist presents small architectural utopias that question the urban landscape as a place of ritual and relationships. Drawing inspiration from specific architectural situations—the spectacular entrance halls of '70s Parisian architecture or Japanese playgrounds—he navigates the points where nature and culture intersect.

Media: Collage, photography and sculpture.

Bio: Urban planner, architect and photographer, Antoine Espinasseau graduated from the Ecole Nationale Supérieure d'Architecture de Versailles. Selected solo exhibitions include *Les Nappes*, *Public sculptures* (2015) and *Le soleil se lève et se couche sans obstacle*, Chapelle du quartier haut, Sète (2015).

Quote: 'I like the idea that an exhibition is first and foremost a public space.'
www.thedotproject.com

Left
Ry David Bradley
UVV1
2016
Dye Transfer and spray paint on synthetic suede, Dye transfer on synthetic silk
44 x 72 inches

Below
Antoine Espinasseau
Miroir
2014
200cm x 98cm

RY DAVID BRADLEY
OPENS 6 APR

A rising star within the international art scene, Australian painter Ry David Bradley explores the territory between the virtual and the physical realms. Downloading material from the web, Bradley subjects images to a rigorous editing process and then prints them onto synthetic suede using a dye-transfer process. The result: abstracted canvases vividly blurring paint and pixels to give a languidly hazy effect. Following a sell-out show at Tristian Koenig last year and recent acquisitions of his work by the National Gallery of Victoria, Bradley presents his first UK solo show at Evelyn Yard.

Something else you should know: Initially trained as a media artist in his early 20s, Bradley says his discovery of painting was accidental. Waiting for complex Aftereffect software to load, he would often stray into nearby art departments—which eventually resulted in an encounter with a very prominent artist and a lesson in canvas stretching. The rest is history.

Bio: Bradley graduated from Melbourne University in 2013. His recent solo presentations include *Border Protection*, Tristian Koenig, Melbourne; and *Access All Areas*, Bill Brady Gallery, Kansas City; both 2015.

Quote: 'Recently I've been thinking that some of my favourite contemporaries—Takeshi Murata, Ed Atkins, Kate Cooper, Jordan Wolfson, Jon Rafman, Bunny Rogers, etc—are all artists who have been riffing on the Uncanny Valley [our strange revulsion towards things that are almost human], whether aware of it or not. 3D modelled figures and robotics are something we are all becoming increasingly comfortable with, and with the advent of Oculus Rift and so on, the next 5–10 years will be defining.'
www.evelynyard.com

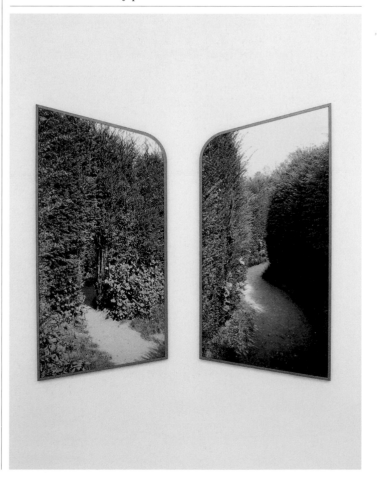

HT THE GARDENER
ART BRUSSELS
22—24 APR

Exhibition: Although it is one of Europe's oldest fairs, Art Brussels has managed to retain a cutting-edge profile, establishing itself as a European nexus for contemporary art practice. Bringing together 140 galleries from 28 countries, the fair is keen to promote artists as yet unfamiliar to a wider public. This year's edition has a '*Rediscovery*' section, dedicated to underappreciated and overlooked art dating from 1917 to 1987. Other highlights include Marinella Senatore at MOT International (Brussels, London) in 'Solo', a section that accommodates gallery booths showcasing individual artists.

Bio: Founded in 1968 under the name *Art Actuel*, the fair was the brainchild of a small group of Belgian gallerists, each of whom invited a foreign gallery to exhibit.

Something else you should know: Art Brussels places an emphasis on the individual presentation of artists, so it is natural that the fair's flagship project for 2016 should adopt the ethos of the late Belgian curator Jan Hoet. Entitled *Cabinet d'amis*, the exhibition pulls from Hoet's personal collection and will include works by Thierry De Cordier, Marlene Dumas, David Hammons and others.

Quote: 'Art is not an illustration; it is the mirror'—Jan Hoet. *Art Brussels will run from Friday 22 April – Sunday 24 April 2016 at its new location of Tour & Taxis, Brussels: www.artbrussels.com*

Top
Nicolás Lamas
Connaissance des arts
2015
book, stones,
31 x 51 x 4.5cm

Left
Ann Gertsberger
Untitled (Tapestry)
2016
290 x 240cm

Some become part time singers and some keep pretending.

to hypnotize them with forgetfulness.

DEUTSCHE BANK
KUNSTHALLE, BERLIN

THE STARS WERE ALIGNED FOR A CENTURY OF NEW BEGINNINGS
BASIM MAGDY
29 APR–3 JUL

Exhibition: Winner of the prestigious 2016 Deutsche Bank 'Artist of the Year' award, Basim Magdy will be celebrated with a major survey held at the Deutsche Bank KunstHalle.

Encompassing a broad range of media, Magdy's work is concerned with observation, memory and archiving. Possessing a sharp wit and idiosyncratic humour, the artist creates enigmatic narrative structures based on skewed observations of reality. In exploring the shady area between reality and fiction, Magdy quests through futuristic worlds and landscapes rendered in lurid kaleidoscopic colours, investigating the collective utopias and inconvenient truths that remain inextricably linked in his eyes.

Bio: Magdy graduated from Helwan University in Cairo. His career has been internationally recognized with selected works exhibited at the Sharjah and Istanbul Biennials (2013), La Biennale de Montréal and MEDIACITY Seoul Biennale (2014).

Born: Assiut, Egypt.
Residence: Basel, Switzerland, and Cairo, Eygpt

Something else you should know: In his seminal 16mm film works such as *The Dent* (2014), Magdy employs his signature technique of 'film pickling', whereby the artist exposes film to household chemicals, leaving eerie chromatic streaks across the developed image.

Quote: 'Maybe I'm more interested in issues that are not particularly pleasant, but I have to say that my favourite reaction to the work I make is when people look at it and smile or laugh.'
www.deutsche-bank-kunsthalle.de

From top
Video-Still
The Dent
2014
Super 16mm film,
19 mins 02 secs

Video still 2
The Everyday Ritual of Solitude Hatching Monkeys
2014
Super 16mm film,
13 mins 22 secs

Portrait Basim Magdy
Photo by Deridre O'Leary

TATIANA TROUVÉ
6.2. – 28.3.16
KÖNIG GALERIE | ST. AGNES NAVE

KIKI KOGELNIK
6.2. – 6.3.16
KÖNIG GALERIE | ST. AGNES CHAPEL

SURRREAL
12.3. – 24.4.16
KÖNIG GALERIE | ST. AGNES

ANNETTE KELM
9.4. – 29.5.16
KÖNIG GALERIE | ST. AGNES NAVE

ARMORY SHOW
3. – 6.3.16
PIERS 92 & 94, NEW YORK CITY

ART COLOGNE
14. – 17.4.16
KOELNMESSE, COLOGNE

JORINDE VOIGT
4.6. – 24.7.16
KÖNIG GALERIE | ST. AGNES NAVE

GALLERY WEEKEND BERLIN
29.4. – 1.5.16
KÖNIG GALERIE | ST. AGNES | SCULPTURE GARDEN

JOHANN KÖNIG | DESSAUER STRASSE

KÖNIG GALERIE

ST. AGNES
ALEXANDRINENSTR. 118–121
D-10969 BERLIN

OPENING HOURS
TUE–SUN 11–18 H
KOENIGGALERIE.COM

MAR

JOE TILSON
2 MAR—2 APR / LONDON

Painter Joe Tilson brings a cornerstone of Venetian life back to London for his seventh solo show at Marlborough Fine Art. In a new body of work that sees architectural church façades and large-scale replicas of postcards rendered in a bold schematic colour palette, the British artist celebrates the interdependence of paintings, architecture, design and written word against the backdrop of the floating city.
Tilson: The Stones of Venice
Marlborough Fine Art
www.marlboroughlondon.com

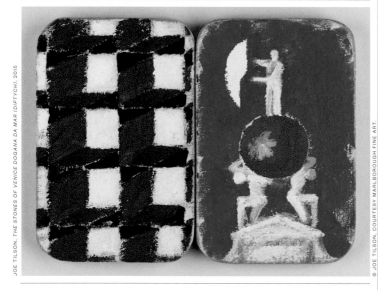

JOE TILSON, *THE STONES OF VENICE DOGANA DA MAR (DIPTYCH)*, 2015

© JOE TILSON. COURTESY MARLBOROUGH FINE ART.

MOT ANNUAL 2016
5 MAR—29 MAY / TOKYO

Currently in its 14th year, the *MOT Annual* is a group exhibition that introduces the latest trends in contemporary art. The exhibition features work by over a dozen emerging Japanese artists, each struggling to change their environments in a bid to re-evaluate the position and role of artists today.
Museum of Contemporary Art Tokyo
www.mot-art-museum.jp

DIANA AL-HADID
6 MAR—28 MAY / ABU DHABI

NYUAD Art Gallery presents *Phantom Limb*, a major solo exhibition by Syrian artist Diana Al-Hadid. Inspired by Old Master works and classical imagery alike, Al-Hadid transforms this visual language into large-scale towering sculptures of seemingly molten gypsum and cascading wax. Evoking both mythical and futuristic worlds, her work handles the concept of memory and its physical manifestations.
Phantom Limb
NYUAD Art Gallery
www.nyuad-artgallery.org

THE PROMISE OF TOTAL AUTOMATION
11 MAR—29 MAY / VIENNA

It's largely accepted in the natural sciences and object-oriented philosophy that 'things' have autonomous means of information processing, and that they can develop relationships with each other that are not facilitated by humans. *The Promise of Total Automation* imagines this concept and maps the responses of nearly 30 artists who have produced works motivated by the glorification of automatism.
Kunsthalle Wien
www.kunsthallewien.at

RENEE SO
11 MAR—16 APR / LONDON

London-based artist Renee So returns to Kate MacGarry for her third solo exhibition, bringing her poetic ceramics and knitted two-dimensional works with her. Inspired by the panache of the nineteenth-century *flâneur* and the traditions of antiquity, So's fascination with craft results in completely charming works that have a contemporary twang.
Kate MacGarry
www.katemacgarry.com

REVOLUTION IN THE MAKING: ABSTRACT SCULPTURE BY WOMEN, 1947-2016
13 MAR—4 SEPT / LA

To mark the opening of Hauser Wirth & Schimmel's new LA venue, the inaugural exhibition *Revolution in the Making* brings together nearly 100 works made by 34 female artists over the past 70 years. An ambitious undertaking, the cross-generational show traces the ways in which women have changed the course of art by deftly transforming the language of abstract sculpture since the postwar period.
Hauser Wirth & Schimmel
www.hauserwirthschimmel.com

EPHREM SOLOMON
24 MAR—30 APR / LONDON

Ethiopian born Ephrem Solomon presents socio-political works using woodcut and mixed media. Informing his work are views of the city and the people that inhabit the spaces around him, as does a fictional world that exists beyond the present—a reality that is free from the limitations of anecdotal recordings of experience. Using black and white to symbolize this juncture in reality, Solomon presents his observations though symbolism and use of archival material, which provide personal

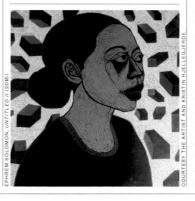

EPHREM SOLOMON, *UNTITLED II* (2016)

COURTESY THE ARTIST AND KRISTIN HJELLEGJERDE

and political narratives beyond his locale.
Kristin Hjellegjerde
kristinhjellegjerde.com

ALEX DA CORTE
OPENS 26 MAR / NORTH ADAMS

In his typically off-kilter and quirky aesthetic, Alex Da Corte plunders the banal vocabulary of domestic and consumerist life, employing a catalogue of items ranging from shampoo to soda. Conflating consumer objects with pop-cultural references and personal family narratives in a series of sculptures, paintings, videos and immersive installations, *Free Roses*, his first institutional survey, will showcase a selection of his work created over the past decade.
Free Roses / Massachusetts Museum of Contemporary Art
www.massmoca.org

APR

MARILYN MINTER
2 APR—10 JUL / NEWPORT BEACH

For three decades, Marilyn Minter has photographed the makeup-laden lips and soiled stilettos associated with contemporary femininity in the 1980s. Her seductive portraits capture beauty conventions and contradictions pertaining to the female body. Whether she is playing the role of provocateur, critic or humourist, Minter certainly knows how to bring the power of desire into focus.
Pretty/Dirty / Orange County Museum of Art
www.ocma.net

LUKAS DUWENHÖGGER
3 APR—29 MAY / NEW YORK

Istanbul-based artist Lukas Duwenhögger paints large-scale figurative canvases that are often politically charged, electric and dressed in the allure of gay desire. Artists Space Gallery will present a major exhibition of his paintings

across both of its New York venues.
Artists Space
www.artistsspace.org

PHILIP METTEN
3 APR—18 JUN / AALST

Antwerp-based sculptor Philip
Metten creates modern effigies
to the digital age. Large-scale
and unwieldy, his sculptural works
are zany hybrids of primitive art
forms and street graffiti culture.
Here, Netwerk Centre for
Contemporary Art stages a solo
exhibition of the artist's work.
Netwerk Centre
for Contemporary Art
www.netwerk-art.be

MOUNA KARRAY
8 APR—21 MAY / LONDON

Tunisian-born Mouna Karray's first
solo exhibition in London shows
her elegantly composed and often
performance-based photographs,
merging sociopolitical themes with
personal experience to examine con-
structions of identity and memory.
Tyburn Gallery
www.tyburngallery.com

FLORIAN SLOTAWA
9 APR—28 MAY / BASEL

German-artist Florian Slotawa
makes the everyday extraordinary,
investing quotidian objects with
a new lease of life. Blurring the
boundaries between domestic and
public, his artistic practice employs
found objects taken from the
hardware-store shelves (and even his
own home) which he then reappro-
priates and recontextualizes to form
fresh perspectives. The exhibition
will mark his second solo show with
von Bartha Gallery.
Von Bartha
www.vonbartha.com

DAN FLAVIN
13 APR—26 JUN / BIRMINGHAM

A master of light, American artist
Dan Flavin is known for his searing
fluorescent light 'situations' which
have become icons of minimalism.
A key protagonist in American
post-war art, Flavin took an interest
in artworks that refer to nothing
beyond their factual presence,
placing an emphasis on industrial
materials and intense colour. Expect

to see Ikon's exhibition space in
a whole new (radiant) light.
*It Is What It Is and It Ain't
Nothing Else* / Ikon Gallery
www.ikon-gallery.org

GEOFFREY FARMER
13 APR—17 JUL / BOSTON

Canadian-born artist Geoffrey
Farmer will present a selection

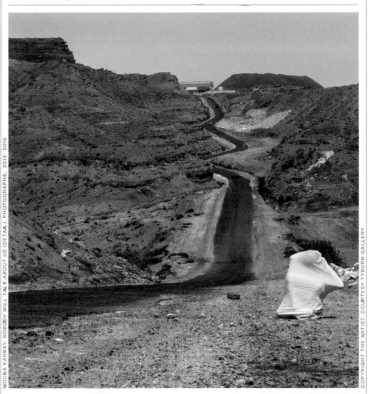

MOUNA KARRAY, *NOBODY WILL TALK ABOUT US (DETAIL), PHOTOGRAPHS, 2012-2016*

COPYRIGHT THE ARTIST, COURTESY TYBURN GALLERY

of his installations and large-scale
sculptural photo collages in a
major survey held at ICA Boston.
The works—products of his inter-
est in historical and vernacular
imagery—resemble small theatres
of classical statuettes, gathered
together in an effort to trace the
historical contours of our image-
saturated culture.
Institute of Contemporary
Art Boston
www.icaboston.org

CUT, FOLD, RECREATE
22 APR—14 AUG / CINCINNATI

A surprising look at the ways artists
reinvent the everyday and make
it resonate, *Cut, Fold, Recreate*
is a small international group
show featuring the work of Noel
Anderson, Ying Kit Chan, Lisa
Anne Auerbach and Maårgarita
Cabrera. Investigating materiality,
labour and touch in relation to
production politics, highlights

include Icelandic artist Hildur
Bjarnadóttir's delicate textile works
alongside Adrian Esparza's hard-
edged abstract wall drawings.
Contemporary Art Centre Ohio
www.contemporaryartscenter.org

KERRY JAMES MARSHALL
23 APR—25 SEPT / CHICAGO

This three-decade survey of

Marshall's large-scale paintings—
featuring figures asserting their
blackness in a medium
that has historically ignored their
existence—is testament to the art-
ist's inspired and imaginative ability
to chronicle the African-American
experience.
Mastry / Museum of Contemporary
Art Chicago
www.mcachicago.org

TOBIAS ZIELONY
OPENS 29 APR / BERLIN

In his fifth solo exhibition with
KOW, Berlin-based artist Tobias
Zielony continues his humanist
exploration into those living on
the margins of mainstream society.
With his critical approach to social
documentarism, the young artist
has been earmarked as one to watch
within the contemporary German
photography scene.
KOW
www.kow-berlin.info

MAY

MONA HATOUM
4 MAY—21 AUG / LONDON

Mona Hatoum is celebrated
in a major survey at Tate Modern—
which is actually the first institu-
tional show of her work in London.
Drawing on 35 years
of radical thinking, the exhibition
stays true to Hatoum's viscerally
immediate practice. Both highly
political yet beguilingly poetic, her
work can be read as a profound
meditation on the body, trauma
and power relations.
Tate Modern
www.tate.org.uk

LEE KIT
12 MAY—9 OOT / MINNEAPOLIS

Hong Kong-based artist Lee Kit
is known for his poetic object-ba-
sed installations loaded with
political weight and references
to the dominant market capitalism
of his birthplace. In his first US
institutional solo exhibition, Lee
presents a selection of work created
over the past five years including
seminal video work *I Can't Help
Falling in Love* (2012) alongside
a newly commissioned site-speci-
fic installation.
Walker Art Centre
www.walkerart.org

SACHIN KAELEY
14 MAY—14 JUN / PORTO

With gloriously thick layers
of acrylic paint and gels mimicking
fingered butter icing or malleable
clay, Sachin Kaeley's impasto paint-
ings are invitingly tactile. Yet the
recent RCA graduate's work also has
an oddly digital aura, the ridges and
grooves of physical paint manipula-
tion deftly referring to Photoshop
illusions. The show will be Kaeley's
first solo exhibition with the gallery.
Múrias | Centeno
www.muriascenteno.com

SILICON VALLEY FOR AND AGAINST CREATIVITY

CONCEPT AND DESIGN BY LA TIGRE

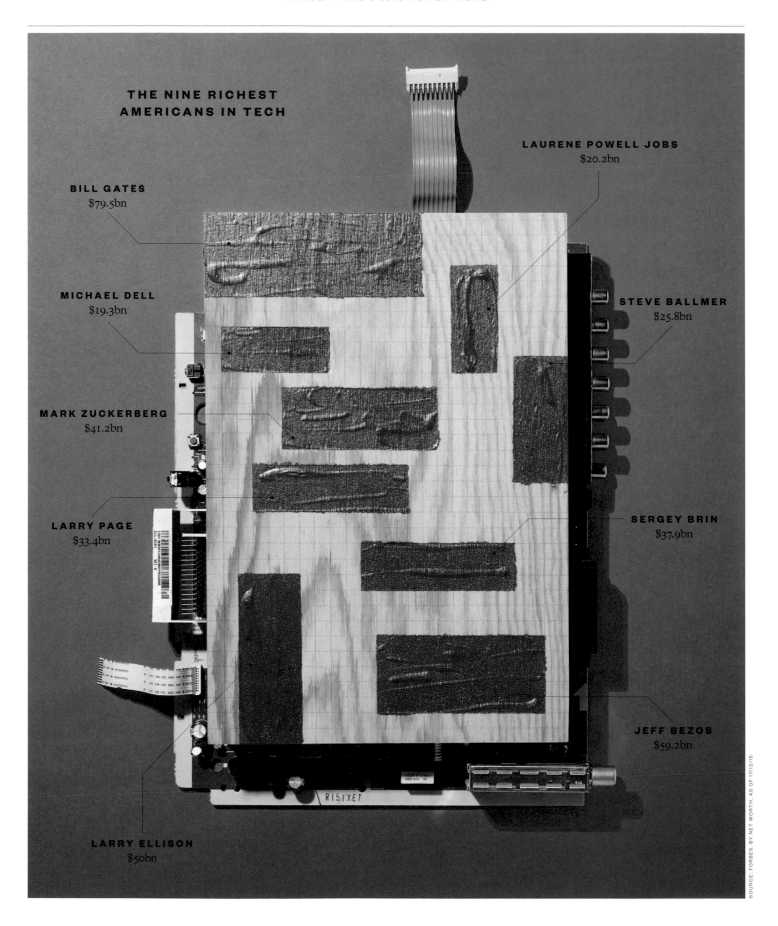

THE NINE RICHEST AMERICANS IN TECH

LAURENE POWELL JOBS
$20.2bn

BILL GATES
$79.5bn

MICHAEL DELL
$19.3bn

STEVE BALLMER
$25.8bn

MARK ZUCKERBERG
$41.2bn

LARRY PAGE
$33.4bn

SERGEY BRIN
$37.9bn

JEFF BEZOS
$59.2bn

LARRY ELLISON
$50bn

SOURCE: FORBES. BY NET WORTH, AS OF 17/12/15

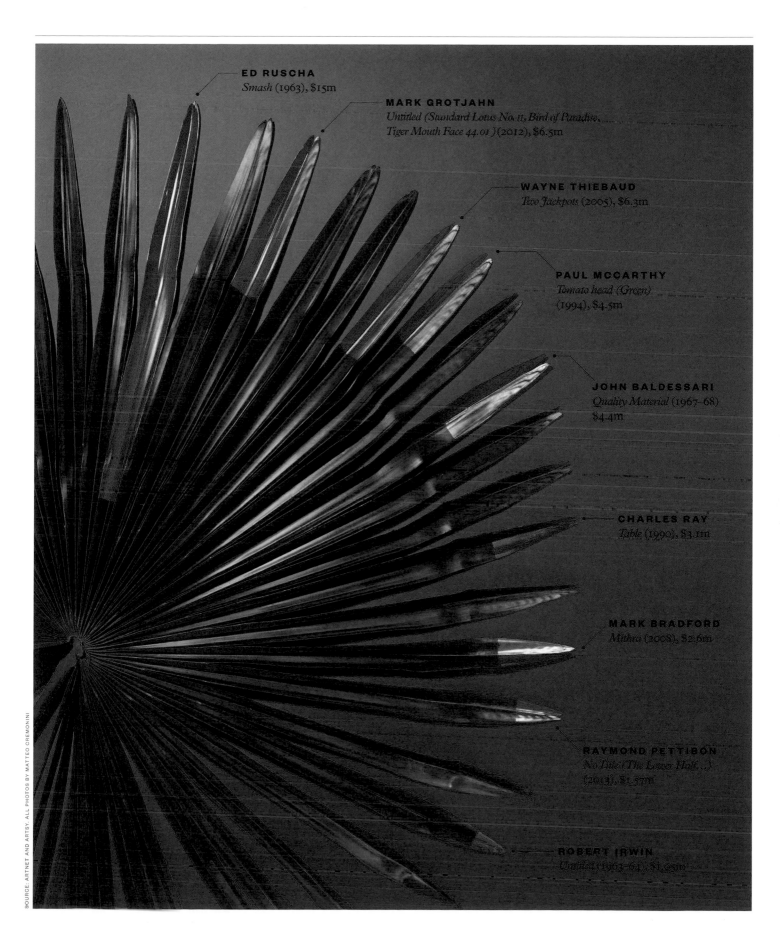

ED RUSCHA
Smash (1963), $15m

MARK GROTJAHN
Untitled (Standard Lotus No. II, Bird of Paradise,
Tiger Mouth Face 44.01) (2012), $6.5m

WAYNE THIEBAUD
Two Jackpots (2005), $6.3m

PAUL MCCARTHY
Tomato head (Green)
(1994), $4.5m

JOHN BALDESSARI
Quality Material (1967–68)
$4.4m

CHARLES RAY
Table (1990), $3.1m

MARK BRADFORD
Mithra (2008), $2.6m

RAYMOND PETTIBON
No Title (The Lower Half...)
(2013), $1.57m

ROBERT IRWIN
Untitled (1963–64), $1.95m

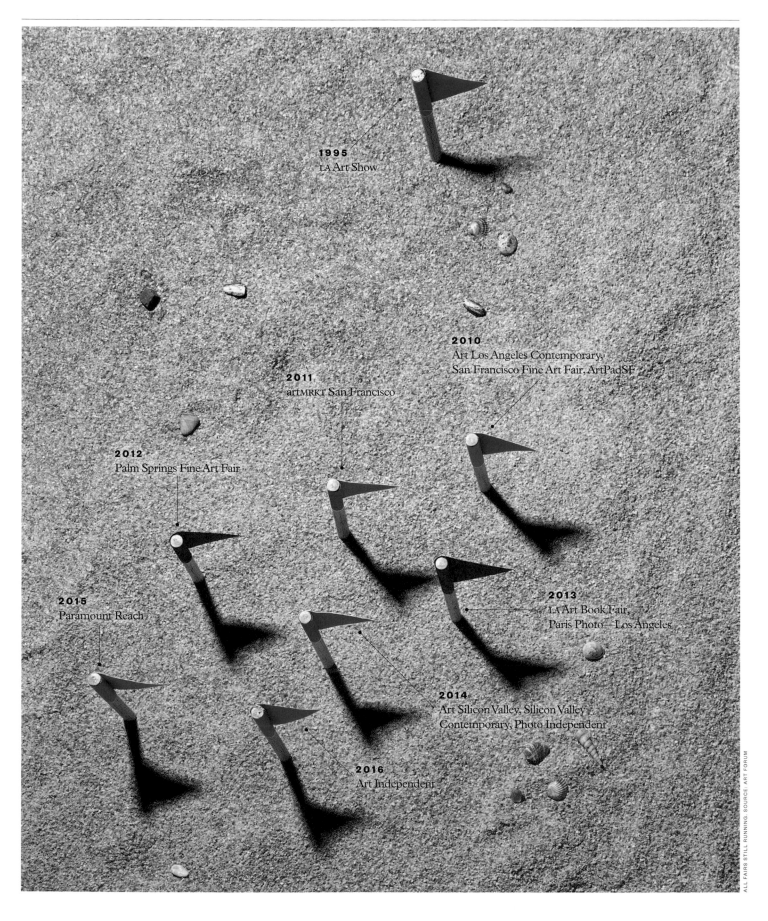

1995
LA Art Show

2010
Art Los Angeles Contemporary,
San Francisco Fine Art Fair, ArtPadSF

2011
artMRKT San Francisco

2012
Palm Springs Fine Art Fair

2013
LA Art Book Fair,
Paris Photo—Los Angeles

2015
Paramount Reach

2014
Art Silicon Valley, Silicon Valley
Contemporary, Photo Independent

2016
Art Independent

BILL GATES
Microsoft co-founder

Net worth: $79.5bn
Collection worth: Unknown
Preferred styles: Late nineteenth- and early
twentieth-century American painting
Collecting style: Private sales, public exhibitions
Star pieces: Winslow Homer, *Grand Banks*, $36m;
Childe Hassam, *Room of Flowers*, $20m; George
Bellows, *Polo Crowd*, $28m
Controversy: Bought Leonardo da Vinci's *Codex
Leicester* for $19m, then distributed digital versions.

PAUL ALLEN
Microsoft co-founder

Net worth: $18.1bn
Collection worth: $750m
Preferred styles: Landscape painting, Pop Art
Collecting style: Very private
Star pieces: Claude Monet, *Rouen Cathedral:
Afternoon Effect*, $40m; Pierre-Auguste Renoir,
La Liseuse, est. $13.2m; Roy Lichtenstein, *The Kiss*
Where does he show? *Seeing Nature: Landscape
Masterworks from the Paul G. Allen Family Collection*
went to Seattle Art Museum, the Phillips Collection
and Portland Art Museum.

SEAN PARKER
Napster founder, Facebook founding president

Net worth: $3bn
Collection worth: Unknown
Preferred styles: Contemporary
Collecting style: Public
Star pieces: Ai Weiwei, *Circle of Animals/
Zodiac Heads*, $4.4m
Controversy: Parker's LA-based art consultant
Stefan Simchowitz has been blacklisted from
a number of galleries for his swift reselling tactics.

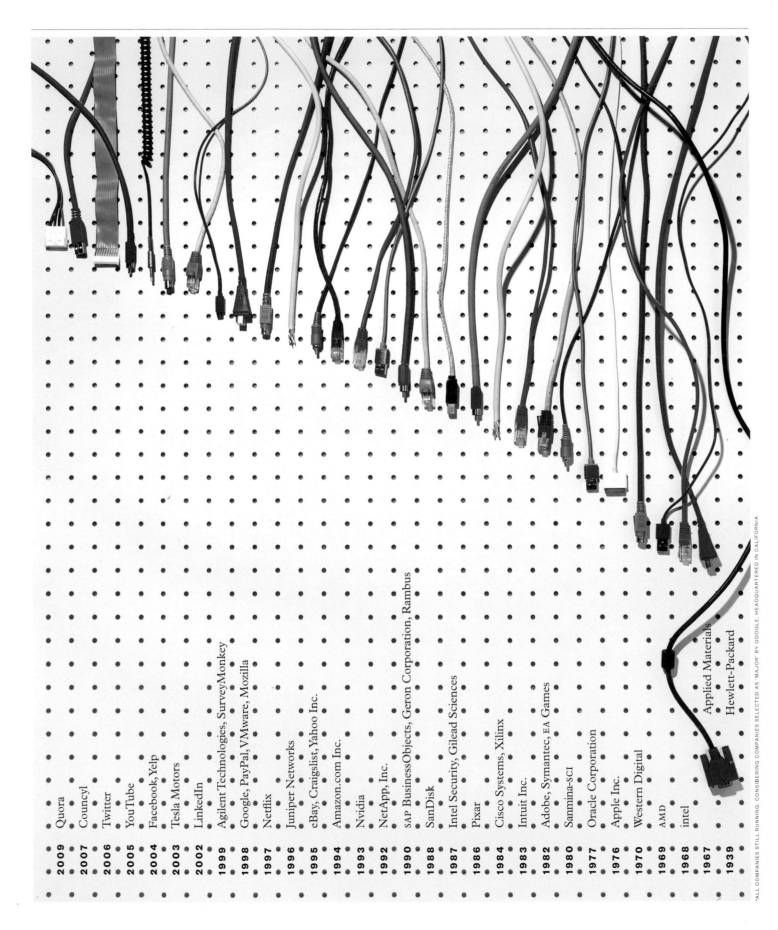

2009	Quora
2007	Councyl
2006	Twitter
2005	YouTube
2004	Facebook, Yelp
2003	Tesla Motors
2002	LinkedIn
1999	Agilent Technologies, SurveyMonkey
1998	Google, PayPal, VMware, Mozilla
1997	Netflix
1996	Juniper Networks
1995	eBay, Craigslist, Yahoo Inc.
1994	Amazon.com Inc.
1993	Nvidia
1992	NetApp, Inc.
1990	SAP BusinessObjects, Geron Corporation, Rambus
1988	SanDisk
1987	Intel Security, Gilead Sciences
1986	Pixar
1984	Cisco Systems, Xilinx
1983	Intuit Inc.
1982	Adobe, Symantec, EA Games
1980	Sanmina-SCI
1977	Oracle Corporation
1976	Apple Inc.
1970	Western Digital
1969	AMD
1968	intel
1967	Applied Materials
1939	Hewlett-Packard

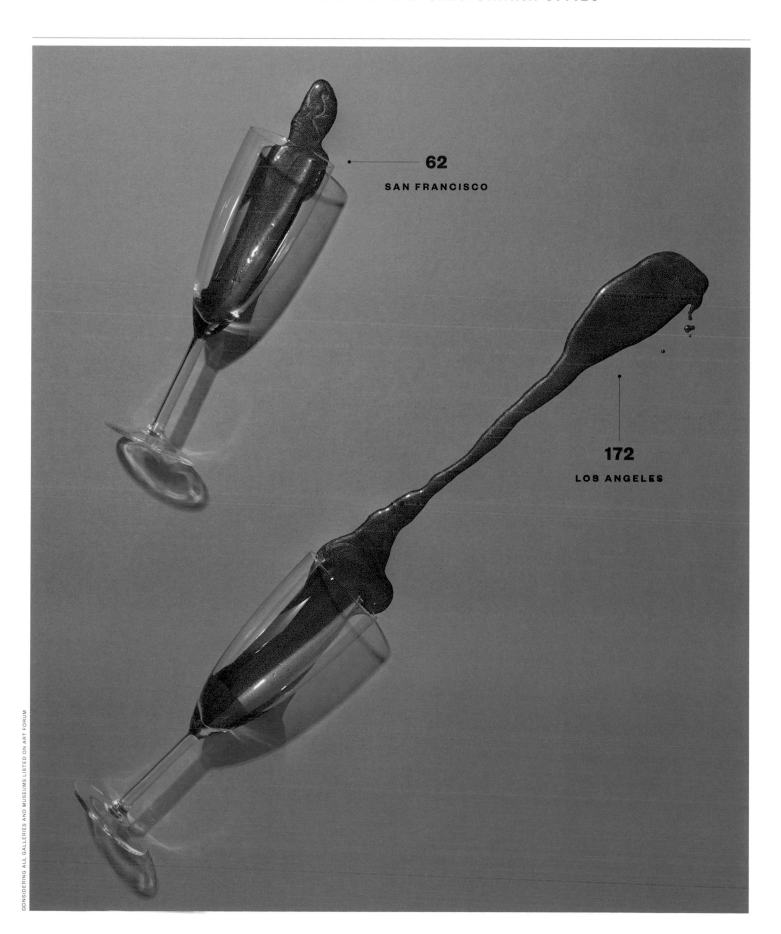

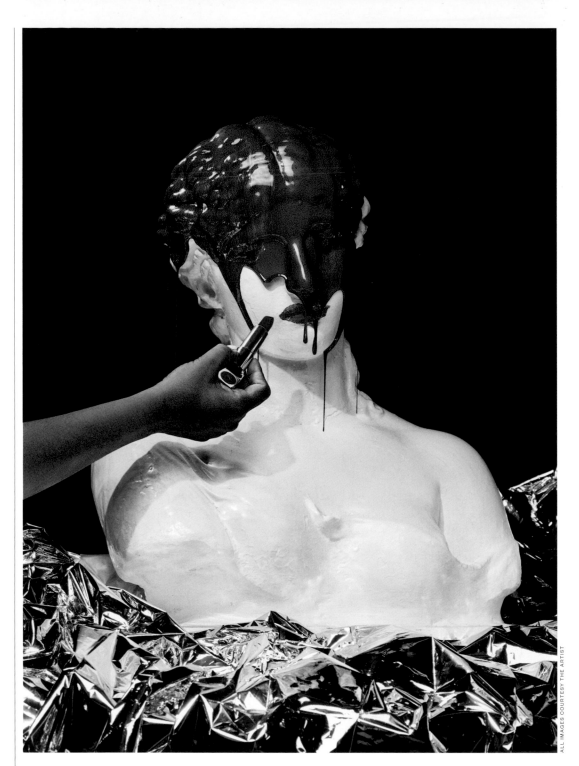

SILICON VALLEY VERSUS CREATIVITY

Silicon Valley has colonized every corner of the globe. Art has been eclipsed by engineering; the Dadaists have all become Big Dataists. Surely it's time some anarchic, soulful spirits emerged to romance the binary, says **ROBERT URQUHART**.

Why does contemporary art and design so often fail to translate the void between technology and emotion? Has digital art fallen into the trap of sidelining intuition, perception and sensitivity in order to mimic the cash-rich world of production-line product? Or is Western art tied to a limited palette, rendered obsolete by continued blind subservience to outmoded twentieth-century means?

I've been interested in the link between the squeaky-clean tech-engineer approach to creativity and the dirtier, hands-on approach to art for some time. During trips to the West Coast of America I've spent a disproportionate amount of time hopping in and out of studios, meeting designers and artists with a view to writing up a status report that feeds back on the state of this relationship. This is just that: a status report, for which I visited Los Angeles and San Francisco, then Dutch Design Week in Holland to get a European perspective on the matter.

I start inside the hollow mall that is the 'Blue Whale', aka the Pacific Design Center, on Melrose Avenue in West Hollywood. I'm there to meet curator Paul Young about an

exhibition I'm going to see at the Depart Foundation, on Sunset Boulevard, by Petra Cortright.

I met Cortright at Frieze Art Fair in London a couple of years ago. We spent an enjoyable time talking about the merits of how jet lag, mixed with quantities of over-the-counter enliveners, can open the doors of perception and that the concept of selling her video work based on YouTube hits seemed like an interesting move.

Young's primary area of expertise is in moving-image art forms, with a special emphasis on video art, digital works and computer-based practice. Some of his recent curatorial efforts include The Silicon Valley Contemporary 2014, Art Miami's international contemporary art fair headed west. Young is fairly downbeat about the turnout for last year's event, saying, 'People that are the innovators, people that are the money people, they don't have time to go to galleries, that was the problem with that art fair. It's like Hollywood: people don't go to galleries very often, they usually send art advisors.'

Young is a perfect mode of induction for the quest I'm on: to discover the play-off between 'traditional' practice and contemporary Silicon Valley interest

in, and disruption to, creativity. The theme of time creeps in at every stage of the journey.

Surely sending art advisors to a show is a positive? What do collectors look for in contemporary digital work? 'Collectors understand that new media is part of the language of contemporary art. They are keen on this notion of longevity and obsolescence,' says Young. 'They want to make sure that this work is valuable and will run in 20, 40 or 100 years because that's how they value traditional work.'

Does that affect Young as a curator when he approaches an artist? 'Not as a curator' he says. 'A lot of artists don't think that way, artists are interested in "hot right now" and pushing borders to the extreme, they are not always thinking long term. In fact, most of them aren't. I'm the one that has to remind them, as a gallerist, that this is important, that we do have to think about things that last as long as possible, as opposed to simple plug and play.'

What about time as a muse and medium for the artists that Young deals with? 'It's a primary medium,' he notes. 'Video has a cinematic tempo to it, so a lot of artists like

to affect you with montage, but I've noticed that a slower tempo is happening in digital. Digital is about the tempo of your heart; it's calm, it's meditative, it works more like painting or photo collage, you can bring your own time to it. Cinematic work tells you that you have to spend x amount of time engaging. Newer digital artists like Petra Cortright understand the pacing and the way the work can inhabit time and space.'

After spending time with Young, I walk up the road to the Sunset Strip to see Petra Cortright's solo exhibition. Sunset Boulevard is the perfect sleazy backdrop for a show with the coquettish name of *Niki, Lucy, Lola, Viola*. Inside I'm greeted by a hypnotic, writhing sea of semi-clad porn stars, animals and painterly landscapes all superimposed, repeated and manipulated to great effect by Cortright.

Time to head north, to San Francisco, for some gentle old-school conversation around the theme of 'refined chaos' with Martin Venezky of Appetite Engineers. Venezky is associate professor in the graduate design program at California College of the Arts (CCA) in San Francisco,

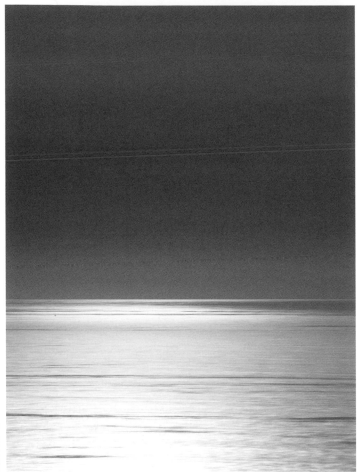

Previous pages
NJ(L.A.)™
Illustration for *GOOD*
magazine, autumn 2015

Left
Brett Wickens
Palomarin 06
1 February 2015
Camera: Olympus EM-1

Opposite
Brett Wickens
Big Rock 31
12 July 2015
Camera: Canon 5DS

Overleaf, left
Petra Cortright
Forest Range w Aqua Sky 2
2009
Digital collage

Overleaf, right
Petra Cortright
Cropped_masked_final
2015
Video, 120 mins
From *Niki, Lucy, Lola, Viola*

where he has taught since 1993. His studio on Bryant Street, just off Market Street, is sandwiched between car mechanic garages and picture framers, the perfect setting for a grafting artist. Venezky's studio is curated with an expert eye for what I can only describe as 'Californi-copia': Not quite kitsch, not quite chaos. Aside from teaching, Venezky has made a name for himself in the world of books: a recent collaboration on a Wes Anderson book, entitled *Grand Budapest Hotel*, sums up his attachment to highly stylized, thoughtful absurdities. But throughout Venezky's work there runs a deeper path, perhaps unwittingly. He stands at the threshold of what digital art deals with today. Even though the majority of his work is hand rendered and stems from physical interaction with materials, his process mirrors that of digital.

'People say my work looks random, I never thought it was. There was a school of design during the mid-90s where people would just throw random stuff down. I really work hard to find resonance between things, so

it isn't random. It's no more random than when a crowd gathers; they start to gather and form groups,' says Venezky. 'I look at my work as a crowd organizing itself. I like to make it feel like the images found their way next to each other and not like a designer came along and forced things to happen.'

Aside from his work in publishing, Venezky often deals with physical space, hence his constant, obsessive additions to his studio interior design layout. On the back of an exhibition organized by fellow CCA tutor Jon Sueda in 2013, Venezky was approached by Adobe to create a temporary exhibit for their San José headquarters. 'I think a lot of this is to do with them liking *real* material. Everyone there works with virtual stuff,' muses Venezky. 'This was a chance to push against that, and to show work that was about artefacts, about the real things.' The result was an outdoor installation of 3,000 images collected by Venezky: a vastly time-consuming piece that took far longer to orchestrate than the time it then spent on

display. Where does the notion of time come into play with his work?

'One of the important things to me is "slowing down",' he explains. 'In Silicon Valley, the profession is about speeding up, so I intentionally try and slow it down. Putting these things up on the walls is a slow process, putting pictures next to each other and spending time with them is a slow process. It's a lot quicker to have a whole plan and slip everything into place; it's a lot slower just to see what the images are saying to each other.'

Back near Venice Beach in Los Angeles, Nicole Jacek of NJ(L.A.)™ is busy growing her new studio. A serial immigrant, first from Germany to the UK via Ian Anderson at the Designers Republic, and then to New York to work for Stefan Sagmeister and, latterly, Karlssonwilker Inc, Jacek headed west to set up a studio in 2013.

Jacek is part of the new-wave talent between USA and Europe where craft meets the 'fail forward' mentality in culturally led commercial projects. Like

Venezky, Jacek has worked with Adobe, on a brand-awareness project entitled Adobe Remix that saw the Adobe logo manipulated by user-generated audiovisual content. But unlike the softly spoken, gentle Venezky, Jacek is a brash, outspoken totem of design stardom: her much-coiffured hair has its own Twitter account. Thankfully, the neon, fuck-it, rock 'n' roll attitude is alive and kicking in an increasingly sepia, Instagram-filtered landscape.

'For me, creativity is about knowing the craft, we are not there yet in the U.S.' notes Jacek. 'The way things are taught here is about short-term thinking and short-term projects: "make something in a second." That's not how things work. Design is a real craft. I'm here because I want to pursue what happens when you meld the craft, the thinking and the business side of things, and go and make something.'

Jacek is currently hiring a studio team, 'We have an influx of Europeans right now because they are stuck where they are at home,' she notes, partly blaming the arts-funding crisis for the exodus. How does Jacek feel about working increasingly on technology-driven projects, having come from a largely European print background? 'I seek simplicity. We [creatives working in technology in the US] will have to reach the point of

absolute simplicity. It's far too crazy at the moment.' How to combat the stress of the constant barrage of digital? 'We are aiming for sustainable plans in everything we do, it's now the key. For a long time, design was just about creating something "pretty". What does pretty *do* now?'

Back to San Francisco. Here Brett Wickens, partner of Ammunition Design Group, awaits.

Wickens, a Canadian-British expat, moved to LA from London with his then-design partner Peter Saville in the early '90s for a short period, creating posters for the movie industry before departing, on his own, for San Francisco. Speaking of his time in LA, Wickens states: 'We thought the entertainment industry was going to be the interesting future of things after album covers. It wasn't.'

The period in LA wasn't completely dry, though. As VP creative director at Frankfurt Balkind Partners, Wickens produced the highly memorable logotype for HBO's *The Sopranos*. But perhaps he just got to town too early—his interest in futuristic electronica and digital design was only just beginning to make itself felt in a commercial environment, and it was arriving further north, in the Bay Area.

'I arrived in San Francisco in 1998, before the first dotcom bust,' he explains. 'My interest

at the time was in digital design. Finally everything collided; my interests, passions and the commercial side, plus, the internet became "a thing".'

For Wickens, who'd been raised to look, think and create on behalf of a generation of futurist electronica aficionados for whom the works of New Order and Joy Division are still graphic design in musical form, the move towards Silicon Valley was compelling. Wickens had started his career as a pioneer of electronic music in Canada. He'd illustrated the cold-steel, thousand-yard-stare of defiant, new-wave England and the emotive sensation of digital, tasted the entertainment industry in Los Angeles and now, as communication, product and aesthetics became entwined, he found himself a namechecked man in a gold-rush town.

Ammunition is now one of the most successful design firms in the Bay Area, partly due to its interesting business model which sees it financially investing in many of the companies that it works with. The company designs hardware, software and graphic identities for many companies, including Adobe, Beats by Dre, Polaroid Corporation and Square, Inc. Yet Wickens, based in a city where the only angels are the investors, still manages to retain a cool, artistic detachment from the Silicon tribe with their

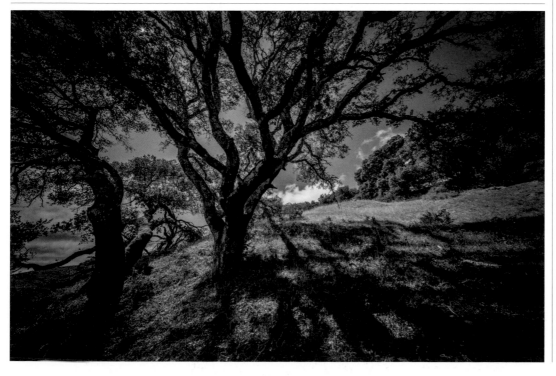

artistic sensibilities that only stretch as far as their IPO.

Talking to Wickens about the link between sometimes hedonistic, artistic vision and current commercial entrepreneurship brings this response, 'Going back to the late 1990s, Peter and I took very different paths. Peter has really gone into fine art more than commercial design, but I always knew he would. He always wanted to be the Andy Warhol of the twenty-first century, so he had to do it. I didn't, I was always more interested in design as a tool for change, whether it was commercialized or not. I wrestle with this business because you can go to the lowest common denominator with design, just slip into the world, or you can try and take a stand and make a point of view. I almost always try and do the latter but at some point in the process I realize it's not appropriate. But unless you keep on trying to push the language of design, why are you getting out of bed in the morning?'

What about the 'characters' associated with twentieth-century creativity, where are they in today's creative line-up? Isn't Silicon Valley run by the new suits that have swapped a tie for a tee-shirt? 'It is a bit weird,' says Wickens. 'It's a squeaky-clean environment full of clean-cut, smart engineering types that now sit on top controlling the world's data, entertainment, delivery mechanisms, transportation, whatever. There is no "shit to stir, what can I fuck up?" vibe. There is no Richard Branson here. I think Branson is an early model for the whole thing but he was a total shit-stirrer from the early days with a record shop. That's really what's missing'.

We finish our discussion talking about the role of photography in digital media. I mention my conversation with Paul Young and how Silicon Valley views the art world. Wickens flips the discussion, 'I don't think people have really studied the fabric of Silicon Valley as art,' he says. 'It's all business, it's all money, it's all product, it's all deals. I can't think of any interesting or important artistically inspired response to what Silicon Valley actually is.'

Wickens is planning to work on a self-initiated photo series in this vein. 'That's the thing I'm working on. I feel a little bit

"I CAN'T THINK OF ANY INTERESTING OR IMPORTANT ARTISTICALLY INSPIRED RESPONSE TO WHAT SILICON VALLEY ACTUALLY IS"

at odds because I think it will be subversive, which in light of the day job, which is all about avoiding subversion, is quite a thing to do.'

As I leave, Wickens passes me the details of a person who, he says, has successfully bridged the gap between Silicon Valley designer and free-spirited artist: Keith Cottingham.

By this time, I'm up in Portland, Oregon, so I have to make do with an early morning call on the last day of my trip, to Skype Cottingham back in San Francisco.

'I'm going to show my age now,' reverberates the voice of Cottingham over Skype. 'There used to be a big difference between fine art and commercial art, especially in the schools. We used to call commercial art selling out. I don't really see any difference except if it's personal art then it's me, if it's commercial I'm solving someone's problem.'

Does your personality come through in commercial art? 'Yes, I think the personality comes through. I think that's why Brett likes working with me. He just gives me certain parameters, and so my personality comes through, but it's not work I'd do on my own,' he notes. 'I used to work for Apple, I've worked on their logo and some of their packaging for them, and it definitely had "me" in there.'

Cottingham, originally from Los Angeles, studied at Suite 3D—Center for Computer Art, San Francisco in 1987–88, then at the Center for Interdisciplinary Programs, San Francisco State University, 1988, and finally attended Computer Arts Institute, San Francisco in 1989.

'By the time I finished school we were in a bad recession so I had a crappy job and a liberal arts background didn't help. I'm an outsider, but I just wanted to work. Back then "computer" was a dirty word. Apart from the course titles we didn't even really use the word in art, but that's what got me into design world: I was the first guy at Landor Associates that could use Photoshop 1.0. I'd been using it for my artwork, and that's what got me into Landor because I was the only kid that had done that kind of stuff. They didn't know what to do with it, but they knew they wanted it for something.'

After Landor Associates, Cottingham moved to CKS Partners/Marchfirst, where he created marketing material for Apple, before joining the company in Cupertino in 2001 to work on the original 3D illustrations for the graphic design group, including their new Apple and QuickTime logos. After three years, Cottingham moved on to top design firms in the Bay Area, working as a digital

artist for MetaDesign, Autodesk and TBWA\Chiat\Day before pursuing his own interests, and sometimes working for Wickens at Ammunition.

Cottingham has managed to build a career both as a commercial artist and as a notable fine artist. From an early group show in 1994, at the Christopher Grimes Gallery in Santa Monica, to being taken on by Ronald Feldman Fine Arts in New York via numerous awards along the way, Cottingham has managed to walk the line between technology and art and still be taken seriously.

'There is a really huge void between technology and art. There is so much potential, and people have got nothing on it here and I don't know why,' says Cottingham. 'I went to a huge art show in Stanford recently, famous for technology and computer science, and it was horrible. Even for a college show it was terrible. It was all traditional media and, I don't want to sound like a bitter old cynic, but I was shocked that none of it was blending technology and art.'

Was it any better when Cottingham started out in the mid-90s? 'There was a division, there were certain shows like *Ars Electronica* that tried to bring things together, but then a lot of times that work would be interesting technologically or

design-wise but usually didn't have much substance to it.'

What's the scene like now, aside from Stanford? 'Painting is still the dominant art form today in the US,' he says. 'And I love painting but you'd think computer work would be further in the mix. I guess computer work is still mostly transitory. Collectors collect the stuff but it doesn't last for very long, or perhaps digital media is seen as disposable landfill?'

Back in Europe, I visit Graphic Design Festival Breda where I meet infographic designer Nicholas Feltron who is in town to give a lecture. I'm struck by his thoughts on the role of digital as a true, poetic and creative language. 'Is data strictly for accounting tabular? Or a medium that can make people laugh or cry?' asks Feltron. 'Can we do what painting, art, novels and films do? Can we have that same kind of experience through data?'

Feltron was part of the development team at Facebook that was responsible for the bittersweet arrival of Facebook Timeline, an addition that arguably alienated as many people as it brought together. 'One thing I've been thinking about recently is narrative time and how most communication involves some

compression,' he explains. 'If I'm going to relate a story to you then I'm trying to condense it in a way to express it to you, and that's basically what you see in a movie. A concern for this kind of compression and ways of relaying things more quickly is more evident in the kind of technological products and communication that we are witnessing right now.'

How does Feltron see the work associated with data ordering and infographics aiding the art world? 'Our camera rolls are overflowing with the amount of photos we take,' he says. 'Expressing to someone what you've seen is a really daunting problem. Finding new ways to condense photography, besides just pure, straightforward curation, is, I think, a pressing concern.'

Just how Feltron plans to curate without curating based on emotive response remains to be seen, but if anyone is likely to have a go at doing it, it'll be Feltron. He has continually surprised with his in-depth annual reports that have detailed his life with ever-increasing precision and analysis since 2005. Using data as a tool for personal discovery with almost poetic abandon has led to him journeying far beyond the conventional modus operandi of an infographic designer, into the

realm of digital infographic performance art. Feltron is the data, and the data is Feltron; he is a 'dataist'.

My final destination is Dutch Design Week in Eindhoven. Here I visit an exhibition called *OXI* which aims to draw debate on how artists and designers are pinioned by the creative industry into a financial black hole where work is offered up for free, or next to nothing, due to the byproduct of Silicon Valley technology: neoliberalism.

The curators and participants of *OXI* argue that alternative business models for designers and artists are urgently needed to redress the balance between consumption of creativity and compensation for a craft.

Tessa Koot, an exhibitor at *OXI*, states: 'We [contemporary artists and independent designers] don't protect each other from exposure, and we don't create the rules for how we provide services including being published, exhibiting, participating with events and providing access to our intellectual property. The creative industry acts as if the exposure it provides is a reason for us to work for free, be it organizers of art events, galleries, blogs or magazines. In the process of "not selling", we've already created all the

"CAN WE DO WHAT PAINTING, ART, NOVELS AND FILMS DO? CAN WE HAVE THAT SAME KIND OF EXPERIENCE THROUGH DATA?"

means for people to completely "get" our art without the need to even purchase it.'

A concept adopted in *OXI* seems militant for the art world. Here, visitors' emotional responses to the artworks are measured and analysed by software using cameras. The data is then—purportedly (this is a concept piece)—sold to generate income for all participants involved in the exhibition, presumably as research, although it's not a stretch to imagine that other forms of data could be harvested.

Koert van Mensvoort, who wasn't part of the exhibition but entered the debate, states: 'Data is only valuable when you can access the meta-data. The only winners of the future economy are the infrastructural big guys. With infrastructure you make money, others don't. And even when you make money with data or exposure like YouTube views, for instance, there is still very little recompense for the content provider. Artists need to focus their emphasis on developing their own currency transaction that suits the act of art.'

It's back to Petra Cortright. I'm reminded of the conversation I had with her in London in 2013 about YouTube being a barometer of both fame and financial worth.

'I had no reference point whatsoever for selling my webcam works, but they were already all on YouTube by the time I had my first exhibition,' said Cortright at the time.

'When we were coming up with a price list for the show I said: "I fucking hate this, I wish it could be 10c per YouTube viewer" and the gallerist laughed and said he'd never heard of anyone doing that, and so we just went along with it. I've always been uncomfortable about this kind of decision.

'Some artists like to be in control of how their work is distributed and how the price is fixed, but, in general, the value of your work is not up to you, it's up to the world. It's decided by other people.'

NEW ESTABLISHMENT

FIRELEI
BÁEZ

There are many narratives to be discovered in **FIRELEI BÁEZ'S** delicate-looking, encyclopaedically rich paintings. Behind each intricate detail and cultural symbol—headdresses, the fist and floral patterns—there's an untold or forgotten story of resilience and resistance. The artist recently escaped rising rents in East Harlem to relocate her studio to Miami, the city that first welcomed her and her family to America, during Hurricane Andrew, when they arrived from the Dominican Republic. Text by **CHARLOTTE JANSEN**.

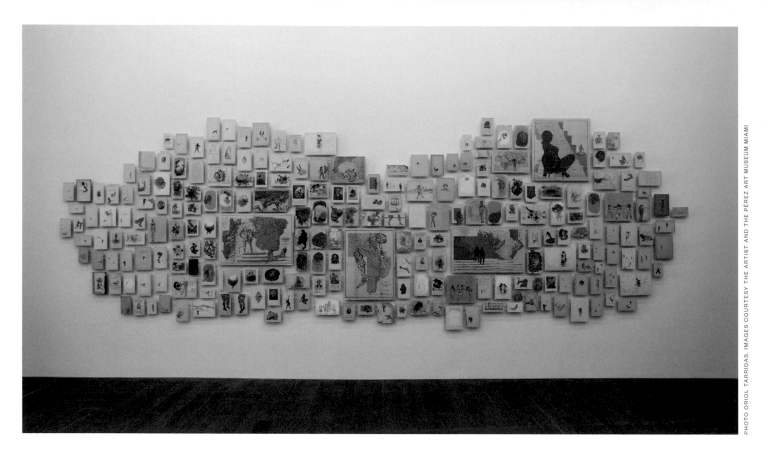

In the essay for the catalogue that accompanies your exhibition at the Pérez Museum in Miami by Maria Elena Ortiz, she mentions an ethnographic book, a catalogue of racial beauty, Femmes Créoles. *How did that inspire the show?*

For some time, I have been researching a law from colonial times in Louisiana in the eighteenth century which forced women of colour to wear *tignons* (knotted headscarves) or they'd have to pay a sumptuary tax. Maria Elena Ortiz, the curator for the exhibition, found this *Femmes Créoles* book while working in Martinique, which further solidified my research. I am interested in how different kinds of headdresses still resonate in contemporary culture. Free women of colour at the time could buy property, they could buy freedom for their families and effectively pass agency on to future generations—the sumptuary law was put in place to curtail that power. However, these women's response was so amazing; they started to import these beautiful materials from France through Martinique, to create the headdresses, which later became a fashion trend in Europe, and eventually overturned the legislation. So that subversive kind of beauty in these women's

gestures informed a lot of the making for the *Bloodlines* show; symbols that are meant to oppress are flipped and turned into emblems of power.

You reveal new histories behind these symbols.

Most Brazilian and Caribbean babies have a pendant of a black or red fist (called either *azabache* or *figa*), which they wear around their neck or wrist as an evil eye protection. That symbol has a lineage to the time of slavery where they would geld male slaves. The hand gesture of the *azabache* comes from this moment where if you wanted to be intimate outside this inhumane breeding system you would hold up your fist with the thumb between the index and middle finger. This hand gesture transformed into a symbol of protection, and I see it as an early form of the ways in which people of colour reclaimed their humanity in the New World.

How do you feel about anthropology, which has been used to inflict imperialism and violence?

This field is, as you mentioned, so deeply embedded in imperialism, and I want to revisit and reveal its underpinnings in my work. I'm not bound by the same rules

that govern these methodologies, which are weighted to give preference to Western canons, and as an artist I can avoid that in order to overcome certain historical narratives and presumptions by instead bringing forth personal stories and cultural narratives. In this sense, I think that I use the strategies of anthropology to describe identity formations in contemporary culture, in a way that embraces both 'obscure' histories and Western painting, drawing, etc.

You forge a strong alternative identity in your work, with these incredible folk tales that emerge, giving a much richer cultural insight into the Caribbean.

When I started to make work after I graduated, I wanted to bring out things I felt a strong connection to, to communicate with people I loved—my sisters and my family—to have them ask questions and maybe generate a dialogue, so different ideas came through, like folklore. I always find it interesting that people have a negative attitude towards adding folklore to their artwork, because it gives us an understanding of what exists other than us. These stories were developed as mental guards, ways of coping with different envi-

ronments, and they're an incredible resource.

Your work has this very special treatment of decorative items, you seem to put a huge amount of thought and research into each element, and every detail carries some significance or alludes to some meaning beyond its prettiness…

In identity building we choose how to present ourselves in many different ways, so when symbols are appropriated without passing on the history, it empties them of meaning and reproduces them only for the surface, which is then dismissed as ornament, and consumed without its original intent. I like to look at things—each element has so much significance for me that each item is like a map for the viewer to travel through, and the image is like a codex where each element can generate a conversation or lead to a bigger story. But I don't want to do that in a way that makes the viewer want to push back, I want them to be seduced by what they are seeing and engage with it through time—and through this long view you get a longer narrative, you get to access a space you normally wouldn't allow yourself to reach.

Firelei Báez: Bloodlines *runs at Pérez Art Museum Miami until 6 March.*

Previous pages
Bloodlines (Past Forces of Oppression Become Frail and Fallible) (detail)
2015

This page
Sans-Souci (This Threshold between a Dematerialized and a Historicized Body)
2015
Acrylic and ink on linen

Opposite
Man without a Country (aka Anthropophagist Wading in the Artibonite River)
2014–15
Installation view,
Pérez Art Museum
Miami

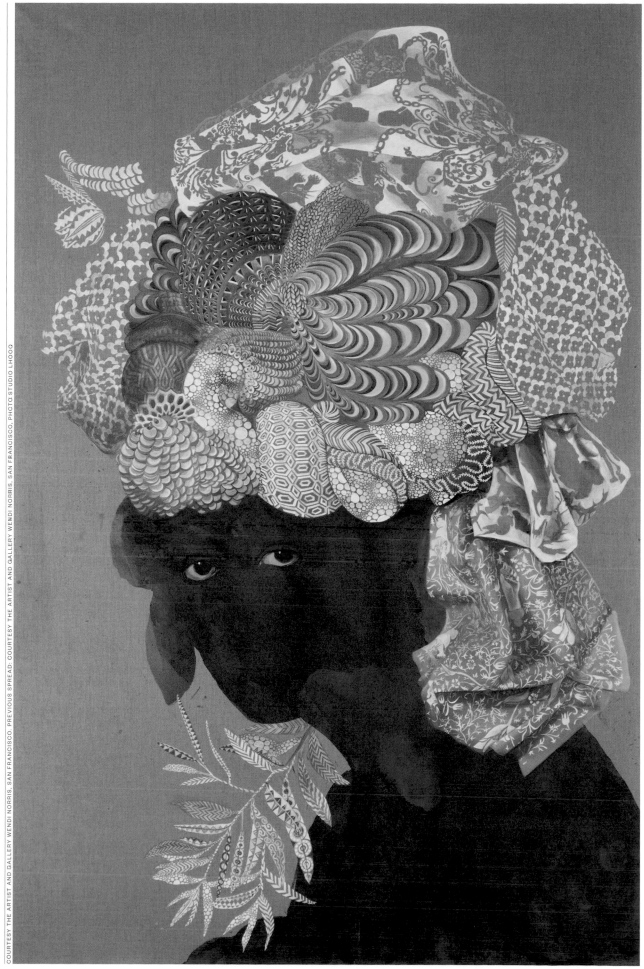

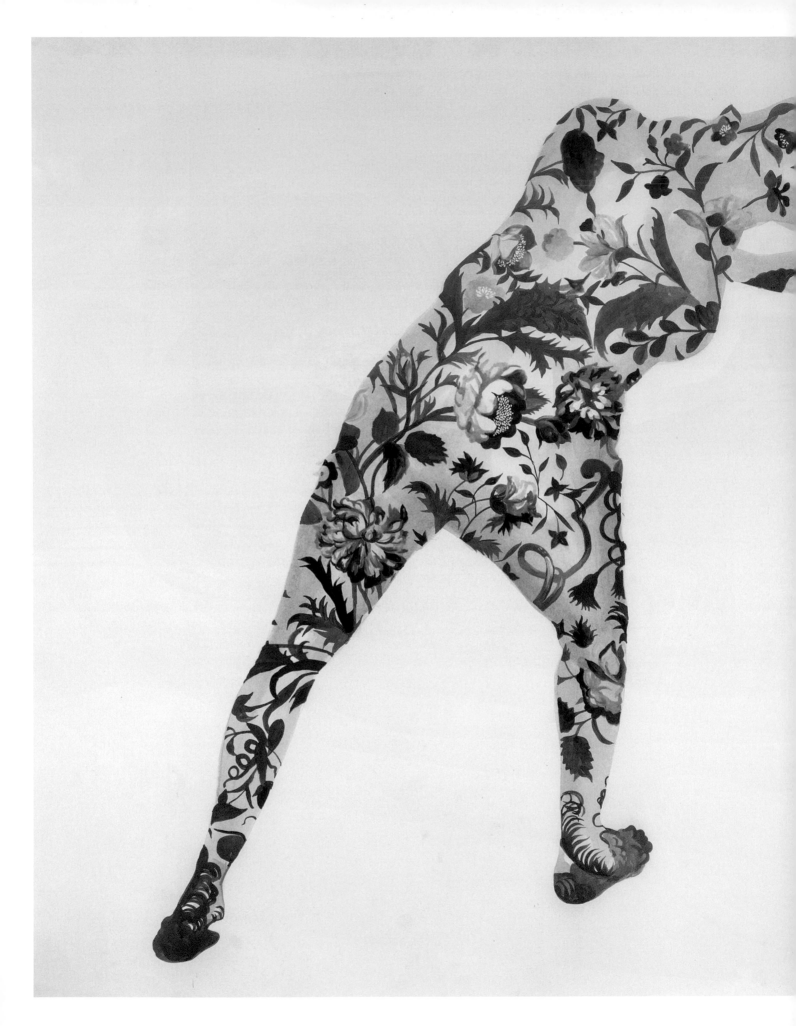

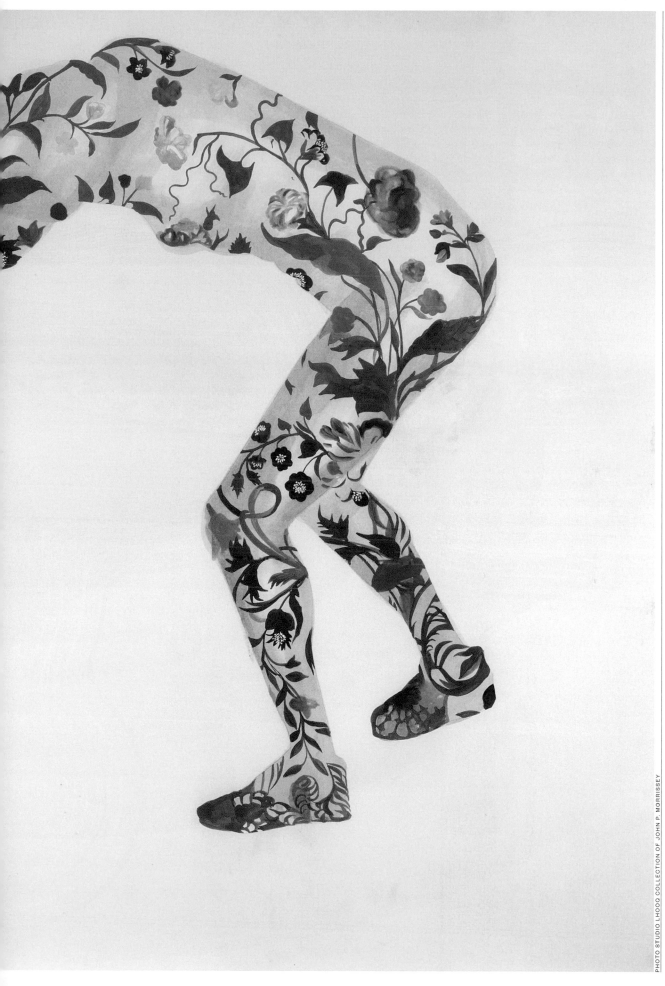

LUKE BUTLER

LUKE BUTLER'S deceptively simple-looking, densely coloured paintings riff on '70s masculine stereotypes from TV or restage cinematic tropes in order to see beyond the two-dimensional frame. The tidy world of the screen becomes subject to scrutiny—the American artist's way of 'teasing reality out of artifice', he tells **ELLIE HOWARD**.

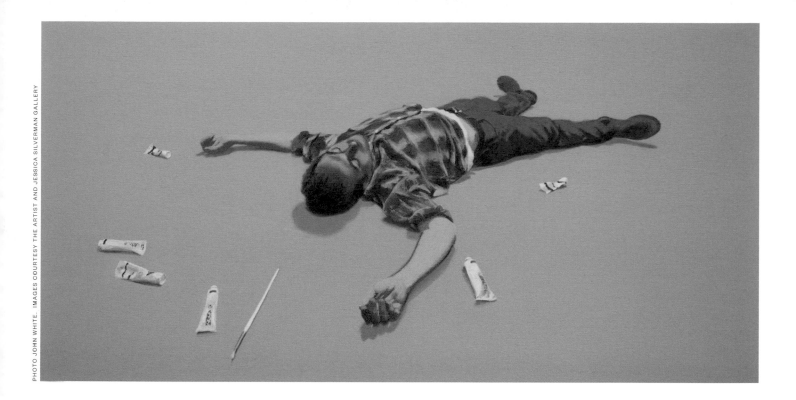

How does an image come about? Do you work directly from stills?
I am fortunate to live in a city on the Pacific Ocean. The beaches and cliffs of San Francisco are vast, humbling spaces that I can never see enough. I take pictures in search of imagery that will look and feel iconic, as if it were already in a film. As I work through a painting, I will often go back out to the water to observe the constantly changing colours and atmosphere.

I am creating a pop narrative out of my own world. It is somewhat the inverse of my earlier, television-based pieces, where I mined existing narratives for moments of humanity and vulnerability.

You previously mentioned that your childhood was largely informed by TV. How has your youth shaped your art?
There were some pretty regular conversations between my mother and me, when I was very young, where she wanted me to understand that the things I saw on television were not real. *Star Trek* was on TV every day after school. I particularly admired Captain Kirk, who never had to ask anyone anything—he barked orders and did as he pleased. That, exactly, is what my mother didn't need out of her five-year-old. In later years, *Star Trek* was still on, but now I watched it at

1 a.m. I was impressed that I still appreciated it, and I had friends that did as well—those are connections that are very real, and quite significant. And that is where my work comes from.

Why do you feel moved to go back in time and show a softer side to iconic alpha-male characters such as Kirk?
Even though I love the idea of decisive, heroic action, it is not really what life is about. So much happens by chance or accident. Clear-sightedness and understanding come later, if at all. The struggles of the hero, particularly one as vivid and wonderful as Kirk, are as meaningful as his triumph. They present a moment where narrative and reality intersect.

In THE END *series, you seem to be creating stills from a cinematic production of your own—you even credit L Butler Pictures. Are you playing the artist or auteur?*
These paintings are intended to look and feel like real movie endings, but they are entirely made-up pictures that I take from the world I know. L Butler Pictures is a true statement, and it gives me a chance to sign my work right in the middle of the canvas. I treat the text as a figure in a landscape, and while this is not actually natural, it is very natural for us to see

it there. The preposterousness of these words and gestures is especially appealing to me. L Butler Pictures is both absurd and genuine, which makes for a provocative tension. I suppose I am an artist toying with the auteur.

In your appropriated Star Trek *scenes, it's been noted that a figure's face may bear a likeness to your own. Do you feel a personal affinity with these characters?*
I appear when there is a generic figure that can be replaced. So far it has been as a trivial and disposable red-shirted crewman, whose one moment of significance comes at his end.

As in any great mythology, the primary characters in *Star Trek* are always in the presence of death and danger, but never die. These moments mean one thing in the established narrative context of the show, but another as still images on canvas. The imagery has a classical, even religious aspect—one of enduring pathos and humanity. While I very much want these to look and feel like their original source, there absolutely must be something new in the final painting—an aspect of mortality, anxiety or vulnerability that is significant well beyond the confines of televised entertainment. I am looking to establish the vital connection

between the figures in the pictures and we who admire them.

Up close, the paintings are very graphic—a flat bed of colour with layers of increasing complexity and definition. I make a big, gestural mess initially, and work over it in ever smaller and finer steps. There is some wet painting, but also a good deal of hard-edged blocks of pure colour. I want the imagery to be very descriptive, but to sit in a space that is clearly artificial—that is the conceptual thrust of the work.

Would you ever consider experimenting with video?
Why not? It's good to have a few serious but unlikely dreams. Painting was one of those once, and I'm glad I took that chance.

You've painted many variations of THE END, *but no beginnings. How would you describe your interest in narrative?*
Life is untidy, and beginnings and ends are artificial constructions. I linger at THE END for the handsome, compelling joke that it makes. It is a way of at once celebrating and undermining narrative, of teasing reality out of artifice.

Luke Butler shows at Jessica Silverman Gallery, San Francisco, 10 March–16 April.

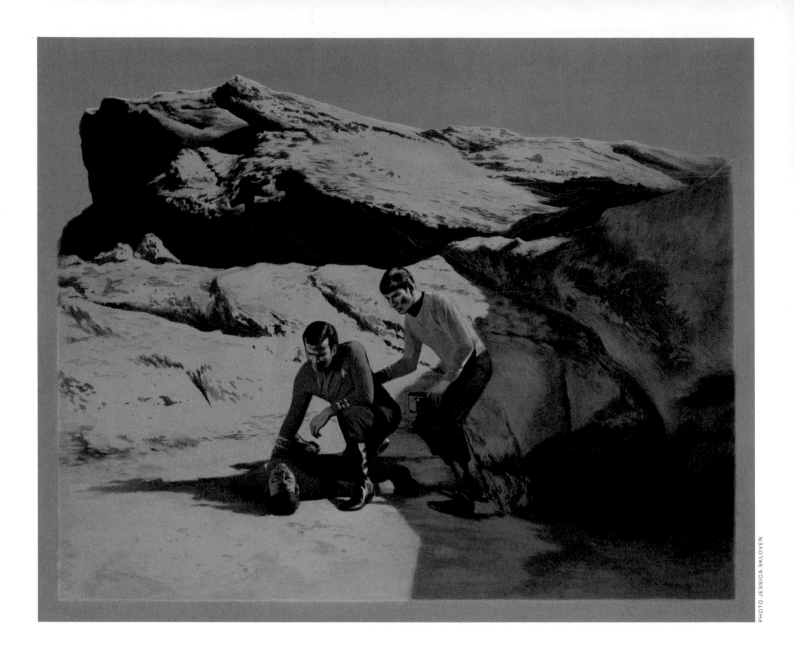

"I WANT THE IMAGERY TO BE VERY
DESCRIPTIVE, BUT TO SIT IN A SPACE THAT IS CLEARLY
ARTIFICIAL—THAT IS THE CONCEPTUAL
THRUST OF THE WORK"

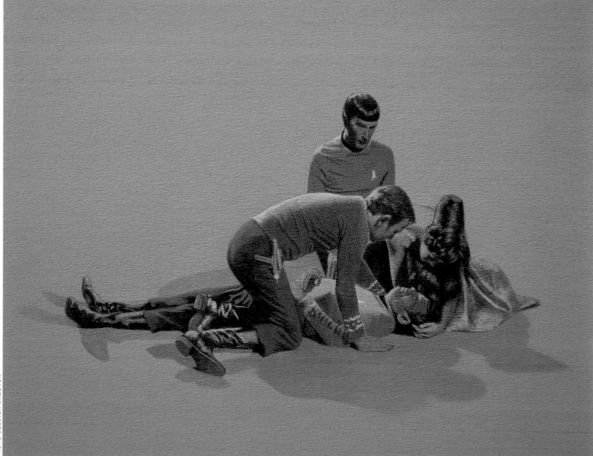

PHOTO JESSICA SKLOVEN

EMILY MAE SMITH

Last year was a breakthrough
year for Brooklyn-based
EMILY MAE SMITH, with a solo
show at Laurel Gitlen that
was picked up by Jeffrey Deitch
for a subsequent show at Art Basel
Miami Beach, positioning her
as one of the painters defining
her generation. Text by
CHARLOTTE JANSEN.

Roy Lichtenstein. René Magritte. Joe Brainard. Walt Disney. Many canonical names come to mind when looking at the paintings of Emily Mae Smith. But which bit makes us think: Emily Mae Smith? It's a question the young female painter puts in the frame with her fastidious references to modernism. And she answers it in part, too, by muscling her way into a heavily male art history with her androgynous alter-ego brooms and piercing stiletto heel.

How do you see your work as sitting between abstraction and figuration?
I see people using the term 'figurative' to mean a few different things. Besides referring to an actual body being depicted, the term is also used to describe artwork that is representational and/or pictorial. I work with images, signs and representations. My paintings are self-reflexive; they are about the world and they are also about the institution of painting itself. I dislike any notion of dividing figurative and abstract. Paintings are always both things at all times.

How do you set about a new painting?
The initial idea for the painting almost always comes fully formed as an image in my mind. I draw a lot of thumbnail sketches to retain that vision and work out the composition. Sometimes I do more elaborate renderings to expand on the idea. The image is honed because I try to eliminate anything that is not necessary. Sometimes I do some research on topics connected to the painting idea and I look for additional source material images.

I have to plan a lot because there are many technical issues with oil painting that must be considered. I draw the composition on the painting following my sketches. Then I start painting in sections and layers. Some parts have to be done before others; some colours are going to determine how other colours look. I spend a lot of time mixing my specific colours. No matter how much I plan there is still a great-unknown part of making the painting that only happens in the moment of creating it. There are inevitable revisions to the composition and plan. The mechanics of the painting are part technical process, part discovery.

A feminist stance or underlying handling of gender politics has been mentioned in reference to your works. How important is this to you when you go about making your work?
It is important to me. I have my subjective and analytic perspective that I create from, like any other human in the world. I feel like a feminist perspective is still sort of

alien to painting and therefore necessary to it. One never fully knows what transmits; any discovery is good. All I can really know is some (not all) of what I put into it—there is a certain amount that is mysterious to me as well.

When and how did you develop motifs such as your sausagey broom and the teeth that frame some of your images?
Both of those started in 2014. They were in my solo show at Junior Projects that year. The first broom I put in a painting was a riff on the broom character in *The Sorcerer's Apprentice*. It was a way for me to paint an object, figure, female and phallus all at the same time. I thought it was funny and an ideal vehicle. It doesn't refer to any other broom at this point; it's my own thing now. The ideas for my broom figure have changed and expanded since then; it has been moulded to my painting needs. You can say more difficult things with a character. The broom is my little Tom Thumb, traipsing through 'Painting', getting into trouble.

The mouth frame also started at the same time. I was studying Art Nouveau illustrations, and noticed how a frame device was often used to contextualize a narrative in those designs. I came up with the mouth/teeth with moustache frame as a way to engender my paintings as 'male'. It was kind of a joke. But then, as jokes go, there was a truth to it that resonated. These motifs opened doors and allowed me to paint ideas that otherwise I could not get out.

You've got quite a few shows happening in 2016. Would you mind sharing a few of the concepts you'll be looking at in these shows?
Increasingly I am making close-up paintings of my broom's face—psychological existential portraits. They embody a crisis of seeing and being. My solo show at Mary Mary, Glasgow, will be called *Honest Espionage*.

NICHOLAS HATFULL

London-based artist
NICHOLAS HATFULL plunders
the banal trappings of modern
culture for his paintings: namely,
the world of Pret a Manger.
It's no straight-up mockery of
the popular food outlet. 'I want
to tap these things for mystery
and, yes, there is certainly a sense
of exhilaration in the work,'
he tells **EMILY STEER**.

Can you tell me a little about your initial interest in using takeaway cups and utensils?

A lot of it relates to—well, the association for me is—Roman sculpture: trophy and battle reliefs. When I was on a residency in Rome I spent a lot of time at this museum in the EUR district, where they had plaster casts of many different reliefs. It was a formal interest in the fanciful arrangements and the rhythmical compositions that were made out of the shields and swords. I started saving a few different coffee cup lids at the end of my postgrad, and a lid was one of the few things I took with me to Rome. It was on a shelf in the corner, and it was after going and seeing this Roman sculpture that I started to garner an interest in it. I began thinking about the pathos of plastic cutlery, and thinking about them as the ambassadors of our global culture at the minute. It's just a short leap to allow other, more far-reaching associations to waft in. But it was also to do with the fact that there is a real scarcity of these things in Rome, that you don't have takeaway coffee culture; it was a stand-in for London in my mind. Initially I started making machined enlargements of the classic solo-traveller coffee cup lid and then I started to

develop iconography. For example, in *Tall Grass*, you have the coffee cup lid—I tend to call them *tondos*, because there's this association with Roman sculpture—but it's housed in a wooden relief fringe of grass. That came out of a wave of publicity that Pret did, where they evoked the origin of the coffee: it would be Ethiopia or Honduras and they were using phrases like 'a thick shade' and 'thin air' and 'tall grass'. I was interested in these tableaux that had all this promotional blabber about wilder places, [set] against the banality of actually sitting in the shop in the armpit of a train station.

Do you find beauty in the source materials and enjoy them as forms on their own? Or are they horrible consumer items?

I do have an odd appreciation of them, and packaging has always been an abiding feature of my work. Even when I was small I saved bits of packaging. But, on the other hand, there is an absurdity and an insanity to the amount that is under foot in the city. They do sometimes seem to be as ubiquitous as leaves. There is also an infantilizing aspect to this kind of culture that is interesting, but also disturbing! Pret always seem to be

ahead of the pack in the raffish stylishness of their branding and they always endow their products with a sliver of mystery.

Would you say you're a romantic in the way that you look at the world? There is obviously a sense of cynicism to the paintings, but they also have an element of mystique, or aura.

When people encounter the work they initially presume that it must be some ironic or cynical comment about consumer culture and I don't have an equivocal stance—socially or ecologically—on that. I want to insist on using such banal material, tap these things for mystery and perhaps, yes, there is certainly a sense of exhilaration in the work. It's to do with taking a form and wanting to transcend it and, preposterous as it may seem, trying to get these forms to work in concert in a large-scale painting in a lyrical fashion. There's a stretch between the high=romantic, metaphysical painting, and on the other hand a real appreciation of the everyday and the disposable.

Is there a movement, or a time, in painting that you feel has had a big impact on your work? Do you tend to look to your fellow

contemporary painters?

I think, in terms of contemporary artists, I'm more fascinated by work that isn't painting. Also a lot of other things: I'm a big admirer of Martin Rosen, who makes the political cartoons in the *Guardian*. It is a wilful misreading of his work, but I feel he is an amazing painter. The way that he distils imagery from current events and quite complex situations into these condensed and solid but quick-fire paintings is quite amazing.

How would you describe your own painting technique?

There are passages in my painting that border on billboard painting. I have also been looking at some of Sempé's paintings, technically, taking that watercolour technique and the luminosity and warmth. Then there are these choppy brushstrokes, that are a bit of a nervous tic in my paintings. They tend to work when they have this strident arch quality and I think there is a prevailing weather in the work which is trying to will these things into being expressive and lyrical in a way that they are possibly unable to be. It's as though they have been brought together in a choir and they will shortly disband afterwards.

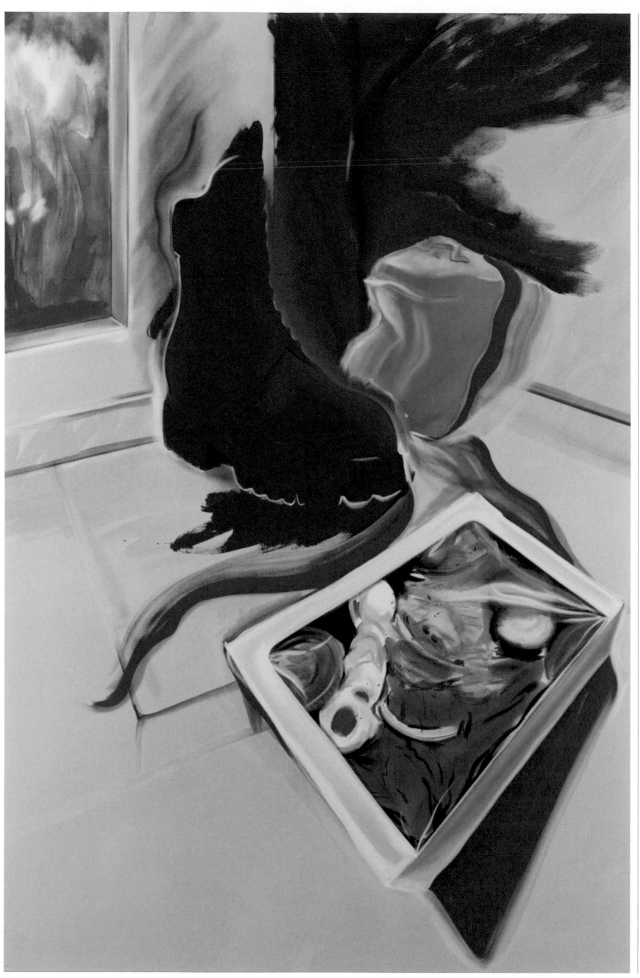

Previous pages, left
Portrait by Tim Smyth

Previous pages, right
*English Gruel and
African Watermelon*
2012
Polyurethane and
fibreboard relief
(four parts)
190 x 120 x 3cm

Left
Rambler Niçoise
2015
Oil and acrylic
on cotton duck
210 x 150cm

Opposite
*El Rey—As Yet
Nonexistent*
2015
Oil and acrylic
on cotton duck
210 x 170cm

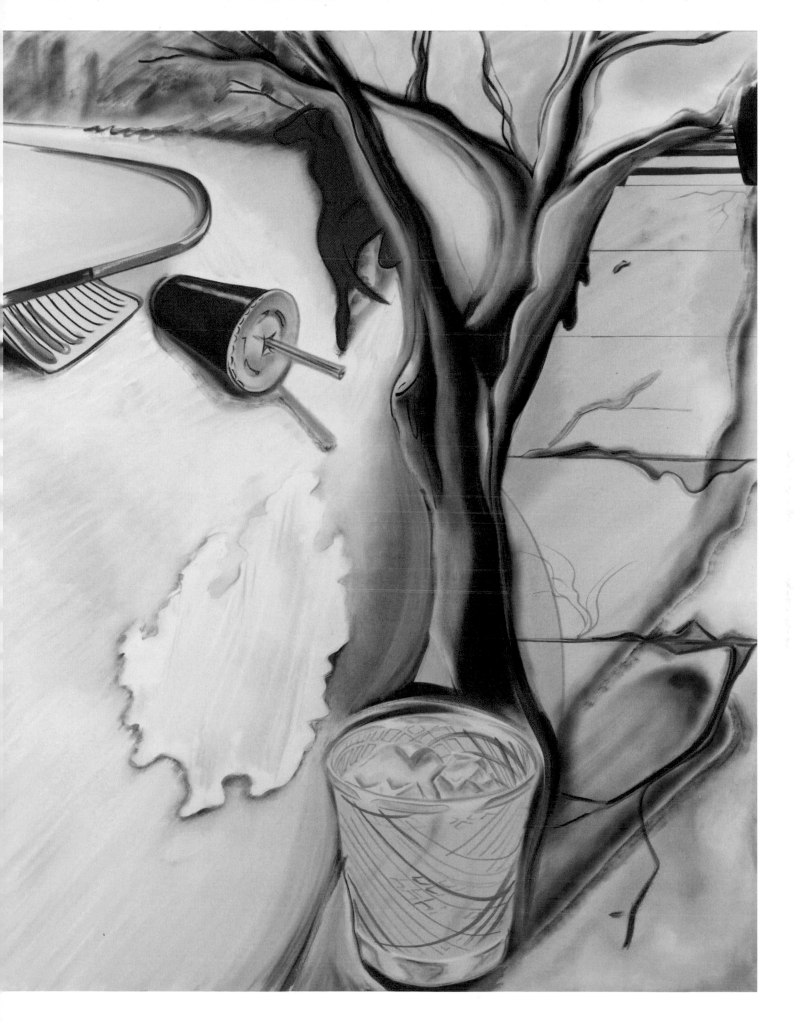

CHRIS HOOD

The Atlanta-born, New York-based artist **CHRIS HOOD** makes enigmatic works, painting backwards from recognizable forms—cartoon characters, icons, wide eyes—to a state of ambiguity. 'If images are untrue then what is the truest painting of that untruth?' he asks **EMILY STEER**.

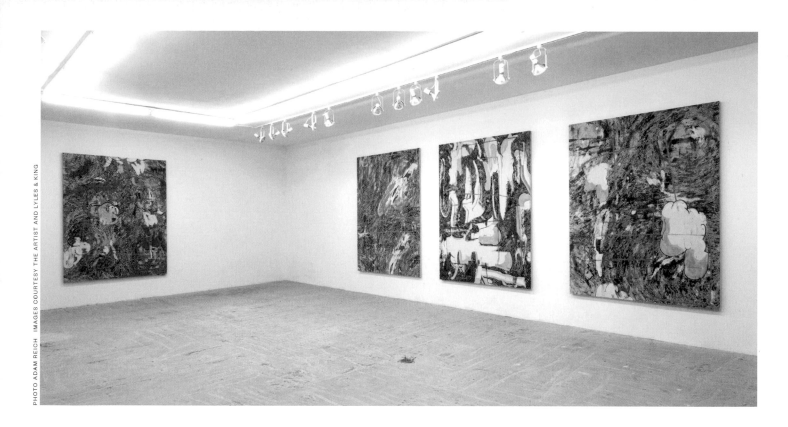

Was it always painting and mixed-media that interested you? Or have you become more fixed on the canvas as your career has progressed?

My earlier work in multimedia was trying to find something new for painting by stretching painting out of itself. Painting as sculpture or installation. It was not until I trusted paintings, just as they are with their own language, that anything interesting started taking hold on the surface. As soon as I gave in and stopped trying to make a deceitful painting the possibilities opened up. It became an obsession. I think you have to dig in your heels and commit fully. We do not really use the term 'sculptor's sculptor' for a reason. The psychology is different.

Is there a process that you follow for each piece?

I developed a technique of making the work from the reverse which has its own physical qualities and limitations to negotiate. I have to build the imagery backwards, for example, and cannot paint over a particular area if I do not like it later. I am trying to describe a third, hybrid kind of space, so often a work will start with a loose sketch that incorporates elements of hand-drawing, digital collage and painting. Although each work has its own set of concerns, I essentially

set up a scenario of guided resolution for the painting, with my intuition and hand being the large variables between success and going in the trash.

Where do you source the imagery for your work?

It began as sticker collections in my youth. I became interested in mascots depicted in advertisements because of their ability to relay human emotion and create narrative. Slap a googly-eyes sticker on anything and it all of a sudden has a personality. Often other imagery speaks to me in a deadpan kind of way or has a connection to cultural vernacular. Many of our everyday cartoons and characters are archetypal images going back centuries—once used as fable, now to sell soap.

You've recently begun working with some darker moods—can you tell me how or why these came about?

It's always about finding contrasts. I want to raise the visual drama and explore some new settings and juxtapositions. I have been thinking about the paintings of St Sebastian for a while—all stuffed with arrows. Recently, I saw an apple in a bodega that someone had plugged all over with toothpicks which reminded me of those paintings, along with the Mexican sacred heart and bad

tattoos of heart-shaped grenades. I doubt those specific references will show up in a work of mine together but details like that collect over time and I will think about how to make a compelling painting with them.

By contrast, there are many humorous elements at play; can this often be more challenging to put out there than the heavyweight elements?

I think of the humour in my work more like a nervous laugh. It helps to get one's guards down and it can open up other content. Is this downtrodden little guy the artist, the viewer or some Faustian protagonist on display?

You've spoken before about the cynicism that has developed around the honesty of the image in the time of the internet. How would you say this has affected painting?

I believe this is the number one issue facing painting now. We have extremely sensitive viewing technologies, compelling virtual reality and the ability to see the surface of planets never visited, yet we are increasingly sceptical of photographs as proof. No one can make any bearing on what is real, but we are seeing more than ever before! If images are untrue, then what is the truest painting of that untruth? This problem with visuality has changed the scope of what it means

to be seeing in the world and painters should be some of the first to bat. I am sceptical that abstraction can address these issues. But I do not see this as a problem of 'unrealism', rather as something closer to a supra-reality.

Who or what are your main influences?

I became hugely interested in the simulated-reality hypothesis and holographic principle. If we are living in this kind of holographic reality, then we would not be able to tell. It now appears that the scientific data and anomalies in physics indicate this might just be the case. This is Plato's cave of the universe, time and space. I read Terrence McKenna and was turned on by his championing of the individual human being and the power of shamanistic visions. Though I certainly have my share of long-standing art heroes, I find it interesting how an influence sort of finds me suddenly when it clicks for my work. Carroll Dunham's early paintings, for example, have been a recent influence. Goethe's colour theory of shadows. Guston's fat fingers!

Chris Hood is represented by Lyles & King, New York, and Rod Barton, London.

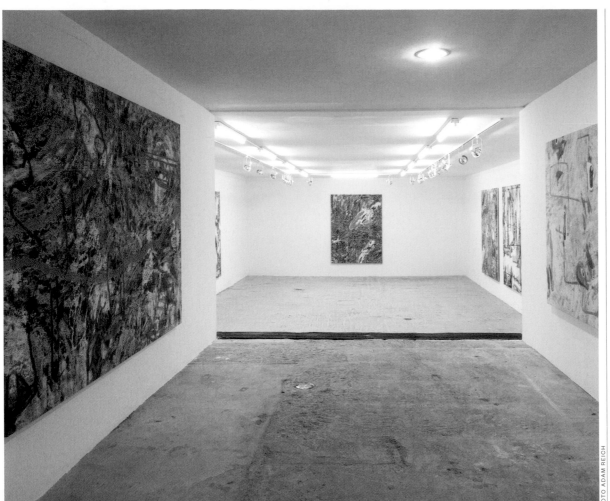

PHOTO ADAM REICH

Previous pages, left
IRL (Double Anamorph)
(detail)
2015
Oil on canvas
203 x 150cm

Previous pages, right, and this page, left
Slow Drag in Margaritaville
Installation views

Below left
Acid Test Reflux
2015
Oil on canvas
150 x 200cm

Opposite
Synthetic Jesus
2016
Oil on canvas
213 x 168cm

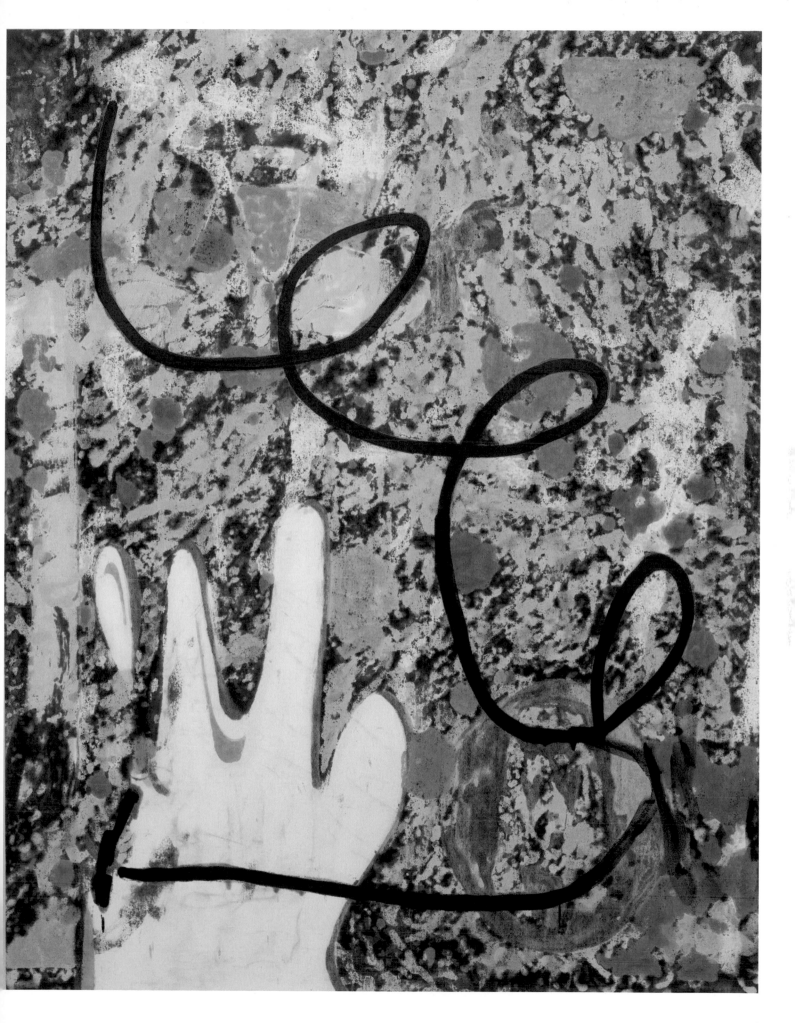

CAROLINE MESQUITA

'Most ideas don't work
in reality, they exist as mental
constructions. Fabrication makes
them move,' says French artist
CAROLINE MESQUITA,
whose figurative sculptures stand
eye to eye with gallery visitors.
'I like this corporeal equality
between viewer and sculpture,
like a status quo between two
animals with the same force.'
Text by **ROBERT SHORE**.

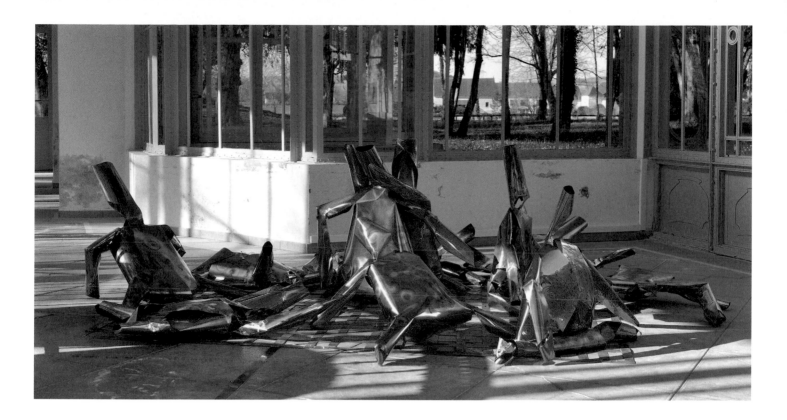

You've studied in both Paris and California. What did the experiences bring to your art making, do you think?
I didn't really study in California, I took part in a three-month programme called Mountain School of Art, a form of alternative school. Before that I was at the Beaux-Arts de Paris for my MA and the Beaux-Arts de Rennes in the French countryside for my BA. Rennes provided a kind of cocoon to develop my practice, Paris made me discover the art world, and Los Angeles exposed me to a new culture and, through this gap, I came to better understand myself, my identity.

You've been working in Berlin. Does that city mould the vision of artists, or is it a 'freer' space than, say, Paris or New York?
Berlin is definitely a cool city—and there is less pressure than in Paris. I have to confess that I am pretty addicted to this kind of permanent speed and violence.

I tend to oscillate between spending time in comfortable environments where I question myself less, and losing myself in new, uncertain situations. I usually alternate between spending time in Paris and taking studio time in Brittany, which is in the countryside on the west coast of France. There, it is only the essen-

tial: my mother, my memories and the ocean. I have a lot of space to let my imagination roam without being paralysed by too much information.

How hands-on are you with the materials you use?
I make everything myself. I don't really conform to particular techniques, I try to build my own logic of construction, to open new territories. I love the gap between idea, immaterial project and final creation. Most ideas don't work in reality, they exist as mental constructions. Fabrication makes them move. It is my own logic, taste and time of birth that makes me create singular things with their own content and personality.

How important is space to your works?
Actually I started my practice by working on spatial installations without producing any objects. The goal was to be attentive to the silent, empty space. Then I became interested in clothing—the kind that you wear when you enter somewhere, this second skin between body and space with little information about identity. Then there is intimacy and the naked body.

My sculptures are lifesize, so my characters have the same size as the viewer. I like this corporeal equality between viewer and sculpture, like

a status quo between two animals with the same force.
They are individual sculptures, but always presented as groups, like frozen scenes. I am interested in individuals and how they relate to the group and social relationships. The bodies were at first naked, then they started to be clothed. Sometimes they are well dressed; in mundane moments sometimes they are a bit more trashy.

I think that their expressivity influences the mood around them a lot, as if they sent out vibes.

What's the process that leads to a work like Windsurfers?
I think it is a mixture between things I see and observe that fascinate me and raise questions, and the need to create objects that have their own material logic. For example, the idea for *Windsurfers* emerged during my time in Los Angeles. I was absorbed by the time people would spend surfing every day. The objective of the activity didn't seem to be competition—sometimes it entails simply looking at the horizon waiting for waves that might never come. And the calm of these people thereafter. At the time I was working on prints made from the verdigris copper oxidization of figurative sculptures and I wanted to make an object that could connect these two elements. The windsurfers

were the perfect subject. The sculptures incarnate the physical world and the prints the imaginary—the world of fantasy and desire. Carnal exchange between human bodies, which could also happen between body and object.

You make soundtracks to accompany your installations.
I started doing sound pieces by making a flute with a piece of metal tubing I had in my studio. Before making art, I did a lot of music: clarinet, drums and bombard [a traditional Breton reed instrument]. I produced visual objects with these tubes, light and immaterial things that could occupy space in different, interesting ways for me. The sound is unique and varies according to each flute, depending on the length and the placement of the holes. The melodies are improvised and incarnate a specific moment and state of mind. Some are really happy while others are more melancholic…

Then I started to produce sound with the other sculptures that were not considered or didn't even look like instruments. I touch them, hit them and record their reactions. These sound pieces are abstract, more like a movie soundtrack. They give intensity, tension, sometimes lightness—it is about emotion and feeling.

Previous spread, left
Fioretta
2015
From *Bal*
Oxidized brass
163 x 66 x 50cm
Exhibition view at SpazioA,
Pistoia

Previous pages, right
Sloths
2015
Oxidized brass,
spotlights, sound
12 parts, variable dimensions
Exhibition view at Pavillon du
Centre d'Art du Parc Saint
Léger, Pougues-les-Eaux

Opposite
Portrait by Anja Schaffner

This page
Windsurfers
2014
Oxidized copper, fabric
140 x 357 x 357cm
Exhibition view 2015
at carlier | gebauer

PAPER

Dream Archaeology of a Brutalist Past

ISA MELSHEIMER

Concrete isn't the dreamiest of materials. But in the gouache recreations
of Isa Melsheimer for her show *Über die Dünnhäutigkeit von Schwellen* (which translates
as something like 'On the Thin-Skinnedness of Transitions') at Esther Schipper
in Berlin, the Brutalist architecture of the likes of Marcel Breuer, Atelier 5 and Gottfried Böhm
takes fantastical flight. Often working initially from black-and-white found
photographs, the Berlin-based artist acts as the archaeologist of sometimes forgotten
or neglected buildings—even if the individual buildings are not all well enough
known to be immediately recognizable, their formal language is familiar, a ubiquitous part
of the urban landscape. But in Melsheimer's recreations, the structures
seem to float in a self-contained, timeless space, an impression emphasized by the presence
of wild animals such as foxes and porcupines, the brilliantly coloured crystalline
formations, and the extravagantly dark and starry night skies. Detached from their
real-world settings, the buildings appear to hover outside time—small
autonomous worlds beyond decay.

Above *Nr 337*, 2014
Opposite *Nr 333*, 2014
Overleaf *Nr 343*, 2014

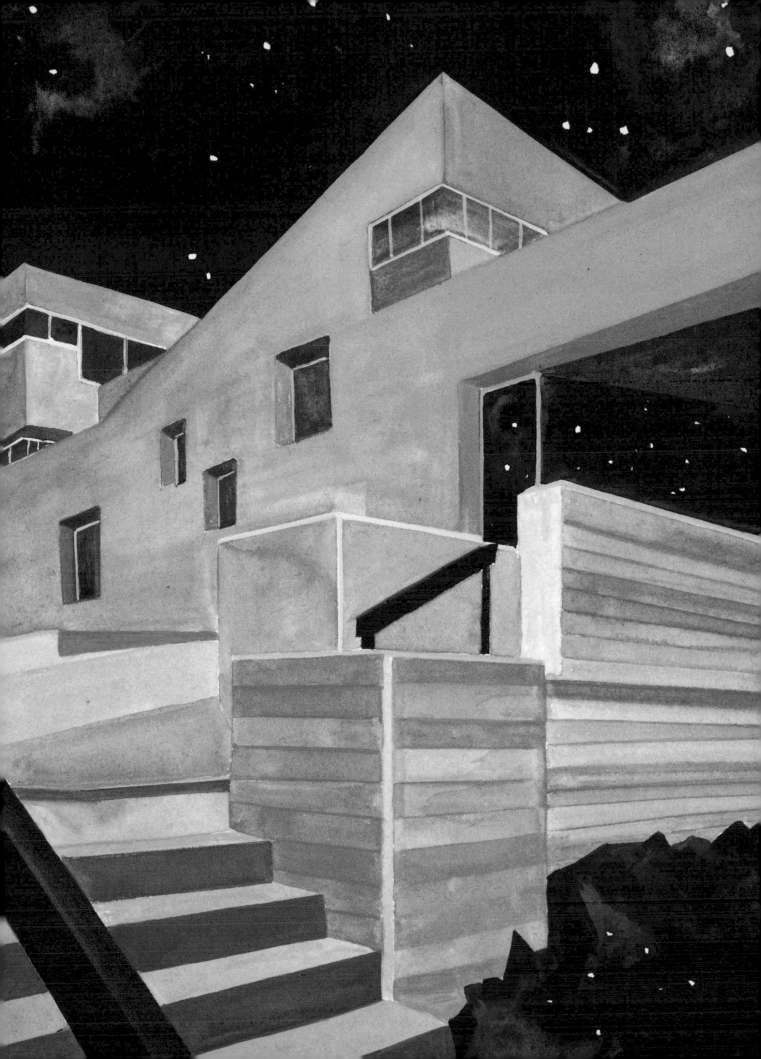

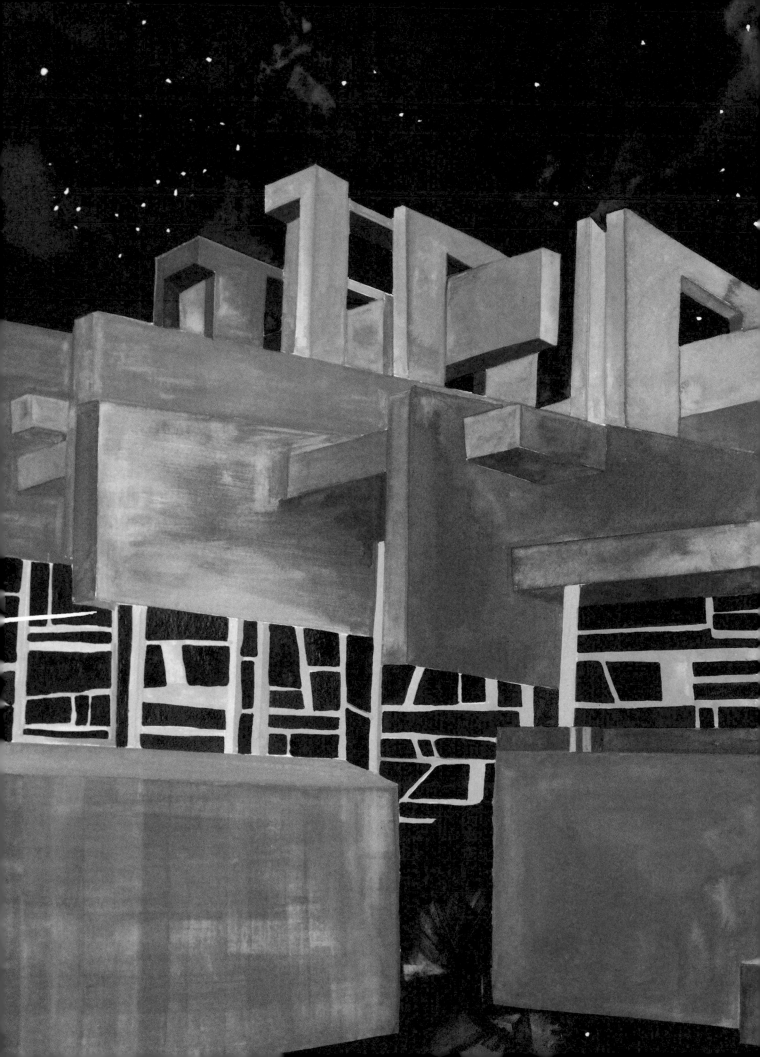

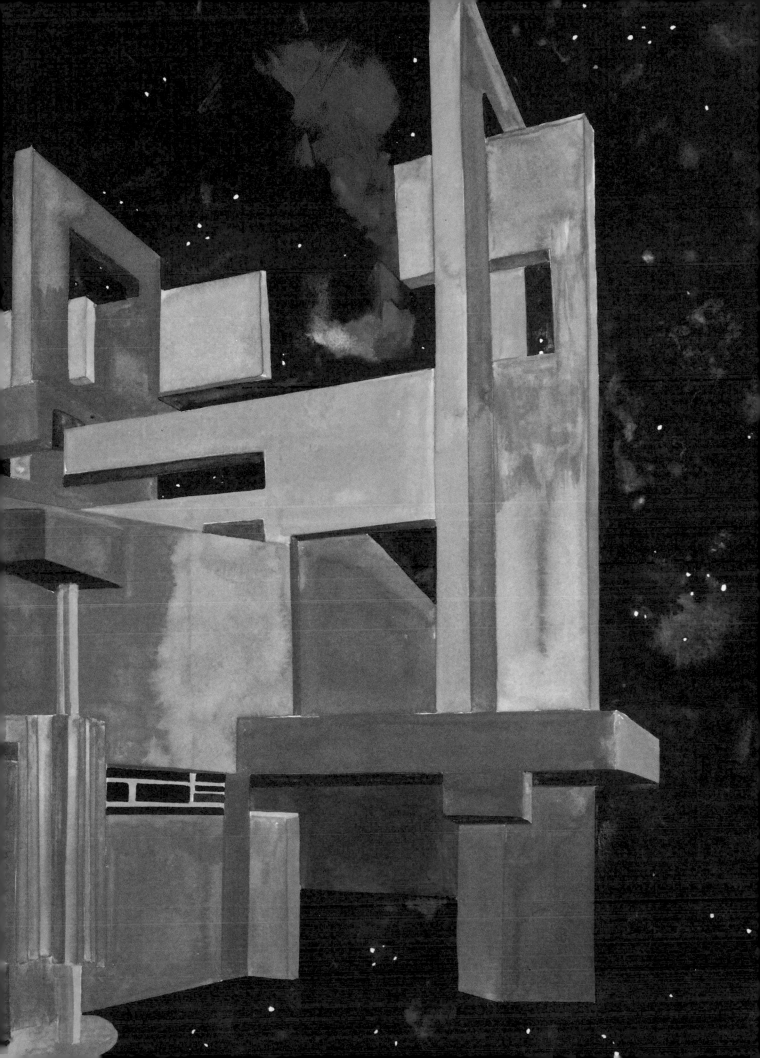

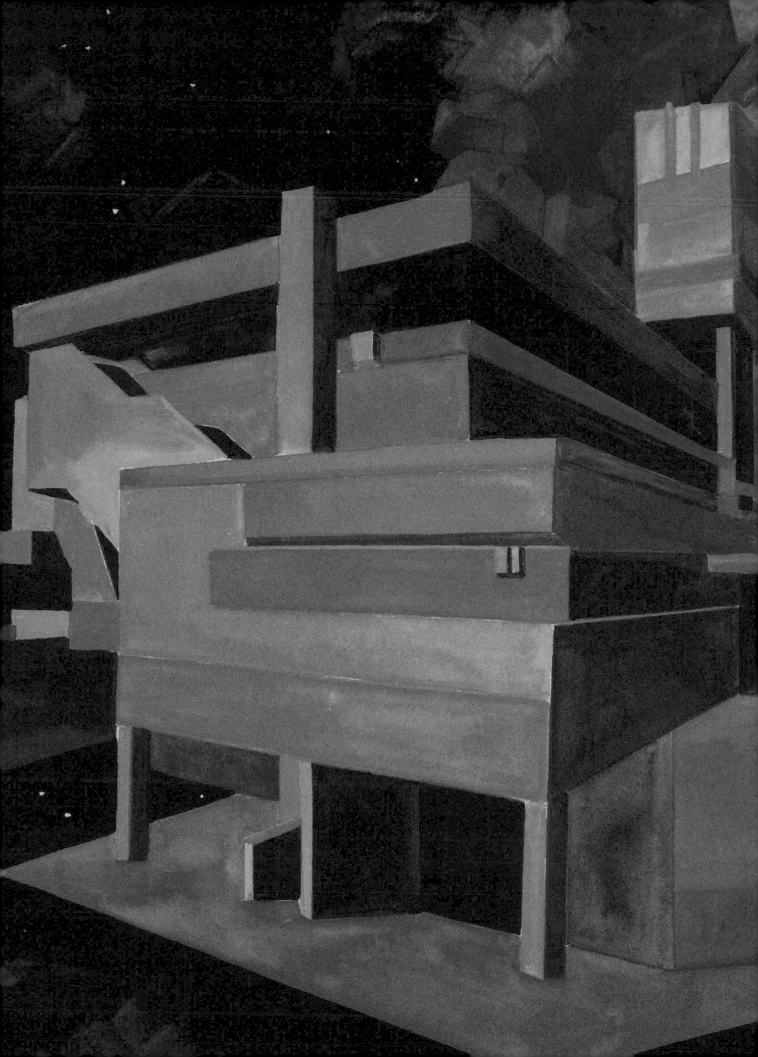

Above *Nr 334*, 2014
Opposite *Nr 339*, 2014

Lucky Strike

AARON KASMIN

Inspired by the miniature artworks that adorn his collection of matchbooks,
Aaron Kasmin's intense, colour-blocked drawings—employing a bold palette of royal blue,
red and sandy gold—reference the glamour of early to mid-twentieth-century American life.
Ladies reclining in martini glasses and suited gents shaking cocktails hark back to the
post-Prohibition era, Golden Age movie stars and the indulgent parties dreamed up
by F. Scott Fitzgerald. 'I love the way these small ephemeral objects portray American life
and the perceived glamour of their time,' the London-born artist says. 'Smoking and drinking
were represented as cool and sophisticated—these matchbooks remind me of the
novels of Raymond Chandler and of films starring Humphrey Bogart and Lauren Bacall.
I wanted to celebrate these little masterworks and bring them to a wider, new audience.'

Statue of Liberty, 2015

The Playhouse Café, 2015

Stars and Stripes, 2015

Rockets, 2015

Cravats, 2015

Bowling, 2015

Fred's Tavern, 2015

Big Boy, 2015

G
A
L
L
E
R
Y

Throwing shapes, a slang term for dancing vigorously, refers to a youthfully innovative approach to traditional forms of choreography. And it's not just in dance that the young like to kick over the traces of previous generations' practices. Here, **CLAIRE SHEA** looks at a group of contemporary artists who are forgoing the traditional pottery wheel to explore new sculptural approaches to ceramics.

Throwing
Shape

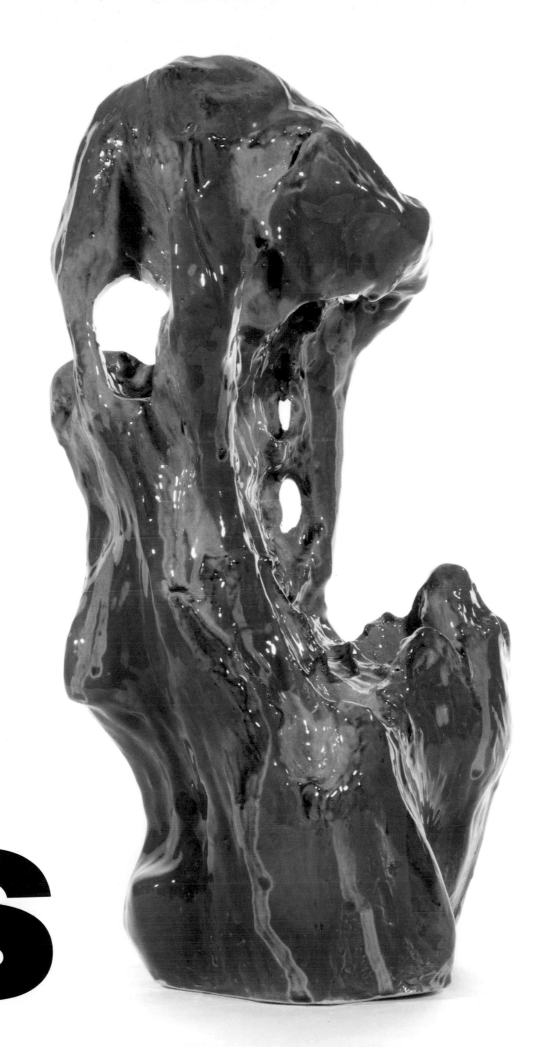

S

"Ceramics have come a long way since the potter's wheel"

For artists, ceramic is a material that is both historically and conceptually loaded. The worn-out argument of craft versus fine art quickly rears its head in discussion. However, this uneasy relationship is proving fertile ground as artists develop new and interesting works that explore the ambiguity between functionality and pure expression. Ceramics are also proving to be a choice medium for critiquing the everyday, the domestic and the familiar. But also, in a world of immaterial imagery, ceramics provide a way of reconnecting the viewer with material and material concerns.

Aaron Angell is an artist who has a self-confessed 'shallow' interest in the ceramic tradition, preferring it for its imagery and appearance, rather than its philosophy. Appreciating ceramic for its anti-art aesthetic, Angell often uses it to produce works that allude to the hobbyist culture that ceramics are commonly associated with. *Molybdenum Bell Courtyards* (2015) exemplifies the bizarre landscapes of unexpected elements unified in unsettling compositions that are central to his practice. To rehabilitate his material, he occasionally dips into the vaults of art history to recreate classic works. For example, Angell reimagined a 1949 William Turnbull sculptural landscape in his *Bill Turnbull's Mobile Stabile in Barium Blue* (2014).

Alex Hoda also finds the surface value of this material one that allows him to develop his ongoing interest in the surrealist approach to chance that runs through his sculptural practice. In his ceramic works, he unifies this with his interest in the grotesque. *Bullfish* (2014) is a sculpture based on the surrealist game of the exquisite corpse, in which collaborators work together to form an image or text that developed on the previous contributor's work. This often resulted in incongruous combinations of forms or text. In *Bullfish*, Hoda has combined the forms of a bulldog and a fish, creatures of the land and the sea that would never normally unite. Here they have been merged through a seemingly bizarre twist of genetic mutation. The glazing process unavoidably leaves aspects of the resulting sculpture's appearance to chance, evoking characteristics of the land and sea.

Recent ceramic works by Laure Prouvost explore the boundaries between utility and futility. These pieces form part of her *Wantee* series, which takes the relationship between her grandfather and German Dada artist, Kurt Schwitters, as its starting point. Through these works she creates objects that reimagine her

Previous pages
Alex Hoda
Puncture
2015

Left
Laure Prouvost
*Improving the Everyday
(In Support of Grand Dad
Visitor Center)*
2015
Stoneware clay with a wood
fired glaze, mild steel
137.8 x 104.5 x 93.4cm

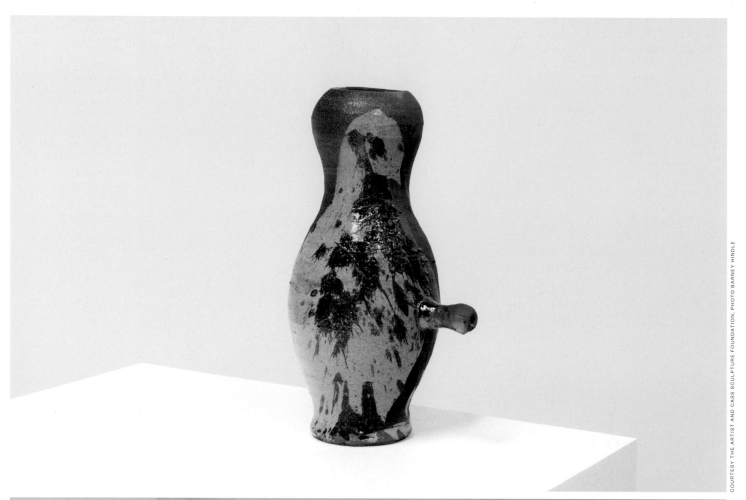

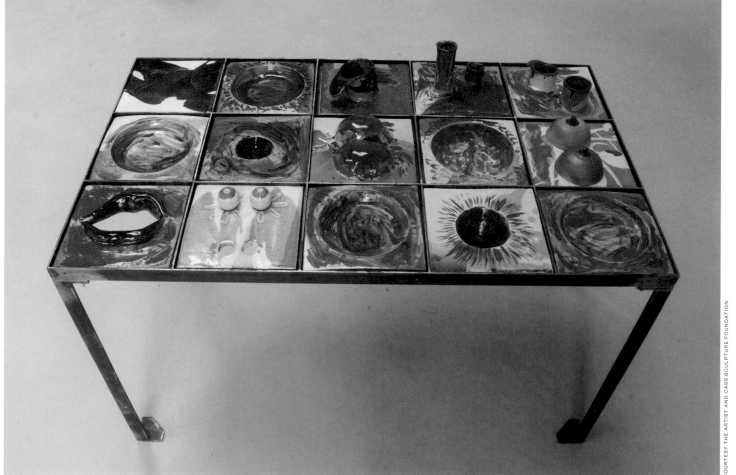

grandmother's constant need to appropriate her grandfather's art objects as domestic objects. Her recent tables such as *Improving the Everyday (In Support of Grand Dad Visitor Center)* (2015) are comprised of absurdist elements ranging from eyeball salt and pepper shakers to busty butter dishes to cat milk spouts. Prouvost's ceramic tables recreate the unexpected frames of juxtaposed imagery often found in her films.

Ceramic seems both unlikely and also perfectly pitched to create works that allude to the body. In works such as *The Porcelain Blushed O* (2014), ceramics allow Zoe Williams to explore the representation of seductive and illusory surfaces. Unlike other materials, ceramic has a direct corporeal relationship. The unfired clay responds directly and immediately to the artist's body temperature and records every touch, making it a choice vehicle for sculpture about the body. Both Williams and Prouvost capitalize on the warm materiality of ceramics alongside their cool digital works in film. Williams has stated: 'the use of High Definition video acts as a cold modern counterpart to the natural richness and exclusivity of my crafted objects, enforcing a sense of uneasy temporal fusion of epochs and materials.'

Jesse Wine also finds the immediacy that clay provides to be one of the most engaging reasons for working with it. In archaeological research investigating the history of ceramic works, forensic fingerprint technology is often employed to learn a bit more about the maker of the work. Wine's works are often clever and humorous approaches to the material world we live in. *jw I've Got Nothing to Offer??* (2014) has a multilayered self-awareness. It is a work about making work, but also it is a work that records its own production in the most material of ways. Wine's fingerprints are used to pinch seams around the structure. These pinches record his fingerprints, ensuring that any questions of authorship can be overruled with a small bit of forensic evidence.

In direct opposition to this, the Grantchester Pottery, established by Giles Round and Phil Root, plays with questions of authorship. Inspired by the modernist artist studios such as the Omega Workshop, the Grantchester Pottery produces works that question the relationship between fine and decorative arts. Artists and designers work together to produce works that contribute to a collective output. In their 2013 exhibition, *ARTIST DECORATORS*, at the Institute of Contemporary Art in London, ceramics were combined with murals, wallpaper and furniture to investigate where decoration stops and fine art starts. The works of the Grantchester Pottery continue to investigate the legacy of artists' workshops and questions of collaborative practice in working today. This way of working allows for a fluid exchange of ideas and forms.

In fact, many artists working in ceramics seem to have a collaborative approach

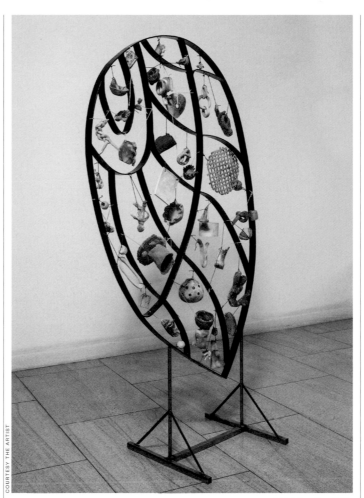

COURTESY THE ARTIST

COURTESY THE ARTIST

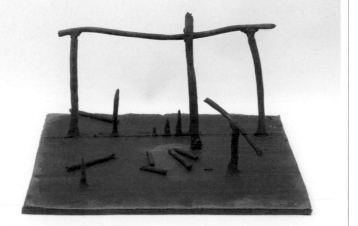

COURTESY THE ARTIST

Opposite, top
Alex Hoda and Robert Rush
Puzzle Jug
2015

Opposite, bottom
Laure Prouvost
Improving the Everyday (In Support of Grand Dad Visitor Center)
2015
Stoneware clay with a wood fired glaze, mild steel
137.8 x 104.5 x 93.4cm

This page, from top
Laura Aldridge
Ever Open Openings/Ever More Open Openings/The Expanded Vessel
2014
Iron, string, spray paint, ceramics, banana skins, commercial glaze, wood, words, sunshine
200 x 100cm

Aaron Angell
Molybdenum Bell Courtyards
2015
Lead-glazed earthenware
50 x 50 x 15cm

Aaron Angell
Bill Turnbull's Mobile Stabile in Barium Blue
2014
Glazed stoneware
50 x 50 x 28cm

Overleaf
Jesse Wine
Big Pictures
2015
Installation view

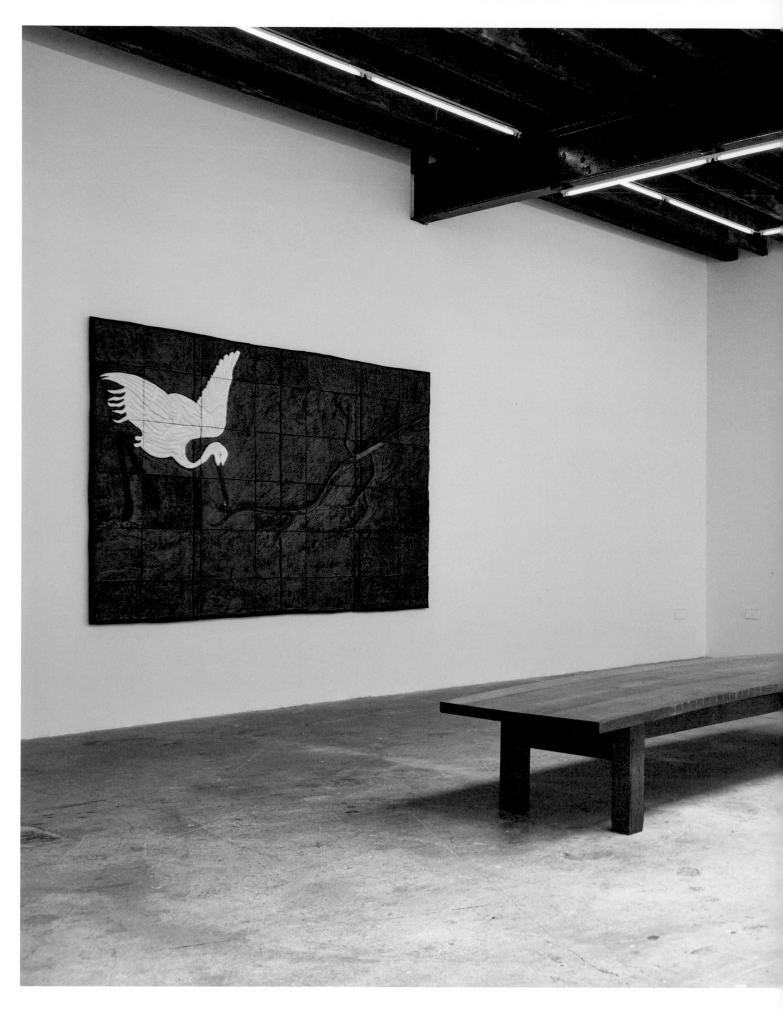

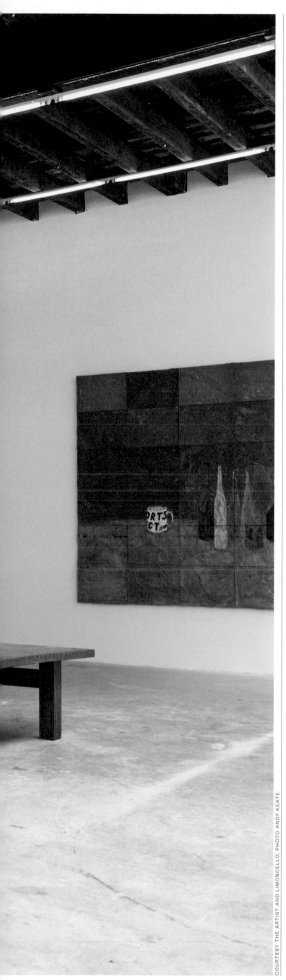

"In a world of immaterial imagery, ceramics provide a way of reconnecting the viewer with material and material concerns"

to working with other artists. It may be that the material itself cultivates such specialist knowledge that working with other artists creates a community in which artists value an exchange of knowledge about clays, glazes and firings.

Aaron Angell developed Troy Town Pottery as a ceramic workshop for artists, providing a place to work that operates outside traditional modes of ceramic production. Artists are invited to undertake residencies at Troy Town and to share their knowledge with one another throughout the process. Furthermore, Angell has developed an extensive glaze library to encourage artists to learn new techniques and to experiment with new materials.

In 2014, Laura Aldridge and Anna Mayer constructed a portable kiln for Glasgow International. They invited local artists and practitioners to contribute new works to the kiln. There is an undeniable social aspect to making work like this. *Ever Open Openings/Ever More Open Openings/The Expanded Vessel* (2014) is a sculpture composed of the variety of works fired in this kiln in 2014 by numerous artists. The firing was imagined as a ritualistic process: sage was burned by curator Alhena Katsoff, a poem was read by Quinn Latimer who lowered

a ceramic microphone into the kiln, and a work by Thomas Clark was performed by several participants. These events, together with the ceramic works fired, were considered offerings, and the results form the sculptural work. It therefore acts as a record of the firing and as a type of social sculpture by incorporating objects from multiple collaborators.

In 2015, Alex Hoda and Robert Rush proposed a new 'open-source' sculpture for Cass Sculpture Foundation in the form of a wood-fired kiln. This year, 11 contemporary artists working with ceramics fired new works in the kiln for an exhibition entitled *Rough Music*. Over the years, the kiln will build a wider community of contemporary artists whose works in ceramics can be fired collaboratively.

The artists above offer just a few examples to the varying approaches to 'throwing shapes'. Contemporary artists are investigating the historical use of ceramics and the relationship of this material to craft in new and interesting works. It is also being embraced for its flexibility, economy, immediacy and accessibility. Furthermore, its use as a vehicle for collaborative practice and community building is being explored. Contemporary ceramics have come a long way since the potter's wheel.

The internet is a colonial machine that flattens us with its fast, relentless flow of Western capitalist values—values that have been undermined by the effects of neoliberal failures on us all, from social inequality to terrorism. Though the web may have widened our collective conscience, it's also led us towards an ideological crisis. So what are artists doing about it? asks **CHARLOTTE JANSEN.**

Art for

Post-Capit

lists

"We may interact with the clean dirt-free space of screens, but screens crack"

Art (at its best) is a necessary reaction to the systems, ideals and aesthetics imposed upon us by dominant forces—not least, at the moment, the internet. In the dawn of a postcapital era, there is more to this reaction than the (already tired) idea of the synergy, or lack thereof, between the physical and digital space. Artists working with a post-capitalist agenda now seem united instead by a critical concern with the cultural and political structures that the internet has duplicated and magnified. The political idealism of post-capitalist art is rooted in a traditional notion of the web's possible value, rooted in the dotcom utopia of the '90s.

All of the apparent freedoms capitalism offered in the Western world in '80s (the decade most post-capitalist artists were born) have turned into constraints: private wealth and ownership, wage labour, the competitiveness of free markets, individualism. Capitalism has shoved many people out, and artists are typically among the first to find themselves among the rejects. So it follows that they're among the first to vividly propose an alternative model to 'crush the past' (Mark Tribe, artist and founder of Rhizome) and imagine a post-capitalist society with an ideological, ecological and economic system that aims to replace our current systems and that uses technology, as Paul Mason writes in *Postcapitalism*, as 'a new route out'.

Art in the post-net age reimagines our relationships to objects, and to one another, to better suit our partially disembodied world, where the object/non-object tension is seen as a central part of our ideological meltdown. Aspects of this techno-ambivalence are typically identified in the works of Ed Atkins and Ryan Trecartin, but the ideals of postcapital techno infinity are manifesting themselves, visually and conceptually, in multiple and highly diverse ways.

Paris-based artist Horfe creates pandemonium in imagined hybrid worlds. Inspired by American animations from the 1930s, his paintings are saturated mash-ups, psychotropic and pulsating with energy, crowded with amorphous, asexual characters. Rather than revolting against the industrial machine, they enact an orgy between man and mechanism. As a graffiti artist, among other things, Horfe embraces the disruptive presence of the artist in the context of capitalism. He explains in an email: 'The artist living in our time is extremely conscious of their role and their work, because in an attempt to be considered or recognized they will be compared to or in a constant competition with their fellow being... In seeking to push the artist to produce a profitable art form and therefore a sustainable investment, are we not responsible for its stylistic and intellectual sclerosis?'

But objects are not pointless: they are among the few things that we can be sure of in our physical existence. It's our system of attributing and distributing their purpose and value that is kicked around in these works. In Doris A. Day's painting series *Bugs Bunny* (2014) familiar Looney Tunes characters can be identified—but they've been more than half-effaced in a primordial gesture. The determined movement of the brush can be seen on the canvas—as in action painting—here conveying the mordant disappointment of someone discovering that the cartoons that animated their childhood are in fact full of malicious ideals, consumerism, racism, militarism and gender discrimination, dressed up in addictive sugary colours. Day and Horfe take us to the root of our contemporary capitalist struggle: to the television age, when mass pop culture began—and contemporary art developed in parallel.

Where Day responds in brushstrokes to the violence inherent in the capitalist system, Amalia Ulman critiques consumerist ideals diffused through the language, prosthetics and aesthetics of the contemporary consumer environment. In *International House of Cozy* (Rotterdam, 2015), Ulman makes a porn video out of a Zara ad, showing how easily gestures can be displaced, and context and meaning manipulated in a consumer-biased world.

Affected by her own first-hand experience of poverty, Ulman declares herself anti-capitalist because 'it promotes a kind of competitive behaviour that not everyone can keep up with. It is a system that leaves many people behind.' In her work Ulman typically infiltrates capitalist environments in order to reconstruct their iconography precisely, like a method actor inhabiting a character. For her much-publicized Instagram performance *Excellences & Perfections* (2014), for example, she lived as a preternaturally pretty American It-Girl, even getting Botox injections (though a boob job was faked). In *The Destruction of Experience* (London, 2014), her ironic juxtapositions of self-help mantras and the exploitative demeanour of a cold anonymous corporation show how systems gain power by manipulating lexical and visual information. 'No More Dying Today,' reads a clinical calendar. 'Nirvana' is turned into a shiny corporate logo. The work suggests the social and cultural anxieties endemic to the West—and becomes even more disturbing when we realize that, when searching for the spiritual, we find it has no space in the current capitalist condition.

Though to the eye these works are rendered very differently, the experimental politics of these young bloods are aligned. London-based artist Christopher Kulendran Thomas's text and visual works, including his ongoing project *When Platitudes Become Form*, are an attempt to articulate and define them. Thomas, whose parents fled Sri Lanka in the 1970s, purchases works by contemporary Sri Lankan artists and reshapes them for the Western market. This cultural translation takes the works of other artists and reconfigures their context via contemporary cultural clichés (lasers and neon) or multinational brands (Nike, Abercrombie & Fitch). His work invites the viewer to understand better how we appropriate and assign value.

In his essays (see 'Art & Commerce: Ecology beyond Spectatorship' for *DIS Magazine*) Thomas proposes theories on the relation between art and capital and the potential for the artwork in what he refers to as a 'post-work economy'. Looking at the pieces that make up *When Platitudes Become Form*, Thomas raises a fundamental concern—is globalization just another word for colonialism? Though the discussion relates directly to his own practice, his ideas give an insight into the work of his peers: 'Whereas new technology is often deployed toward reproducing existing patriarchal power structures, I think even Karl Marx understood the emancipatory possibilities of capital in dissolving concentrations of power and "melting all that is solid into air". But harnessing this radical technological potential toward social justice beyond capitalism would require political imagination on a much longer timescale than the symbolic, affective, localized, reactionary strategies of critique or resistance.' Even in Thomas's radical, intellectual approach the object is relevant—but it is being

"I don't think the object is necessary in any way, but the current art economy is that of the art object"

Opening spread
Doris A. Day
Have Brain. Will Travel
2015
Oil on canvas
110 x 110cm

Second spread, left
Doris A. Day
Foxy by Proxy II
2015
Oil on canvas
110 x 150cm

Second spread, right
Christopher Kulendran
Thomas
From the ongoing work
*When Platitudes
Become Form*
2013
Wood, acrylic, *Lion* (2012)
by Prageeth Manohansa
(purchased from Saskia
Fernando Gallery,
Colombo, Sri Lanka)
and Nike New Distance
singlet (blue/volt/reflective)
77cm x 61cm

Previous pages, left
Amalia Ulman
*International House
of Cozy*
2015
Screenshots

Previous pages, right
Ed Fornieles
The Leftovers
2015
Digital print, acetate,
polished aluminium,
hardware

Right
Ed Fornieles
*Workland: The Fence
Is a Narrow Place*
2015
Château Shatto
Los Angeles

repositioned as the whole system that holds it is redesigned.

In the same way that Thomas approaches the imperial economic system and its ideals to create a material work/product out of the immaterial system/ontology, Ed Fornieles uses intangible social interactions of the illusory communities of online networked media as if they were physical substance. Re-creating very material worlds out of the things that surround us—'digital, object and system', as he puts it—has permeated Fornieles's practice over the years (he trained in sculpture) and it has remained an integral part of his output. The multisensory disorder of his solo exhibition at the Chisenhale Gallery, *Modern Family* (2015)—all sticky leftovers, crushed cereals, weeping girls, Tic Tacs and giant fruit made out of hay—deals with the emotions of separation in a three-dimensional way.

Fornieles is an alchemist with daily detritus, performing transmutations on banal everyday belongings so that they become more than sentimental vessels for memories; they are an expression of a rich interdimensional life texture; emotionally disorienting. He collects stuff, but rather than sorting it out, he regurgitates it in a pile of ideological contradictions. 'Be Yourself,' screams one image. 'We Are One,' another yells back. Though objects do not disappear, their political agency is subverted. 'Food porn' is translated IRL into stale cholla bread, the thoroughbred 'Modern Family' is unravelled by a (staged) girl crying in front of a homemade fetish film. The position of material possessions as 'assets' seems silly when set on Fornieles's stage of jumble and clutter: 'We may interact with the clean dirt-free space of screens, but screens crack.' In his most recent production, *Workland: The Fence Is a Narrow Place*, at Château Shatto, Los Angeles, Fornieles developed these post-capitalist sentiments, and constructed a fantasy post-work ecosystem (bean bags, hot desks and diagrams) that pushes the question on value to the fore.

An affectionate attachment to objects—to their beauty, their plasticity, their surrogacy—is evident in these post-capitalist works. In pragmatic terms, as long as the art world is powered by capitalism, such physical end products will remain an obligation. 'I don't think the object is necessary in any way, but the current art economy is that of the art object,' Ulman concedes. 'Without institutions providing grants for ideas, artists will have to continue this sort of production to keep up with their practices.'

These young artists are throwing down a challenge to our prevalent state of being, connecting life with art in epiphanic ways: rather than a straight critique of objects, their significance shifts to something subliminal that prompts us to examine the problems in our judgment system. But the destabilizing effect of our overly critical and individualized digital world—the social injustice, the destructive orbit of cynicism and competitiveness—is felt, seen and heard, loud and clear.

MICHAEL WOLF

WITH THE REAL

MICHAEL WOLF began his extraordinary record of Hong Kong life as a photojournalist before making the transition to art. Though his work now appears in galleries and photobooks rather than news magazines, his working method remains rooted in the rituals of his earlier documentary practice. 'It's like roulette,' he tells **ROBERT SHORE**. 'If you play certain numbers often enough, interesting things come up.'

see myself as an anthropologist,' Michael Wolf tells me as he guides me around his latest show, *Informal Arrangements*, at Flowers Gallery in London's East End. The densely gridded façades of Hong Kong's high-rises dominate one wall but elsewhere the material on display has a more improvised, intimate air. As a photographer—the artist's principal medium—Wolf has an abstracting eye, but his shots of the city's unofficial life, taken in the back alleys where Hong Kong's workers retire to grab a quick cigarette or hang their mops to dry exude a rich romanticism.

'It's a bit like looking under the bed,' he says of his ongoing exploration of the city's anonymous offstage spaces.

Although he is also the creator of signature projects made variously in Chicago, Tokyo and mainland China, Hong Kong has provided Wolf with his principal focus since his arrival in the city in 1994. That was three years before the then British colony was handed back to the People's Republic. His work across the decades—initially as a photojournalist for the German magazine *Stern*, and latterly on independent art projects—could be summarized as a celebration of the Special Administrative Region's singularity, a quality under increasing pressure from the homogenizing policies of the mainland Chinese government. 'Chinese influence is going to dilute this feeling of difference, of independence, and that's basically my whole project—recording what makes Hong Kong different from other places. It's an incredible record because in ten

years the back alleys will be over. The government will have sanitized them.'

If Wolf is attracted to the sprawling irregularity of Hong Kong, his project serves to put some order into the disorder, or at least to find patterns in the chaos. 'I don't make a heading and then take photographs,' he explains of the typologies that structure his work—coat hangers, strings, exhausts. 'I just photograph and then in the evening put them in folders and when I'm finished I might say: "Oh I have a folder with 23 plastic bags. There must be something." Some days I just go out and photograph plastic bags.' Plastic bags are a familiar presence in public life the developed world over, but their uses in Hong Kong are culturally distinctive. 'The plastic bag is one of the most ubiquitous storage objects for working-class people there so you see bags everywhere.'

He's always been a collector. 'My mother was a hoarder. I inherited it from her.' A recent house move made him realize how much stuff he'd accumulated. 'I swore to myself I wasn't going to start again. That didn't last very long!' he laughs. Not that's he ever gone in for the obvious in his collections. 'I like to create my own genres,' he says. Hence his *Bastard Chairs*, the adulterated makeshift seats of which he has more than 70, and hence the ever-expanding list of typologies in his photographic work: umbrellas (his *Hong Kong Umbrella* book brilliantly documents the student protests of autumn 2014); gloves ('They have a tradition in photography. You think of

Brassaï and the photographers who shot windows of glove shops. They have this surrealistic element—they're recognizable as something human, a human hand'); even mops ('There were the interesting ways they hung them up to dry').

Wolf never goes out without a camera. On any day in Hong Kong he might take a bus to a particular district and then continue on foot. 'On a good day I'll walk 25,000 steps. I'll look on my phone to see how much I've done.' He used to be a stickler for analogue technologies but gave up on film several years ago now. He often uses his iPhone—'It has one very big drawback,' he observes, 'which is that you can't control the depth of field'—although the prints he makes are presented in a non-native format. He doesn't care much for Instagram. 'I don't like the square format. Hong Kong is a vertical city.'

The years 2003–05 were a transitional period for Wolf. He had moved to Hong Kong in the mid-1990s to work as a photojournalist, but with the new millennium and the advent of new technologies magazine budgets were being slashed and his profession was in financial retreat. 'I had had a long career as a photojournalist but knew I could no longer keep doing it in a dignified manner and in a way that would satisfy me.' Happily, a new—related—career in art seemed to be beckoning. After all, both his parents were artists.

The journey from journalism to art would prove an arduous and frustrating one, however.

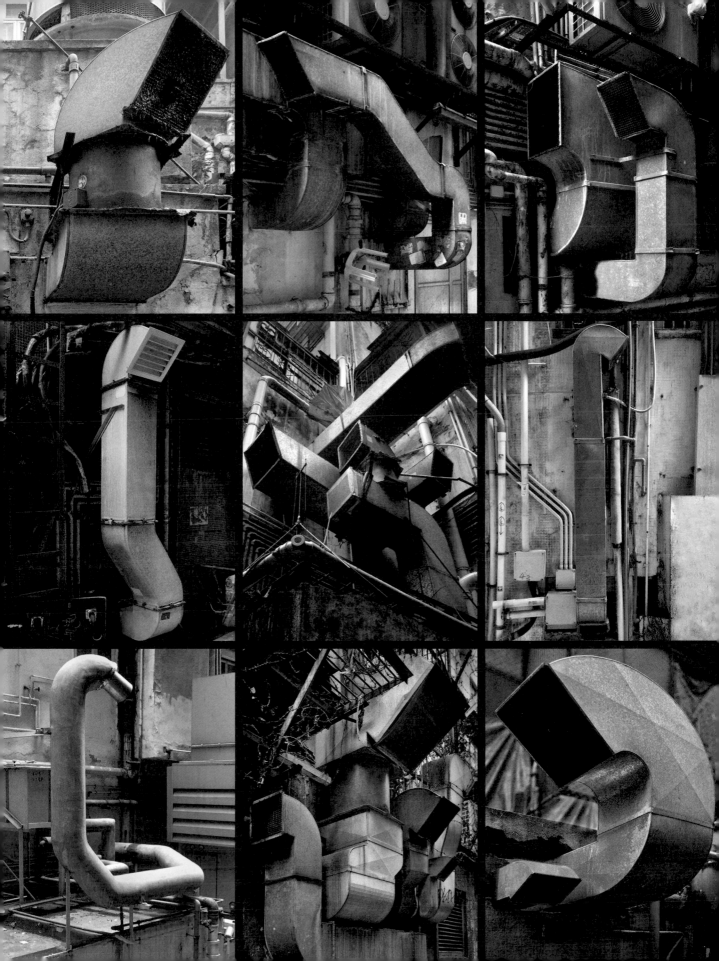

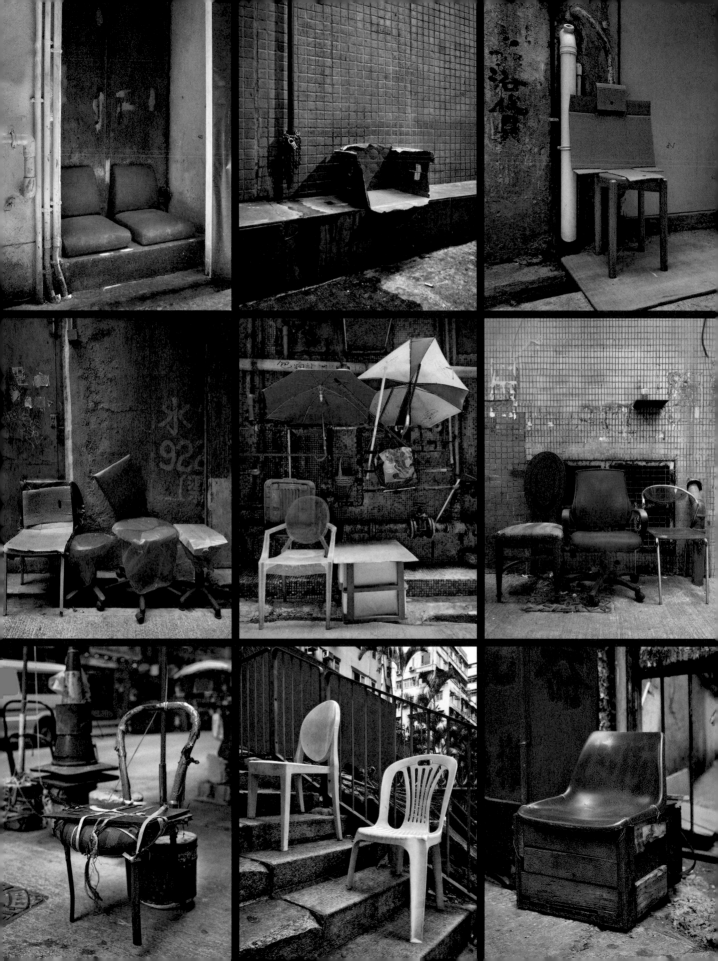

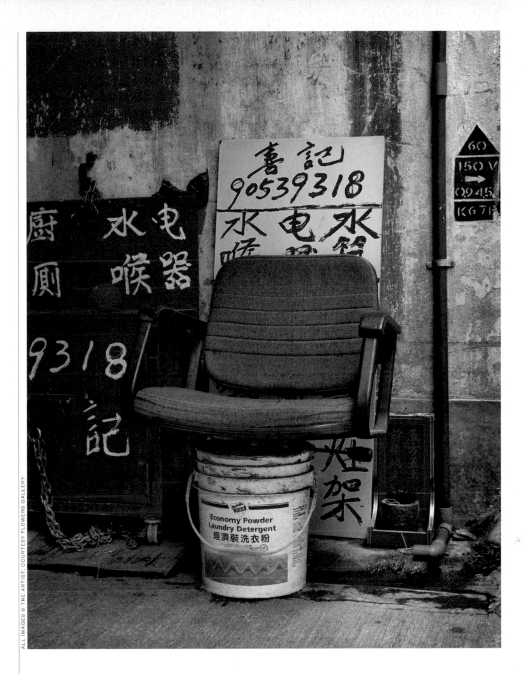

'I was 49 years old. I had never been rejected so many times. You visit people with what you think is a very nice portfolio and some don't let you get in the door. Others say: "Oh it's interesting. Come back next year…"'

He began to wonder whether he should change the way he worked to appeal more directly to the established tastes of gallerists. 'But in the end I think I made the best decision of my life: I didn't change anything. I had this feeling—I have a very neat way of seeing things and I'm going to stick to it. It's very documentary in nature and many galleries like conceptual work. But I'm rooted in the real.'

One of his earliest independent art projects that was very much 'rooted in the real' involved him travelling to mainland China to photograph the artists of Dafen, a village on the outskirts of Shenzen where, in the first decade of the new century, somewhere in excess of 5,000 (estimates vary) painters resided and produced 60 per cent of the world's oil paintings—most of them copies

of more famous artists' work.

The project took shape after a chance encounter with an Australian businessman at a party. 'I asked him what his business was,' Wolf remembers. 'He said: "I sell art to Walmart." He was shipping three 40-foot containers a week of paintings.'

It transpired that his interlocutor ran a production line in Dafen that was churning out literally thousands of copies of masterpieces of Western art, to be sold mostly to hotels and proud new homeowners in the US. Following his photojournalistic instinct, Wolf set off for Guangdong province to witness the phenomenon—part of the Chinese 'economic miracle'—for himself. In one studio in a third-floor walk-up he found 'six people doing different sections of famous paintings. [With van Gogh's *Sunflowers*] one would do the flowers, another would do the vase, and they'd hang them up with clothes-pins to dry.' Wolf decided to shoot a series of witty portraits of the Chinese artists alongside their

copies—Hoppers, Lichtensteins, Hockneys and, inevitably, Leonardo's *Mona Lisa*. 'Because the prices of the originals were going through the roof at auction I decided to make a comment on the copies,' Wolf explains. In the book version of the project, *Real Fake Art*, published in 2011, opposite each portrait Wolf printed the price of the copy. Van Gogh's *Sunflowers*, for instance, fetched $7. 'The price was based on size of canvas and amount of paint used,' he says.

Real Fake Art has proved to be one of the defining photobooks of the past decade but the project didn't meet with immediate success—Wolf encountered resistance to his photojournalistic practices, notably in his native Germany, where he had a meeting with museum curators in the hope of having the images exhibited there. It seemed to go well. 'These have to be shown here!' his hosts told him enthusiastically. 'But two months later I received an email: "Dear Michael, I'm so sorry…"' The problem was apparently that Wolf had studied at the Folkwangschule in Essen

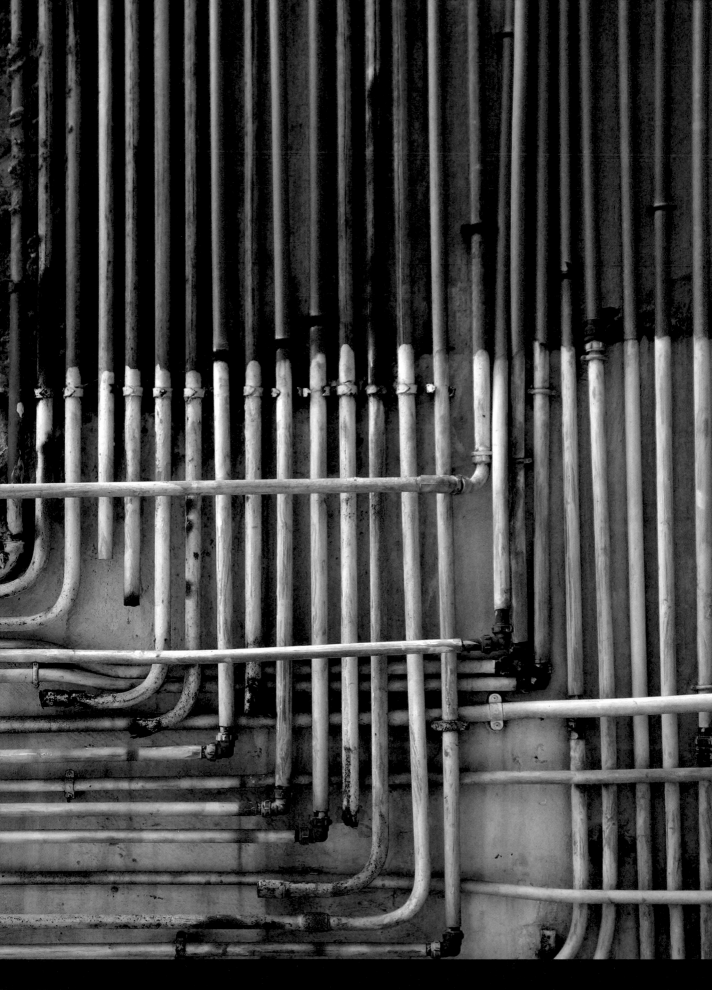

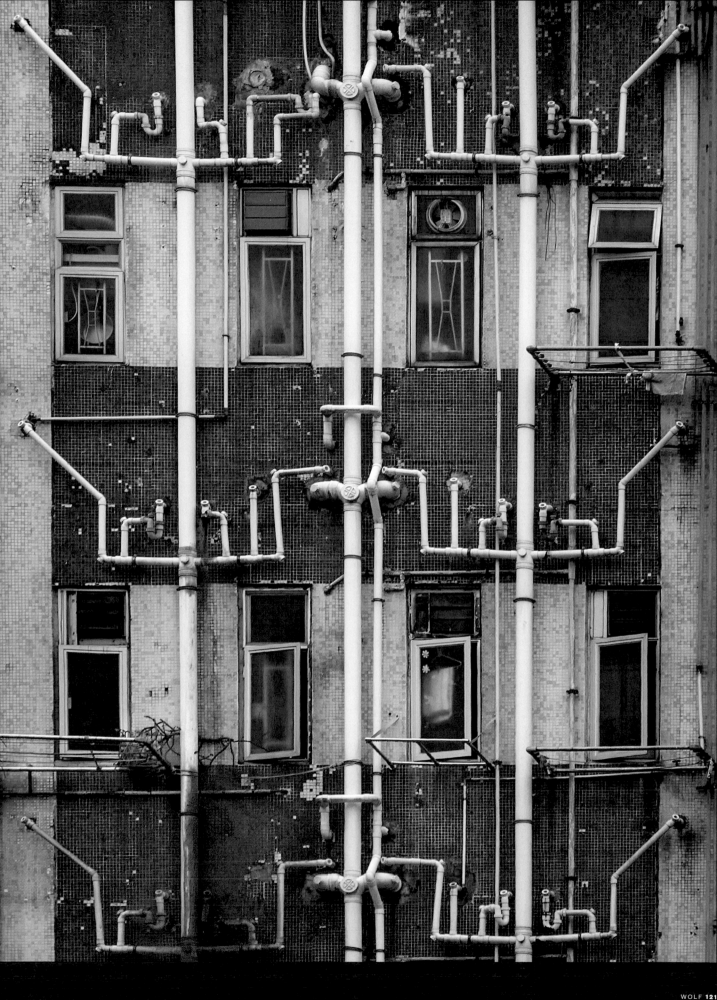

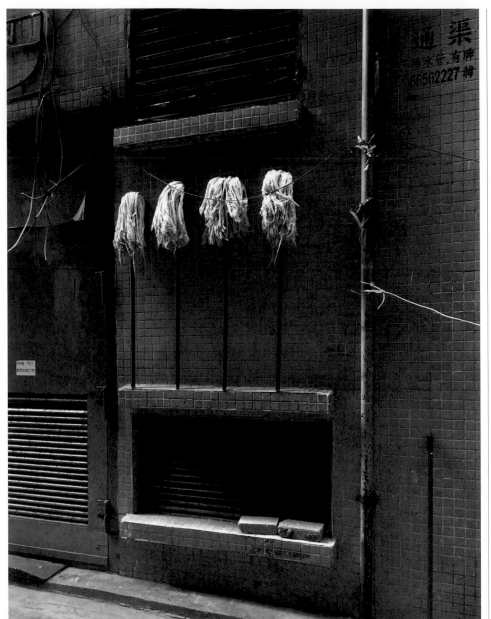

通楽
防水管,有序
66562227 辦

Second spread
From the series *Exhausts*
2003–15
Archival inkjet prints
25 x 20cm each

Third spread
From the series
Informal Seating
2003–15
Archival inkjet prints
25 x 20cm each

Previous spread
From the series *Pipes*
2003–15
Archival inkjet print
25 x 20cm each

Left
From the series *Mops*
2003–15
Archival inkjet print
25 x 20cm each

"IT'S VERY DOCUMENTARY IN NATURE AND MANY GALLERIES LIKE CONCEPTUAL WORK. BUT I'M ROOTED IN THE REAL"

rather than at the Kunstakademie in Düsseldorf, where leading German art photographers such as Andreas Gursky and Candida Höfer did their diplomas. 'Wrong school!' the powers-that-be had declared. 'Had I studied in Düsseldorf, they would have exhibited the work,' Wolf explains. 'But because I went to a photojournalist school, I couldn't be an artist.'

Another of Wolf's most celebrated projects that is also notably rooted in the real is *Tokyo Compression*, a series of magnificently expressive portraits of Tokyo workers wearily pressed against the windows of commuter trains—images of a latter-day Dantesque outer circle of hell.

The commuters weren't necessarily keen to be snapped. 'They couldn't do anything because they were immobilized like sardines,' he says of the subjects of these curiously intimate shots. 'Most art photographers would have had to stage it somehow—buy half a train and put the people in there. It's quite daunting to go there every day and confront commuters who don't want to

be observed by the camera. It's something that I learned as a photojournalist: you don't come back with nothing. If you do, you lose your job. So you figure out a way to do it.'

As a result of changes to the Tokyo commuter network, the project couldn't be repeated now. 'It's over,' Wolf says, not for the first or last time today.

Wolf is a veteran of many self-initiated book projects. But unlike many of the younger generation of post-photographers, he isn't a fan of Publish On Demand (POD) technology with its DIY, you-can-reach-anyone-in-the-world-via-the-web philosophy. 'You need a publisher with some form of distribution,' he says. 'And I need the collaboration. It's so great when people come up with an idea about how to present something.' Most of his work is published by Peperoni Books. 'It's worth so much to have a publisher who's a friend,' he says warmly. 'I can call at three in the morning and say: "Hannes, I have this idea for a new Hong Kong book. It's called *Rubber Boots and Shoes*." And he'll say: "OK, send me the folder and we can work at it." And that's exactly what I did just before I came here. I just decided on another category because there are so many rubber boots and shoes in Hong Kong. We'll play a bit of PDF ping-pong on the weekends when he has a bit of time, and we'll do 15 to 25 versions. His brother has a printing press so we do 600 copies and when they sell out we do another 400.' Wolf's books have become highly collectable.

Though he made his reputation as a photographer, Wolf is expanding his practice and exploring fresh media and materials in his shows. In addition to the raft of *Bastard Chairs* at the far end of the downstairs space at Flowers, there's an assemblage of objects in the streetfront window as you approach the gallery.

And then there are his experiments with moving-image work, shot on an iPhone and shown on small individual screens at the front of the gallery. 'I'd started feeling that I was coming to the end of back alleys photographically. I still go out and I always will but I can only improve incrementally—I have an archive of 5,000 images and if I find one more it's just a micro-percentage,' he explains. 'So I had to figure out a way of representing it which was new to me and that could convey different information. [That was when] I started recognizing interesting back-alley objects which moved.'

So Wolf's remarkable record of Hong Kong singularity continues to grow in scale and ambition, although he's anxious that his decades-long romance with the city can't last much longer. 'In five to ten years from now,' he concludes, 'in the sense of what I loved there, what fascinated me so—this sort of chaos, improvisation, patina—it will be over.'

Informal Solutions—Observations in Hong Kong Back Alleys by Michael Wolf, with a text by Marc Feustel, is published by WE Press, Hong Kong, and is available to order from Flowers Gallery, www.flowersgallery.com

POSSIBLE

PATHS

TO INEVITABILITY

Everyone loves the work of über-illustrator, graphic designer and artist **CHRISTOPH NIEMANN**, which has graced everything from the cover of the *New Yorker* to a super-successful iPhone app. Niemann's creations are immediately recognizable to a global audience for their sense of spontaneity and easy fun, but the path to achieving such inevitable-seeming visual perfection can be tortuous. 'The more playful things look, the more gruesome the process is for me,' he assures **ARIELA GITTLEN**.

Previous pages
Live-Illustrating the
New York City Marathon
2011
Mixed media

Below
From *Sunday Sketches*
2015
Mixed media

Opposite, portrait by Gene Glover

It may just be my imagination, but Christoph Niemann appears so tall that I worry that he'll knock his head against the door frame as he enters the café. It's a blustery afternoon in Brooklyn, just a few blocks from the artist's former home, where carefully maintained brownstones and Callery pear trees sit dark and dripping after a heavy rain. In contrast to his height, Niemann is quiet, his German accent is soft rather than clipped. In conversation he is enthusiastic and precise. He doesn't just talk with his hands—he uses any object within reach. A Pellegrino bottle, a cellphone, a coffee cup are all quickly conscripted into a shadow play illustrating his creative process. It's a bit like watching a cardsharp or a sleight-of-hand magician at work.

Niemann is an illustrator, graphic designer and artist whose work has appeared on over 20 *New Yorker* covers and those of many other magazines. A consummate visual storyteller, Niemann works across media from print to digital and back. He is the author of many books, as well as a columnist for the *New York Times*. His first iPhone app, an interactive storybook called Petting Zoo (in which animals perform silly and unexpected calisthenics in response to the user's taps and swipes), has been downloaded over a million times.

His *Sunday Sketches* series is an experiment in looking closely at ordinary objects and combining them with drawings in surprising and delightful ways. In his cover illustration for issue 21 of this magazine, an upturned red teapot becomes

Clockwise from top left
All from *Sunday Sketches*
2014, 2015 and
(opposite) 2015
Mixed media

the head of an elephant, its spout serving as the trunk and its handle angled precisely to suggest a drooping ear. Although his work seems spontaneous and playful, I quickly learn that for Niemann, his process is anything but.

How does childhood, both your own and also the experience of raising children, influence your work?
Not at all.

Not at all? But your illustrations have such a sense of play!
Well, I can't say not at all, but it's not as if I play with my kids for a few hours and think: 'Oh this is cute, why don't I bring this in?' An idea never comes from a sense of play. The more playful things look, the more gruesome the process is for me. The creation of my work has nothing to do with play. It's all about me designing these moments, so that the viewer gets it in a way that feels effortless. If it's too easy it's boring, but if it's too hard it's just frustrating. Hopefully it's surprising, fun and doesn't feel like being hit over the head with a hammer.

It's all about structure?
Structure, patience and editing. Editing, editing, editing. I always want to make something so that at the end it feels like that was the only possible solution. Inevitability. [Gesturing to the café table top] You're trying to create a path where at the end this bottle and this cap and that phone and that angle on the wooden table are

"THE MOMENT YOU HAVE INK IT'S FOR ETERNITY. PENCIL IS ALWAYS SEARCHING, IT'S NEVER DONE"

such a perfect solution that you start laughing. But it never has to do with arranging the things, it's about arranging the path.

You talk about creating illustrations the way an author might talk about constructing a plot of a novel.
It's totally like that. One of the most ground-breaking books I've read about this is Stephen King's *On Writing*. I've never read a single Stephen King novel in my life, horror is not my thing, but *On Writing* is part autobiography, part writing instruction. He writes that when it comes to plot, you can either start with the end [in mind] and guide the reader there, or you can put your characters together in a room and then let them do their thing. You give the characters freedom to just go places, and I find that so scary. When I started doing the *Sunday Sketches*, that was the idea.

In 2011 you attempted to illustrate the New York City Marathon while running it. You've talked about how much careful planning you do, but live-drawing an event seems like the opposite approach.
That's where this whole thing started. This idea of letting go and giving away control. I've tried a couple of things like that and often I'm just not happy with the results. Nobody likes an idea better because it was done live. You don't get extra points for doing it while standing on one leg—if the drawing is bad it's just bad. What worked with the marathon is it was actually live and you

Left
I Lego NY
(Memories of New York)
from the book *Abstract City*
2010
Mixed media

could follow me in real time, so there was a sense of urgency. If I had published it three weeks later I think it wouldn't have worked. I'm very sceptical of these things.

You said in an interview recently that James Turrell offered 'the ideal art experience'. What's the ideal art experience for you?
What he does is just a hole in the wall and light. There's nothing there. It means nothing, represents nothing, touches on nothing historical, political or social. You don't need any education to see it. You go there and it's all in your head. It seems to be about love and drama, life and death, but there's no blood, no nakedness. The amazing thing is the simplicity and abstraction of the art and what it does with you. Suddenly, you just think about colour and perspective and light, questioning the whole world just from looking at a purple square. I've never had these moments as clearly as I've had them while seeing Turrell's work.

How has Turrell's art influenced your own?
One thing I love about Turrell is that when I see one of his installations I feel like I am the only person who gets it. Not even he understands how meaningful it is. With art that's kind of the holy grail—creating something that somebody looks at and feels that they always knew. It's kind of a stupid aspiration because I can't really plan to do it, I can just hope for it. It's a guiding light for where I want to go.

Bio-Diversity

Willow

Pillow

Yoda Tree

Chewbacca Tree

Millennium-Falcon Tree

Death Star Fruit

There are similarities between your illustrations' style and tone and that of contemporary comics and graphic novels. Do you ever look to comics for inspiration?

I know some. I think Chris Ware is a genius and Adrian Tomine is a genius. What they do stylistically, what they do with storytelling, is just mindboggling. What they do is letting go and creating a literary experience, which is something I'm still struggling with in a much shorter form. When I look at Chris Ware's comics I enter his universe. There's a door opening and I go through the door and I'm in this world. It's a scary world, a fantastic world, but the moment I close the book I have to go back to my life. Instead what I try to do with my work is enter your space. Basically, I want you to stay where you are and give you things that redefine everything around you. I can't take you to faraway places and show you dramatic stories. I'm always limited by our shared experience.

You recently illustrated a collection of Erich Kästner aphorisms. He's such a popular writer in Germany, but virtually unknown in the US.
In Germany he's probably best known for kids' books like *Emil and the Detectives* and *Lottie and Lisa*. He's the classic author that everybody knows. It started as a book project and there were a few challenges. One was that the writing is kind of perfect. I couldn't add anything, especially since most of the aphorisms are very well known. If I tried to do my own take on it,

Right and opposite
Illustrations that
reinterpret the aphorisms
of Erich Kästner for the
book *Es gibt nichts gutes,
ausser: man tut es*
2015
Pencil on paper

"I THINK IT'S STUPID TO MAKE IT SO THAT ART IS CRYPTIC AND DEEP AND ILLUSTRATION IS SUPERFICIAL"

it would make it smaller. It's one of those books that should not be illustrated.

Right, because adding anything to it makes it less potent.

This is like my pet peeve. About 30 per cent of all thesis projects in illustration are kids illustrating Kafka's *Metamorphosis*. There are some amazing drawings, but I've never seen one that made the book better than it is. You try to latch on to the greatness of the story and then you actually drag it down. The horror is that you wake up and you're this bug—the moment you draw it, it becomes more tangible and more boring.

I started with a pencil drawing on a blank page of the book and realized that was the solution. When you get a play by Shakespeare from the library and write your thoughts in the margins, you're not trying to make Shakespeare better, it's more like: 'Oh, this is what it means to me.' Your thoughts might be no less meaningful but you're not trying to compete. I started thinking that pencil was right because it's the ultimate subjective tool. The moment you have ink it's for eternity. Pencil is always searching, it's never done. When you get the book with my drawings, it's really more like you go to the library and someone has doodled in the official Erich Kästner book. At the book party I had all the drawings in frames and my gallerist saw them and said: 'Let's make an exhibition with this.'

How do your drawings change when they move from the page to a gallery wall?

You can never approach a magazine drawing from 20 feet away. It's only one size, one perspective. With a drawing on the wall you can create a mood, create order and narrative. I don't want an art piece or drawing to be cryptic. I think it's stupid to make it so that art is cryptic and deep and illustration is superficial. When I look at all the art that I like to have on my walls I want

something that maybe releases the meaning a little slower. There are elements that maybe don't quite add up. Not because they're nonsensical, but because they describe the reflections of things more than they describe the things.

The exhibition was called Es Gibt Nicht Gutes (There Is No Good)—*a truncated version of Kästner's book title. I was surprised at the darkness of that title because your work is typically so funny and optimistic.*

The overall feel of Kästner's aphorisms is surprisingly positive when you consider the background—he wrote the book while he was banned from writing. Kästner is the only author, to my knowledge, who witnessed his own book burning in Berlin during World War II. These aphorisms, this is some stuff he worked on while he was not allowed to write books. When you consider the circumstances, some of them are extremely upbeat, but of course there's a lot about the political gullibility of the people—in this context it seems amazing that he isn't writing: 'You're all idiots.'

After living in New York for over a decade you recently moved to Berlin. How did that change or influence the way you work?

In New York everyone is so professional and so efficient. For me it's extremely tough in those circumstances to be experimental. When everyone around me is just churning out books and movies I just don't have the balls to say: 'I need to spend the next few weeks experimenting.'

It sounds like the move was pretty liberating.

The biggest problem is that it's the end of all excuses. In New York you can say: 'Oh, I've always wanted to do big metal sculpture but it's just too expensive.' In Berlin if you want to do metal sculptures you can do them. If you don't the only person to blame is yourself.

SP RKLE
A
D
N

At first sight, you might assume that New York artist **CHRIS MARTIN'S** luminous, glittery work is intended as an ironic commentary on flashiness. The truth is quite the opposite. 'Irony is what I would call the academic trope of our time,' the former art therapist tells **EMILY STEER**. 'When you're using irony you don't face your own emotional situation and the implications that brings.'

SI CERITY

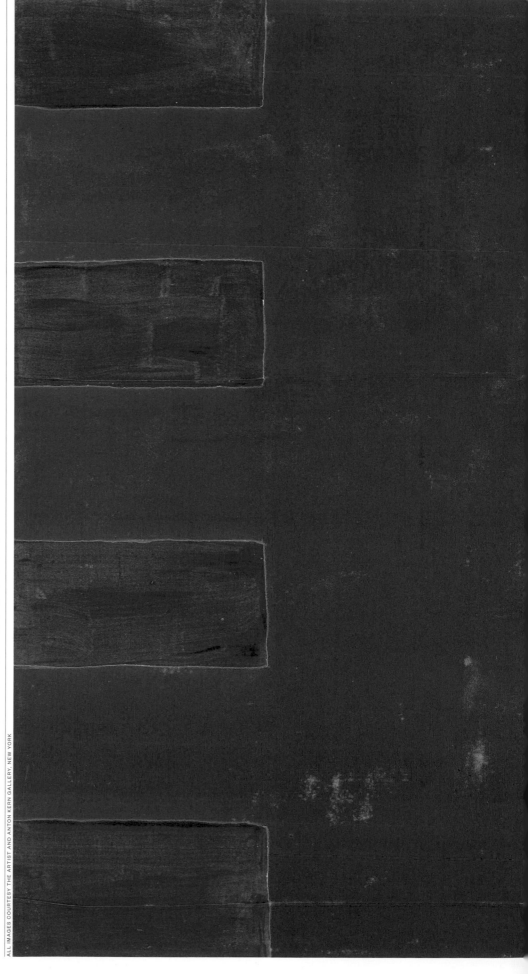

hen I first saw the work of Chris Martin in the flesh, I was struck by one thing in particular. Wow, glitter looks really awesome when there's that much of the stuff. This, obviously, was followed by a quick flash of shame. Excitement about large amounts of colourful glitter should surely not be vocalized in the middle of an art fair—this must be a trap.

I'm talking about Martin's solo exhibit at London's Frieze 2015 with the New York gallery Anton Kern. Commanding in scale, luminous of surface and neon in colour, Martin's canvases are a combination of naturally shaped forms, loose patterns and thickly applied glitter. The immediate feelings they communicate are joyful; they have a suggestion of 'hippy art' about them. His smaller works contain intense bursts of colour, as well as the occasional bit of Pop iconography, all served up with the same hands-on aesthetic. After an initial feeling of attraction towards the work—soon dismissed as the leftover childish longings for all that is disco—it seems natural to attempt to find the 'real' meaning. But concealing his meanings to trick an art viewing public and an art intellectualizing industry is not really the artist's style.

Martin was born in Washington in 1954, and has spent many years taking an unconventional route to his current position, via a BFA

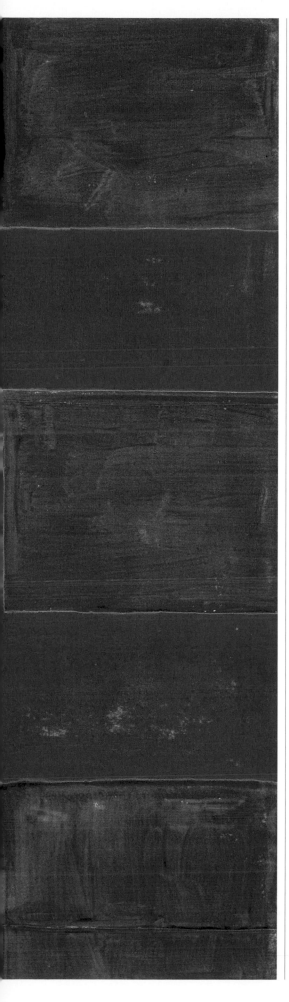

"PICASSO AND JAMES BROWN WERE THE TWO PEOPLE WHO REALLY LIT UP THE WHOLE THING FOR ME"

Certificate of Art Therapy from New York's School of Visual Arts. He worked as an art therapist for 18 years. The more that you read about Martin, in fact, the more you realize how upfront his work is. You will hear his paintings with their New Age vibes described as 'honest', more concerned with immediate visual effects than cynical messages. There are stories of him inviting students to burn their work during his time as a tutor to allow them to loosen up their practice, not to mention a tale about him bringing bongos and a boombox to a talk at Columbia.

You've previously spoken about Richard Tuttle's ability to step aside from a painting, rather than coming on strongly as 'the maker'. Is this something that you feel when you create a work—the ability to step aside from it?
Well that's almost a state of grace and it's very hard. It's when it comes together and you step back and go: 'Wow, who did that? It's really nice.' One always hopes for that, that you can be of service to the whole tribe by presenting something that comes through you, but that is larger. The only other issue there is: Do we know what we're doing? There is a certain trust that you don't know what you're doing, but that you carry on. That is the skill and maybe the experience, where you learn to deal with

your own sense of discomfort or lostness inside a process.

I've read people describing your work as honest painting rather than something which is trying to be ironic or cynical, or trying to discuss the loaded history of painting. Do you feel that you have pure intentions?
Irony is what I would call the academic trope of our time. It's much easier to do—but to focus on the irony is to be distant. When you're using irony you don't face your own emotional situation and the implications that brings. There was a time, obviously, when irony was a really fresh, radical thing for people. But once something becomes the dominant mode it's safer. It's a way of being removed from yourself and the process that you're engaged in. In particular it's used to distinguish fine art from popular art. You might use the drawing on the back of a motorcycle jacket or rock'n'roll posters or a Christmas card or something, but you're not acknowledging the sincerity involved in a lot of that work. I actually try to do the reverse, which is to see not where it's fake, but where it's real.

I'd like to talk to you about your abundant use of glitter. Am I correct in thinking that it came from

Portrait by David Brandon Geeting

"I THINK EVERY ARTIST SHOULD HAVE AN OPPORTUNITY TO BURN THEIR OWN WORK!"

your time as an art therapist, when a lot of your patients were using it?

Yes, that was where it started, and then I began working with it myself. Everyone loves glitter! But there was a certain point when I was looking around at what was considered unacceptable, what was considered bad taste. Looking at those areas is always very healthy. And you're looking at your own taste. I was thinking: Well, these patients want to use glitter, but that's because they're not visually sophisticated, they don't have fine culture—so of course they love glitter. And then you start to see your own prejudice: 'Glitter's not a serious thing, it's for kids and old ladies.' So when you see your own taste, it's a moment when a light bulb goes off. I tried it out and, unfortunately, I fell in love with it.

You have quite an interest in—for want of a better word—'outsider' art. But you are also accepted by the contemporary art world. Do you ever feel the need to pull away from the institutionalized art scene?

It's an arbitrary thing, but there are these distinctions that aren't arbitrary, they are based very much in keeping art as an exclusive domain of a high-society, upper-class situation. You're saying there is great value here because these are the special, famed artists. But if you accept the fact that some of the best art is being made by ten-year-old children all over the globe, then you suddenly lose your standards—and those standards are based on this exclusive club. There are great paintings just lying on the sidewalk, and there is a part of me that is interested in painting, any kind of painting: paintings in barbershops, graffiti art, paintings that kids do, paintings every conceivable way. I was always interested in that, but then when I worked as an art therapist it was very clear to me that the work my clients were producing was fantastic: it was really terrific painting. And they of course had internalized this opinion from society that said that their work was worthless, and they were worthless, and how could they be any good at painting because it was the first they had ever made.

Obviously the tribe has people who are great singers or great dancers and they're trained and they rehearse every day. When you see someone like that dance, it's something very special. But then at the same time, when there's a party going on everybody gets up to dance, and everyone knows they can dance. When you see someone who's having a great time dancing, well, that's great dancing! It's a very human skill, and the closer I stay with the very original impulse to make a painting, the better it is. You can never get rid of your own training, all the books you know about, all the paintings you've looked at. But there are moments when you do forget all of that—where it comes in through the back door when you're not worried about it.

So who were your main influences when you started out? Were they visual artists, or did they come from the wider world?

Really it was Picasso and James Brown. Those

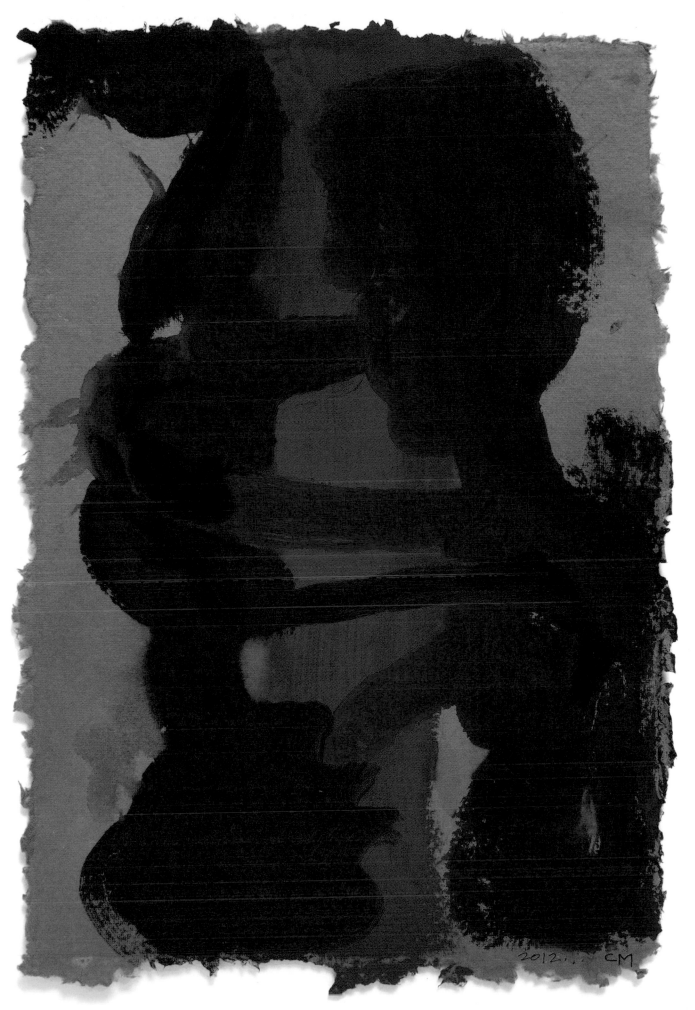

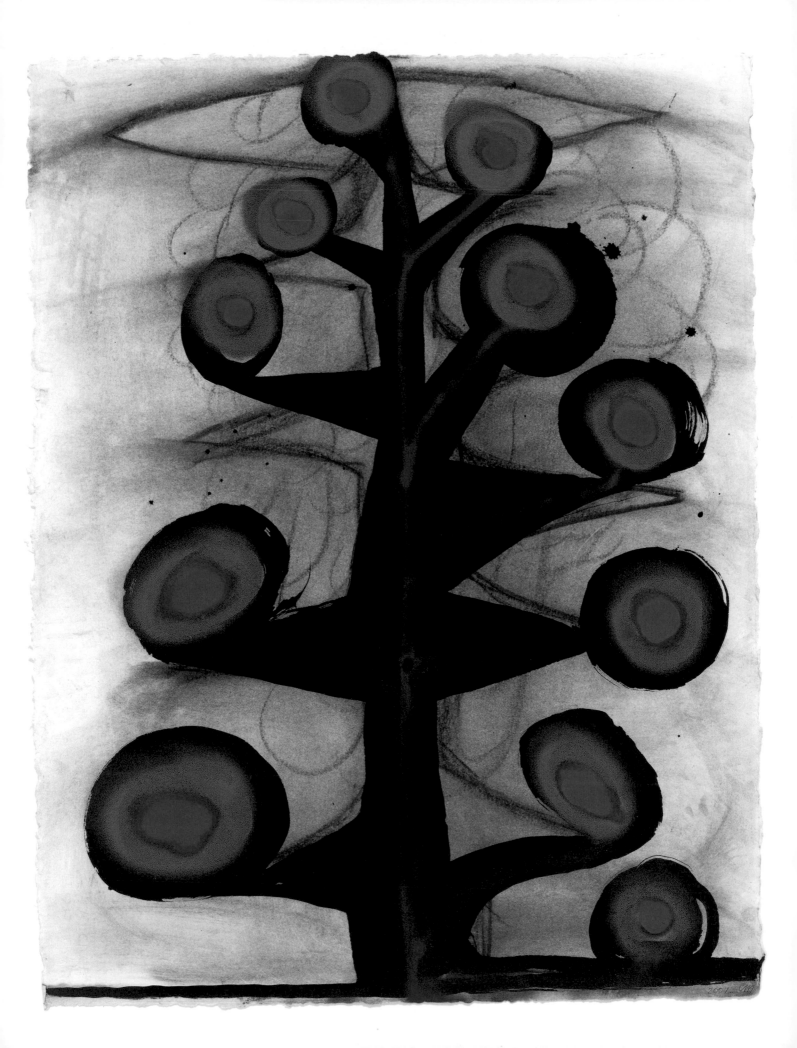

Opening spread
Untitled
2014
Oil, acrylic and collage
on canvas
245.1 x 198.1cm

Second spread
Seven (Pink and Blue)
2014
Acrylic on canvas
224.2 x 195.6cm

Third spread, right
1969
2015
Acrylic on paper
48.3 x 33cm

Opposite
Untitled
2007
Acrylic, spray paint,
charcoal on paper
76.2 x 58.4cm

Right
Untitled
2015
Oil, acrylic and collage
on canvas
162.6 x 149.9cm

were the two people who really lit up the whole thing for me. I grew up in Washington DC, in a very segregated society in the early '60s, but the music on the radio that I really loved was the great African-American and soul music. That just knocked me out. And then I discovered painting by trying to copy Picasso. I realized you can do whatever you want, there is this whole freedom. So the combination of James Brown and Picasso seemed like that was going to be really fun.

Can you tell me a little about your upcoming exhibition at David Kordanksy?
The two spaces at David Kordansky are beautiful; they're big spaces, there's a lot of light and I'm particularly excited by the idea that I can show really large works in Los Angeles. I've shown in LA maybe three or four times but I've never shown my larger work. There's something fresh about LA right now, it's a really exciting art scene and there are a number of younger artists who I really think about, and admire, and they're all living in Los Angeles. They're in a real community there of excitement and openness and they have their own kind of aesthetic and their own take on things. It's very independent and it has its own spirit to it. I also love the landscape, I love the light out there and the sense of colour.

It's very different from New York. The light in the gallery spaces is just very attuned to that. One thing we're going to do is create some paintings and put them in neon-lit boxes and put them on the outside of the gallery. I had a very interesting experience in Brussels: I had a show where we were able to put up a number of larger works outside and it is so thrilling to have it out in the world. It's really interesting to see art as just another thing out there, but on the other hand also see how it has a special relationship [to people], because unlike other images we see outside, it's not trying to sell toothpaste or a movie.

Many of the paintings that you create to show indoors are also on a pretty large scale.
Do you approach these differently from your smaller, more private drawings?
Yes. I mean, there are two words: one is scale and one is size. Scale is a kind of interior relationship. So you could have a small painting that has vast scale; even though they're small there could be a sense of a giant universe in there. The thrill of a large size for me is that you can definitely expand this inner scale; you can have this big wall of a painting but then come closer and see this very little thing. It's something that the big European tradition of painting uses:

you might have a big battle scene, but then you can also go up and spot a little detail of a woman's drapery or a piece of armour or a horse's nostril. That really excites me, that you can get a big mural inside one painting.

And finally, can we discuss the time you encouraged your students to burn their work?
That was just a situation with some students and myself, and there was all this energy, this excitement because people were feeling like they could do anything. People were making work and planning to burn it. I think every artist should have an opportunity to burn their own work! It's a very illuminating thing to do. The larger issue is one's sense of freedom in the act of making something. If you are very protective of what you're making, then there is a fear that you don't want to ruin it. The reason I'm very interested in artists' drawings is that if you have a piece of paper you are very free to do something crazy. If it's a bad drawing, it's just a piece of paper. That freedom to go out and possibly fail, to risk something—it's much easier to do if you aren't worried about the material that's involved.

Chris Martin is showing at David Kordansky from 9 April until 21 May 2016.

'The brush paints,' **BERNARD FRIZE** once joked, as if his personal presence—and the physical movements of his hand—weren't essential to the creation of his works. But out of such denials of traditional ways of thinking a new language for painting emerged. **JURRIAAN BENSCHOP** meets the French artist to talk about (non-)choice and (non-)expression.

Portrait by Anja Schaffner

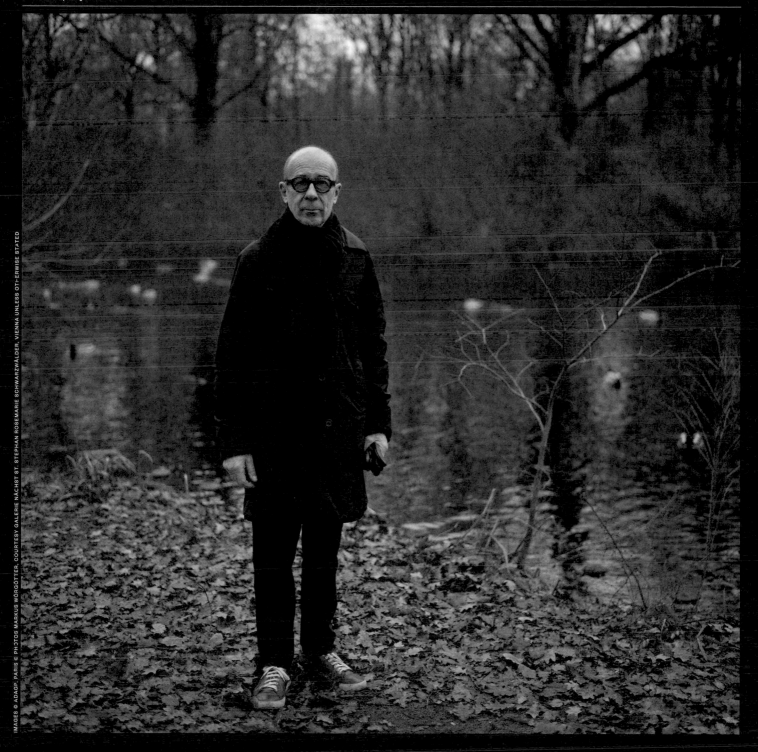

ernard Frize divides his time between Paris and
Berlin. In Paris he has a 600-square metre studio
near Père-Lachaise. In recent years, though,
he has spent most of his time in Berlin, where
he has a modest studio in the neighbourhood
of Charlottenburg. Usually there isn't a lot to
see there, since, once finished, the works go out
quickly to exhibitions. But when I go to meet him
he has just started a few new paintings and is pre-
paring a new exhibition in Vienna.

'I need to paint,' says Frize, stretching another
canvas. All the same, he is not the kind of artist
you will find in his studio every day. He needs to
charge himself before starting and, above all, he
needs a plan. Only then does it make sense for
him to paint. First a plan, then the action. Frize
usually works in series in which he explores a
certain pattern or principle, continuing until he
is done with the motif. For each series he makes

a set of rules, directions or limitations that will
define how the painting will be executed, such
as pouring the paint without the use of a brush,
or taking the round crusts that are formed when
a can of paint is left open and using them to fill
a canvas. In a series on glass (*Avril*, 2013), mul-
tiple works were executed following the same
method: repeating a rectangular form, similar
to the shape of the letter U, and changing colour
after every U-turn.

Frize is not a painter who likes the notion of
being present himself inside his paintings. You
could say that the subjective expressionist paint-
ing gesture is alien to him. Yet, while looking at
his works, I am struck by their colourful expres-
sion; a painter's hand is definitely visible. The
gestures are very explicit. In fact, they have
become the protagonists of the work—there is
no narrative or other subject matter that draws

attention. 'The brush paints,' Frize once joked,
as if he was not there while it happened, and that,
in short, is what we are looking at in his paintings.
When I ask Frize about expression, he is resolute.
'It is just a myth,' he says. 'It is not about expres-
sion at all. It is all about thoughts. Expressionism
is just a label. For branding, it is well chosen. But
for recovering the reality of painting, it is not.
There is always speculation involved. Fortunately
we are not animals, so what we do comes from
thinking.' But isn't there always some kind of
expression involved, even if it is not your focus? 'It
is something random—there is chance, and this
is always underestimated. They call it expression
but expression does not exist. Painting comes
from ideas and conscious decisions.'

A conversation with Bernard Frize often turns
around the question what his painting is *not*.
The artist is keen on peeling away labels that

Previous pages, right
Balaire 2014
Acrylic and resin on canvas
200 x 320cm
Installation view, Bernard Frize,
Käthe-Kollwitz-Preis 2015,
Akademie der Künste Berlin,
11 Sept.–25 Oct. 2015

Opposite
Aprupt 2015
Acrylic and resin on canvas
135 x 60cm

Above
Aigre 2015
Acrylic and resin on canvas
135 x 60cm

Puline 2015
Acrylic and resin on canvas
66 x 66cm

have been glued to his work. Since the work is not really 'about something' a lot of the words that have been used to describe his practice, over the last 40 years, are not, in his view, adequate. Expression is one of those words, process another. Since the act of painting can be traced in many of Frize's works, commentators have identified the process as the actual meaning of the work. But 'process is just like cooking,' Frize says. 'It is regressive to focus on that.'

Of course, there is a process involved in making a work, but this is not content as such. And the same goes for colour and concept. They play a role, but this does not mean that Frize is a colourist, or a conceptual painter. His reluctance to accept such labels could be regarded as being true to his attitude as a painter. He wants to keep the work free from all kinds of meanings and suggestions that are outside the actual realm of painting. What is important is the act of making, and

to make paintings that need to be seen more than once, without leaning on external references.

Why does Frize make different variations of a similar motif? Is there not the danger of repeating himself? 'The repetition in my work takes place within a series, and this is to exhaust the possibilities. I do a similar painting to find out what the end of it is. How could a new idea come out of it? If you see artists doing the same kind of painting over the years, then repetition becomes a way of branding yourself as an artist. That is not interesting. During the working or process time, the aim is to put in motion a little motor, or to find another type of gas, to keep the engine running. In the end you can say this painting or that one is better, but that is a matter of taste. I only disqualify paintings if they have mistakes, if a line is not straight, or because colours are mixed in a way they should not be.'

How did Frize come to this approach, which

seems so focused on the 'how' and execution of the painting and less concerned with visual results? To understand this, we have to look back at the circumstances in which he started to paint in the mid-1970s. Back then Frize felt a gap between the post-1968 political reality that surrounded him in Paris, and the individual activity of an artist in the studio, in his private world. What would be a relevant painting? How could he participate in society, embody a critical view, understand himself as a political being, without making a kind of actionist image that he did not believe in? He stopped painting altogether for some time and then started again from scratch, developing his approach to working in series, each time with a set of rules that defines what is to be done. The early works were simple and minimal in approach: they consisted of endless, very thin brushstrokes, both vertical and horizontal, overlapping each other until they filled the

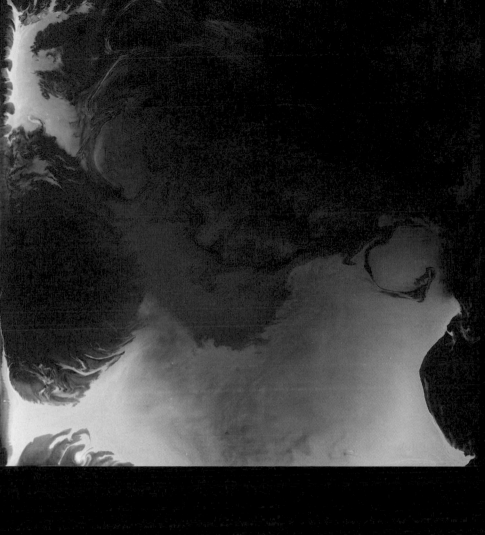

Brome 2015
Acrylic and resin on canvas
66 x 66cm

whole canvas. Frize wrote about these very early works: 'These were my first paintings in which the materials, the technique (however minimal it may have been), and the content (the "what was thought") showed solidarity.' The coherence was to be found in a credible way of making a painting.

It would not make sense in Frize's approach to try to influence the mood of a painting, to retouch it after making it or to correct it visually. Ideally, the paintings are made in one session. Once done, either they work or they do not. This points to a performative attitude towards painting, more than a compositional one. It is more about the action that can be trusted than about a visual construction that should be pursued.

'I'm not interested in colour,' Frize says, standing in front of one of the colourful paintings in his studio. It seems a strange statement. The joy of looking at the work certainly comes from the colours, and from seeing the different methods of their application, which lead to very different moods. The character is firm and monumental in works such as *Apre* (2015) and *Reche* (2015), where colour appears to descend like a waterfall against a black background (or is it a foreground?). Frize seems to have a happy knack in handling colour, but for the artist colour isn't really an issue to think about. 'I just use as many as I can to avoid making a choice,' he says. And not choosing is, of course, also a way of not expressing himself and staying out of the painting as an author.

Does Frize feel that his view on painting, as he developed it in the '70s, is still valid in today's world? The political map has changed—we meet a few weeks after the November terrorist attacks in Paris. 'My generation grew up with the idea that after the Second World War there would be no such big conflict, and now we are in the middle of a mess, but it is a different kind of mess. It is difficult to grasp a world picture of that. It is really ruining my days.'

Doesn't he think that as an artist he should just keep focusing on his work and continue to do that, especially in circumstances where artistic freedom is at stake? 'I used to have the feeling that I was coherent in my work, in my action, in my thoughts, in my political beliefs. But now I don't think that anymore. I don't think that it is enough to just keep doing what you are doing. But I also don't have a solution. Some artists, although not many, are able to embody political reflection in their work. Some do it in a relevant way. Denunciation does not work, but reflection could be a contribution.'

Bernard Frize's show Turn the Pieces into a Place *runs at Galerie nächst St. Stephan Rosemarie Schwarzwälder, Vienna, until 19 March.*

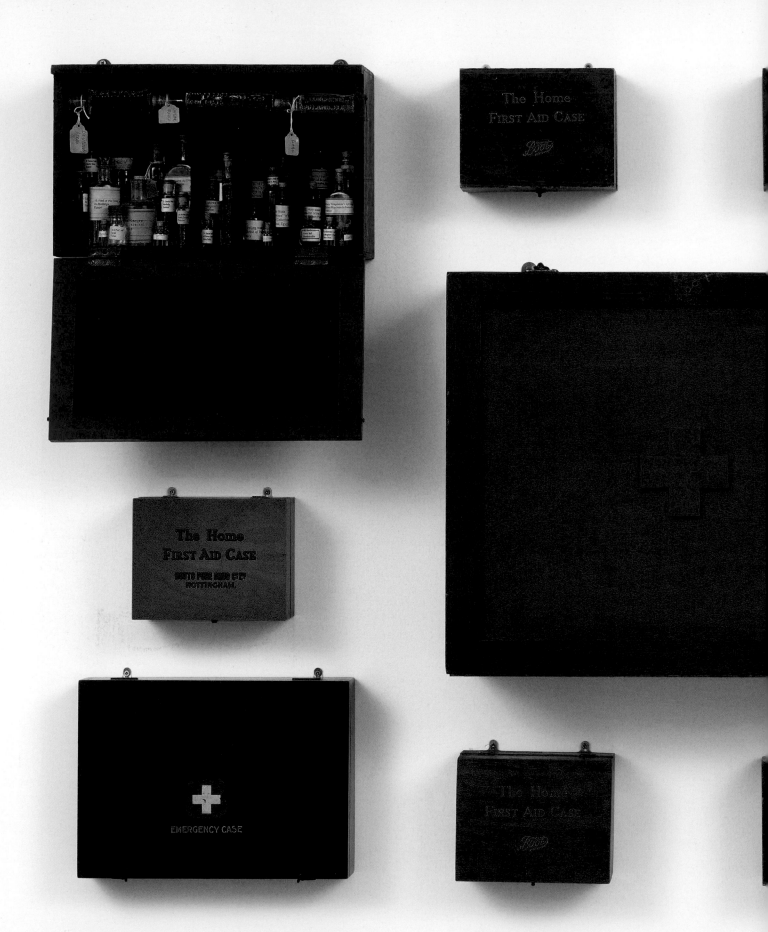

COMMUNICATIONS FROM

SUSAN HILLER

THE CHTHONIC UNCONSCIOUS

Despite making the first video installation to be bought by the Tate, **SUSAN HILLER**—an American long resident in the UK—says she has never quite felt 'at home' here. Likewise, her startling artistic investigations of the irrational and uncanny refuse to be domesticated or comfortably explained away. 'If talking and thinking and working with ideas were enough,' she tells **SUE HUBBARD**, 'then why should we make art?'

'And I reason at will,
in the same way I dream,
for reasoning is just another
kind of dreaming.'

Fernando Pessoa
The Book of Disquiet

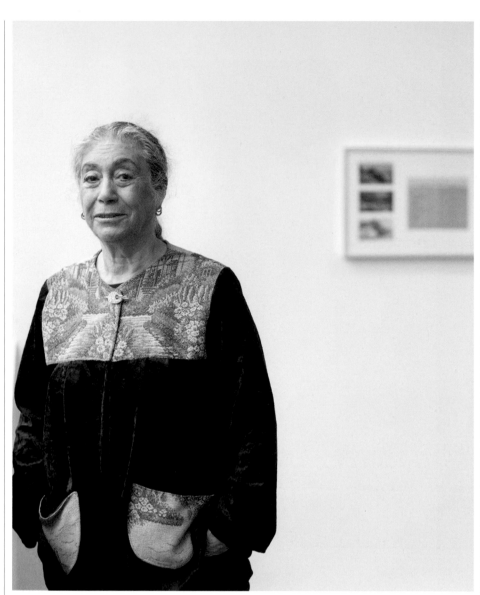

Portrait by Julia Grassi

I first got to know Susan Hiller around 1999 when I included her work in my exhibition, *Chora* (co-curated with Simon Morley). Recently, when we met for lunch, after seeing her debut show at the Lisson Gallery, she told me how much of an outsider she continues to feel despite a major show at the Freud Museum, a retrospective at the Tate and recently joining this prestigious gallery. 'For example, I've never been invited to join the RA', she says over our green tea and satay. 'Some of my students have, but I don't fit. I'm not part of the establishment.' With her multimedia practice of over 40 years, she is one of the most original and influential artists of her generation. But, perhaps, there's some truth in her self-assessment. An American who has lived in London since the '60s, she's never felt quite 'at home' in her adopted country. 'I'd never heard a woman called a cow before I came to England,' she says, a phrase incorporated in her installation *008: Cowgirl* from the Freud Museum, London (1992–94).

First trained as an anthropologist (a fact that, if given too much weight, annoys her), Hiller displays the intellectual rigour and curiosity of the academic, counterpointed with the 'irrational' explorations of the artist. Her work poses complex questions about identity, feminism, belief and the role of the artist. Never cynical or market-driven, it remains uncompromising, erudite and complex. The sort of art that forces you to think. She describes it as 'a kind of archaeological investigation uncovering something to make a different kind of sense of it', focusing 'on what is unspoken, unacknowledged, unexplained and overlooked'. She explores what, to many, may seem irrational, sidelined and marginal aspects of human experience. She is interested in the traces we leave behind, be they the automatic writing generated in *Sisters of Menon*, a work made in the '70s that investigates the permeable boundaries between conscious and unconscious utterance, or the investigations in *Lucid Dreams* (1982), where the presence or

absence of her own face, photographed inside a photo booth, underlines the fragile nature of identity and the transience of existence like a series of grungy, do-it-yourself vanitas paintings. For the *J Street Project* (2000–05), she searched for every street sign she could find in Germany that included the word *Juden* (Jew). A chilling reminder that these are places from which whole populations and histories have been erased.

Her sources are eclectic, ranging from arcane texts and psychoanalysis, to popular culture. In her 2002 lecture at the Edinburgh College of Art, she quotes Freud who, in 1921, wrote: 'It no longer seems possible to brush aside the study of so-called occult facts; of things which seem to vouchsafe the real existence of psychic forces... which reveal mental faculties, in which until now, we did not believe.' Freud, she writes, claimed 'that an uncritical belief in psychic powers was an attempt at compensation for what he

Susan Hiller
7·73

poignantly called "the lost appeal of life on this earth" and that the problem with believers in the occult is that they want to establish new truths, rather than scientifically "take cognisance of undeniable problems" in the current definitions of reality'.

Her Lisson debut, which occupied both gallery spaces, interwove these tensions between the scientific and the rational with our desires and instinctual drives, in four ongoing themes: transformation, the unconscious, systems of belief, and the role of the artist as collector and curator. The presence of rare and unseen early works from the '70s and '80s underlined her interest in alchemy and psychological transformation. The 1970–84 *Painting Blocks*—made from cutting up and reassembling old paintings into sculptural 'books', labelled with the dates and dimensions of the original work—were shown alongside the small, ash-filled vials of *Another* (1986). Packed with the remnants of burnt paintings, these illustrate the reconfiguring of objects (or identities) in a transmuted form, one that echoes the theories of the psychoanalyst Melanie Klein on reparation and creativity.

Belief and the boundaries between the unconscious and the paranormal are examined in another work on show, *Belshazzar's Feast* (1983–84), the first video installation ever to be bought by the Tate. As with much of Hiller's work, the readings are fluid. This new bonfire version (which surely evokes notions of burning heretics and witches at the stake) is built from a stack of television sets that each frame a flickering orange flame. Accompanied by Hiller singing, whispered reports from people apparently seeing ghostly images on their TV screens, her young son's reminiscences of the biblical story and Rembrandt's painting of the same name, it creates a work that evokes primitive uncanny feelings.

In her 2012 *Emergency Case: Homage to Joseph Beuys*—that quintessential shamanic artist—Hiller extends her investigations into faith, the irrational and reason. Vials of 'holy' water, from as far afield as the Ganges and an Irish sacred spring, allude to traditional beliefs, as well as to contemporary 'alternative' systems of healing. Clustered in reclaimed wooden cabinets picked up in antique markets, the installation is reminiscent of a medieval apothecary's shop, as well as Damien Hirst's medicine cabinets, suggesting that faith and reason are, to a large extent, cultural and historical.

It was in the eighteenth century that Carl Linnaeus devised a system of taxonomy, that branch of science concerned with classification which drew together species into rational groups and gave meaning to the modern world. This desire to define and categorize is inherent in *A Longing to Be Modern* (2003), an installation made up of 32 ceramic vases from the old East and West Germany, along with 18 recycled cast bronze letters from gravestones, arranged on a kidney-shaped table in the gallery.

"I'VE NEVER BEEN INVITED
TO JOIN THE RA. SOME OF MY STUDENTS
HAVE, BUT I DON'T FIT.
I'M NOT PART OF THE ESTABLISHMENT"

Opposite
On the Edge
2015
Rough Sea postcards, map,
482 views of 219 locations,
mounted on 15 panels
77.5 x 107.3cm each

Right
*Split Hairs: The Art
of Alfie West*
1998
20 framed and captioned
split hair works by Alfred
West (1901–85) on glass
or mirror; various dates;
installed in vintage vitrine
with accompanying
catalogue by Susan Hiller
(curator) and David Coxhead
(collector)
Dimensions variable

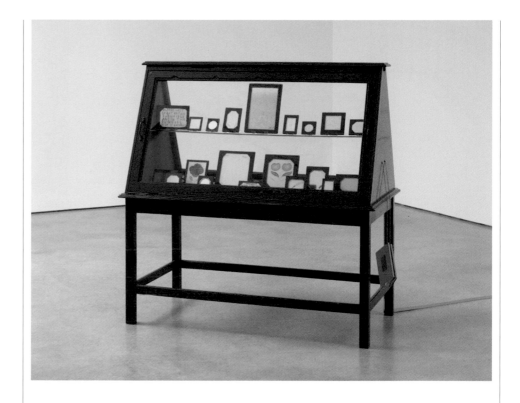

The role of curator and collector has long been part of Hiller's practice. In the '70s, a seminal work, *Dedicated to the Unknown Artists* (1972–76), consisting of a collection of over 300 postcards by unnamed artists, all bearing the words 'Rough Sea' and picturing stormy seas around the British coast, used the methodology, labelling and tabulation of a scientific research project. The investigations of this highly conceptual work have, more recently, been revisited in *On the Edge* (2015), a piece that presents 482 views of 219 locations along the coast of Britain where rough seas meet the land. Not only does this work tap into notions of English landscape and seascape painting, with its Romantic penchant for untamed nature and the sublime, but, in the use of ephemeral postcards, evokes that very British love of the untamed and unspoilt; that need to get away from the hurly-burly to become immersed in the authentic, raw and unmitigated. The phrase 'on the edge',

of course, carries multiple readings—on the edge of sanity, of mainstream society, and of artistic or psychological breakthrough (or down). The relentless stormy tides battering this small island could easily be understood as the chthonic unconscious beating at the doors of reason or anarchy pommelling the gates of polite society.

Over lunch Susan Hiller is cautious about explaining too much about her work. 'If talking and thinking and working with ideas were enough,' she insists, 'then why should we make art?' She has no overarching authorial narrative and does not provide resolutions but simply offers the viewer a complex palimpsest of ideas. What is unique about her work is that her past anthropological studies help to frame a series of questions that are then translated through the sensibility and language of art.

A prodigious writer herself, Hiller is mindful of the possible interpretations, in our de-centred world, between the discourses of art,

anthropology, religion and psychology. Her evocation of the work of Joseph Beuys seems to emphasize a belief that the traditional ways in which artists make and speak about their work are largely exhausted. She does not seek definitions or clarifications but rather reflects the ambiguities of the society in which we live. Like psychoanalysis, these are built on a chain of associations that are often slippery and fluid. 'Truth', a principal allegorical character in the discourse of modernism and humanism, has within this postmodern narrative been replaced by notions of relativity and legitimacy. Hiller refuses to pander to established tastes or prejudices but, to some extent, creates the audience she needs to respond to her work. Never nostalgic or self-consciously poetic, her archeological rummaging through the iconography of the past results in a series of investigations into the arbitrary and the marginal that run like fault lines though the contemporary world.

CONCEPTUAL

By the artist's own account, 2015 was 'a bit of a marathon' for **HELEN MARTEN**, with her work travelling to Oslo, Tel Aviv, New York, Venice and Miami. In 2014—her breakthrough year, according to the mountain of prestigious press she's received—she had her first institutional solo gig, *Parrot Problems*, at the Fridericianum, Kassel. All of which adds up to an increasingly intimidating résumé. **CHARLOTTE JANSEN** tries to keep up with the indefatigable flow of one of contemporary art's leading analysts of the 'narration of familiarity'.

itting in her studio in East London, waiting for shippers to pick up the works she has been making for her latest show at Greene Naftali in New York, Helen Marten claims to be nonplussed by all the attention she and her work have been receiving of late. 'Nothing has changed—my anxious way of working is entirely the same and any sense of pressure I feel is entirely self-initiated,' she tells me.

'Many of the new works straddle an uneasy existence between focused translation and distorted projection,' she says. 'There are objects that in my own convoluted way are acting as imitative models of known real-life constructions. There are supplementary forms of figuration; vector lines which desire to be read beyond two-dimensionality; objects with an approximated touch and whole constellations of smaller material parts which for me are grammatical without necessarily prescribing to an alphabet as we conventionally know it. More simply put, there are three sprawling new sculptures and five new screenprint paintings.'

Marten has a very particular way of expressing herself that is as evident in her way of talking about her work as it is in the work itself—sculptures, paintings and installations that tend to take over the gallery space. Her art is as hard to pin down as the artist herself. She lives in the worlds she creates: 'What I make is how I see the world. It's how I write, how I think, draw… Of course, to an extent, all of these activities are component pieces to a more total outcome, in a similar manner to parts on a game board—they're circuitry, and they need one another to function.'

That world can be confusing for an outsider, with its cerebral puns and material paradoxes. I ask if there's anything that hasn't been discussed about her work already that she would like to explore more. 'Not really,' she returns. Yet she responds generously to questions—you can almost feel the rapid animation of her synapses as she talks, and it's infectious. Perhaps it's impossible to navigate her work in words, because in Marten's terrain, linguistic tools are turned on their head.

'I'm interested in language in its most primeval sense; I think a really beautiful way to think about it is language itself as the abstraction. It's great because words don't look like the things they designate so the reasoning is that this might be possible, however precariously, for images, too. Language is how we describe human methods of communication, so in some way I think that the obsessive importance I place on it is a way for me to destabilize our existing object-oriented hierarchies. I could fall in love with the aesthetic qualities of a thing, but be equally enthralled by its linguistic receptiveness. And this is hilarious because as much as we like to say things are "in dialogue", they are absolutely never talking to us. So it's a visibly masturbatory feedback loop: there I am, pasting my own language onto a reflective surface and getting off on the complimentary glow of false exchange!'

The irony of this statement doesn't pass me by as later I sit and struggle to capture the reflective surface of her work in my own exchange with it. But Marten isn't cynical. There's the feeling of intellectual joy the artist finds in the divorce between language and meaning, the possibilities in the void between word and surface, package and product—a modern evolution of the signifier/signified dialectic, as the linguist Ferdinand de Saussure defines it. In awe of the infinite gap between these things, there's a strong parallel too with the work of the Italian writer Italo Calvino, and a vision of the universe (as he writes in the novel *Palomar*) 'as a regular, ordered cosmos, or a chaotic proliferation'. She creates an expanding universe with the microscopic.

Marten, like Calvino, is the artist offspring of two scientists. I wonder if her parents' profession has influenced her, particularly in relation

Portrait by Juergen Teller

Top Left
Under blossom:
B. uses frenzy
2014
Screenprinted suede,
leather and waxed cotton,
pressed Formica, ash,
cherry, walnut, welded
galvanized steel, glazed
ceramic, strings,
cast bronze and aluminium,
coloured pencil drawing
under resin
269 x 334 x 8cm

Bottom left
On aerial greens
(haymakers)
2015
Mixed media
233.5 x 458.5 x 47cm

Opposite
Night-blooming genera
(detail)
2015
Spun aluminium,
airbrushed steel, welded
steel, lacquered hardwoods,
stitched fabric, hand-thrown
glazed ceramic, leather,
glass, feathers, acid-etched
concrete
Dimensions variable

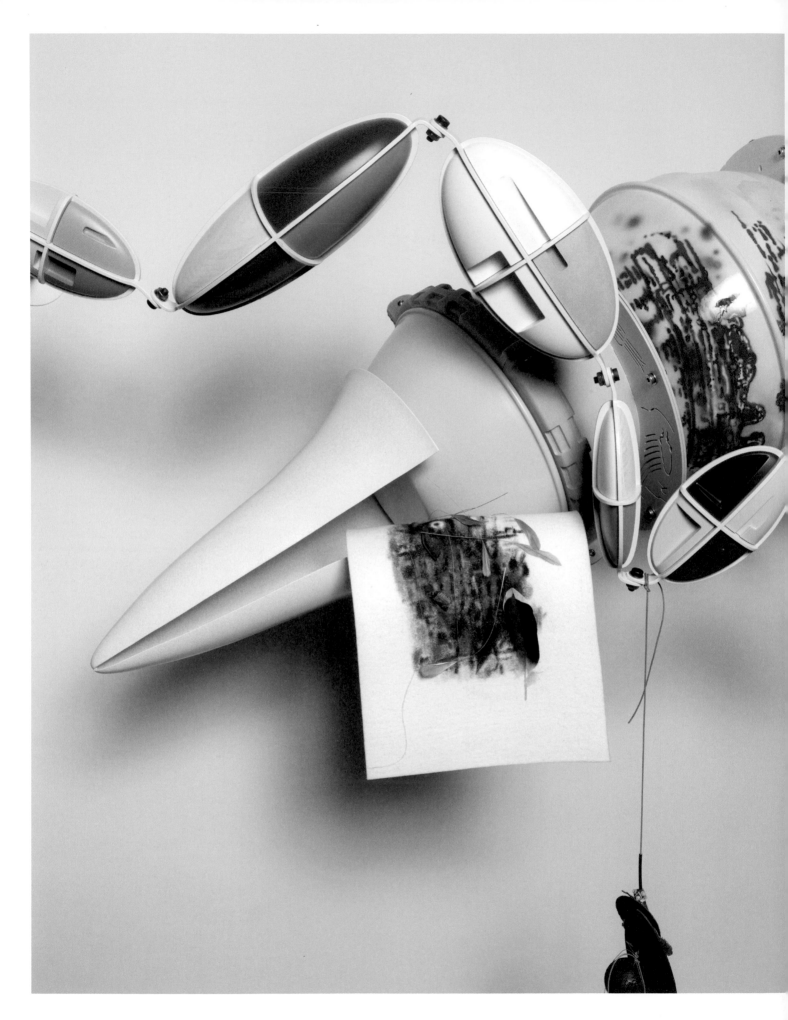

Opposite
Night-blooming genera
(detail)
2015
Spun aluminium, airbrushed
steel, welded steel,
lacquered hardwoods,
stitched fabric, hand-thrown
glazed ceramic, leather,
glass, feathers, acid-etched
concrete
Dimensions variable

"I FEEL SO PREGNANT
AND NERVOUS WITH INFORMATION
WHEN I'M JUST BEGINNING"

to the confidence she clearly has in redesigning reality. She describes them as 'brilliant', but says that her interest in science is more in its algorithms, in 'aspects that have the potential to be exported to a metaphorical or imagistic definition—processes like electricity or osmosis or digestion'. Sometimes—another Calvinoesque quality in her work—her deep study of the world's minutiae appears to be entropic. 'Entropy is such a gorgeous word. I love that it is described as a "measure" of disorder. It has a whiff of a kind of crafted literary oxymoron, something that may be paradoxical too.'

Her *Lunar Nibs* (2015) piece at the Venice Biennale is a recent example of Marten's love of paradox: a desultory ecosystem of fish + zips + chains + cotton buds = …? What's the process that yields such results? 'I'm actually extremely methodical in the way I work. I always start in a very basic incubatory period… things are percolating. I feel so pregnant and nervous with information when I'm just beginning and I often think about this time as a bristling state of laminated suspension. That's grossly rhetorical, but what I mean is that all the intangible things I'm imagining are moving in a strange dance together, not quite totalized in terms of their relationships or movements, but certainly not random either.'

The influence of the internet has been alluded to in discussions of Marten's work, and she has been referred to as a 'digital age artist', and with her interest in networks and ecosystems it might seem an obvious connection for a viewer to make. I do not raise the term post-internet with Marten, but she asserts that she is not interested in technology—her interest lies more in the physical, and especially in galvanizing textures and re-looking at everyday objects.

'Texture is a very conceptual thing for me. I'm really interested in the point at which things become husked down to geometric memories of themselves, where a house, for instance, a pair of legs, or a cat could be communicated with huge economy and speed via just a few lines. The vector can become a mechanism of delivery. As incorporated extensions, even a simple nod towards a shape that might be reminiscent of a readymade form is quite literally a vocalizer of external things—an agent of the world outside art making. And this is the point where you can use recognizable authority, the obstinate fact of a universally existent thing—an arm, a teapot, an alphabet—and extricate it from its own sense of intentionality. Artists can exploit a materialist history of stuff and render it—and by render, I mean it almost in the culinary sense of breaking down, melting the fat—and reform it anew.

'There is an efficiency to the narration of familiarity, but I am always surprised how quickly representation snags and starts to break down. Something festive or luminous can quickly stagnate and become depressing. It's a big turmoil of sign language, but one hinged on the classic established idea that a sign is a physical form, which refers to something that it is not. We also ask substance to behave for us on a daily basis by virtue of interaction, so we're all consummate agents in creating the physical world around us. Anybody who has ever handled a sponge understands that it might be capable of soaking up liquid. That is our haptic power; we're lucky to be optically evolved enough to predict sensation. So the treachery in my work then might be a simulation of authority, a willingness to bastardize substance and ask it to behave in numerous unexpected ways. In fact, I'm certain that even the most definitive materials are whorish deep down; they are metaphysically flirtatious. Maybe that is their skeuomorphic power!'

As Marten is talking about the sponge, I recall something Adrian Searle had written in the *Guardian* about her first UK exhibition—*Plank Salad*—at the Chisenhale in 2012. 'You have to go with it, or not go at all.' With her highbrow credentials, I wonder how the average-minded person might find meaning in Marten's work. Such imagination can be exhausting. Everything in Marten's world seems to have an alchemical charge, and fires off a hundred cannons with each of her installation's many component parts. What about those people who don't go with her indefatigable flow?

'My work is not about encountering a fixed empirical problem, but a deciding of how much of an archaeologist you feel like being, how many layers you want to unearth. I love the process of dragging legibility into crisis and getting to the kernel of something where you know it but cannot name it. I think this is something to do with making images that have an imposed itinerary quality, but are also disassembled to the point where they can be allowed to be non-committal if required. It's like finding out how to give devotion to a process of transformation but still not knowing exactly how everything might aggregate in the end.

'And I'm absolutely languaging-every-move, which means I am interested in imposing content on every gesture I make—these things are fervently PLANNED! But of course they often formally pre-exist in some small way or another, so there is syntax there already which I cannot govern. So in this way, I truly hope there is a shred of universality in all the things I make which allows them to communicate without bias at even the most basic level of understanding or initiation.'

To experience Marten's work, perhaps it's best to let go of the desire to understand according to logic: her all-encompassing environments are predicated on the analogical, and she revels in remodelling the world for us. But it doesn't make it simpler. Is she a complicated person? 'Probably. But I do always say what I think.'

WHO ARE

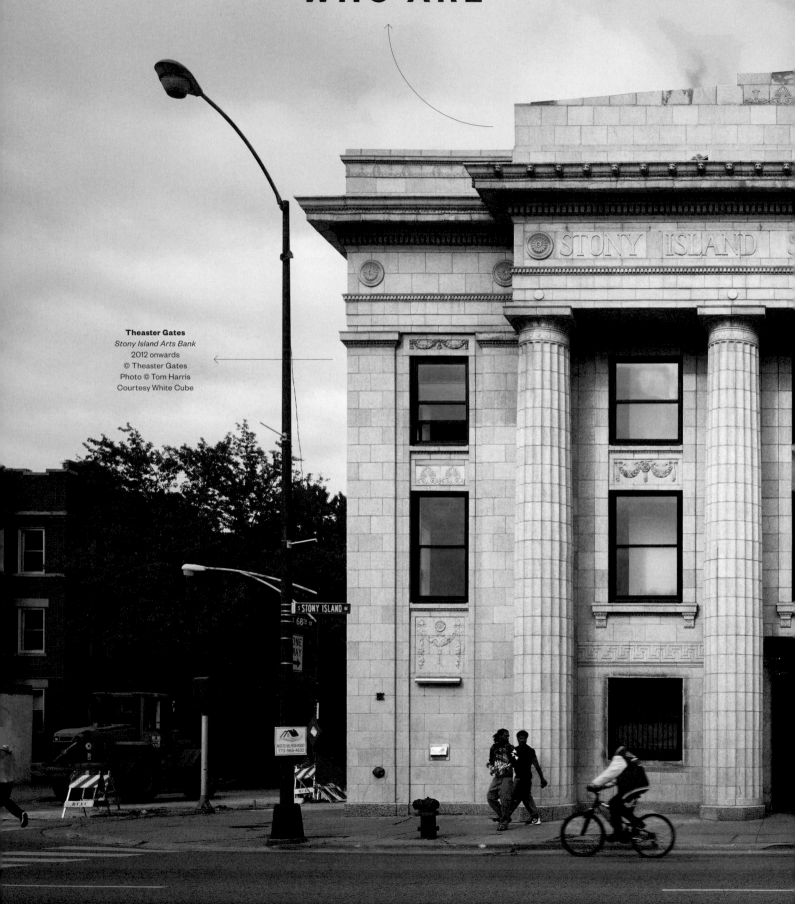

Theaster Gates
Stony Island Arts Bank
2012 onwards
© Theaster Gates
Photo © Tom Harris
Courtesy White Cube

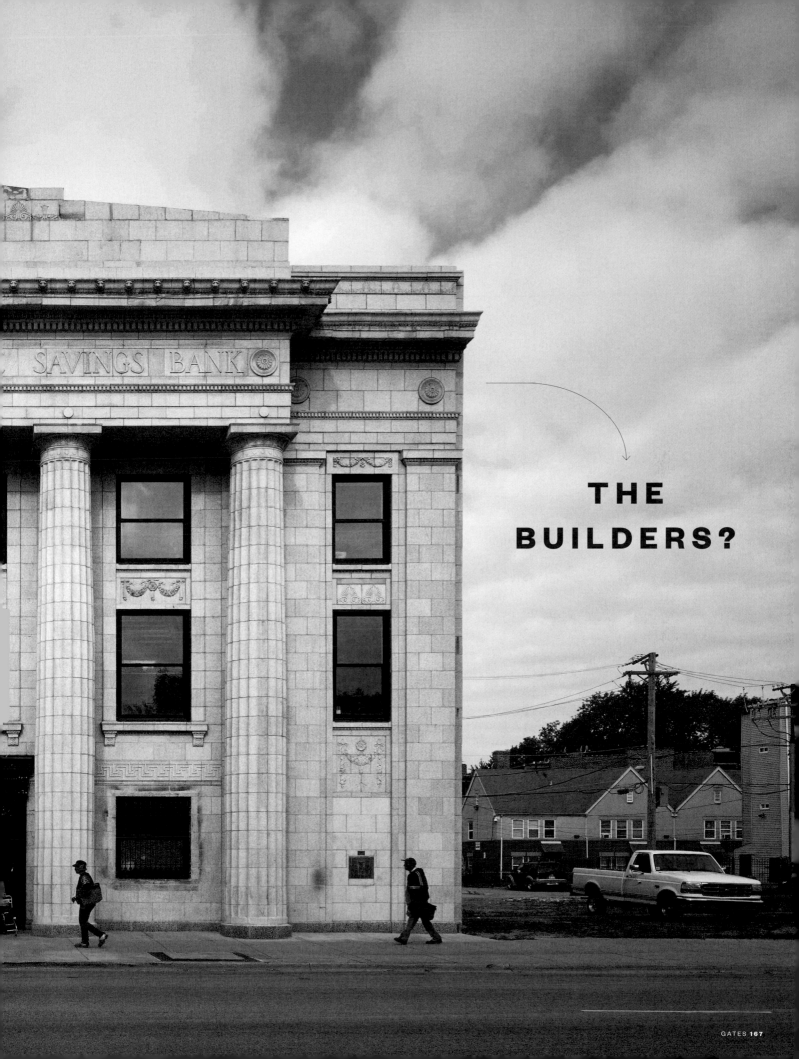

SAVINGS BANK

THE
BUILDERS?

'By offering a microphone and a stage to the broadest spectrum of people possible, and giving them light, saying, "Hey, it's your time to burn", you realize that our cities are much more complicated than we give them credit for.' As the Chicago-based artist, curator, urbanist and facilitator **THEASTER GATES** launched *Sanctum* in Bristol, he spoke to **EMILY STEER** about laying down the plans, stepping back and inviting the city to make it happen.

Cattybrook Brick Co. brick
Opposite Temple Church,
after the German bombing
of 24 November 1940

PHOTO © MAX MCCLURE

Theaster Gates needs little by way of introduction. He is perhaps best known for the Dorchester Projects, which has seen the renovation of multiple buildings on Chicago's South Side for use in a host of community-driven initiatives with the aim of providing a 'model for greater cultural and socio-economic renewal'.

Having studied the unusual combination of Urban Planning and Ceramics at Iowa State University, before going on to do Fine Arts and Religious Studies in Cape Town, Gates's expansive practice now is an enticing mix of these different elements: socially aware, highly respectful of local craft and, perhaps most importantly, gigantic in scale and ambition. He has always felt like an artist who slipped in through the side door, aligning himself more with the ordinary people who breathe life into his projects than contemporary art scenesters.

In late 2015, Gates launched *Sanctum*, a 24-hour, 24-day programme of sound, located in Bristol, in the south-west of England, inside the ruins of Temple Church—a bombed out fourteenth-century site that had, until this point, been off limits for 75 years—with the intention of 'amplifying the city'.

'My part was really language-based,' he tells me as we meet in the autumnal, overcast grounds of Temple Church on *Sanctum*'s first morning. 'In this project, more than in any project, my goal was to be as light as possible. What I wanted to do was give it direction and motivation, and give it the perimeters by which as many people besides myself could be involved.'

'In a way, *Sanctum* could have been a small sound installation coming out of the ruins, or it could have been what it is, which is an architectural work that acts as a platform for the city. That's all in language, as in: "Is it a this, or a that? I think it's a that." And then you have to kind of write that out, and you have to have a team that has the capacity to deliver that. It's been a very different process but I've fallen in love with the project and feel very strongly about the voices that I've heard already.'

I arrive to find the English Heritage site alive with activity on opening night. A wooden coffee truck serves warm drinks to the crowds; performers who haven't yet had their turn wait in an outside seating area, on chunky halves of log that are laid out as benches. The temporary triangular structure that sits within the four walls of the ruin is utterly Gates in aesthetic—a rough-and-ready selection of rustic wood panels, bricks and windows from the Salvation Army and old Bristolian houses cobbled together in a manner that looks terrifically, effortlessly beautiful. Within, a local musician delicately plucks 'Stairway to Heaven' on a harp in front of a crowd of 30 or so. Already, it feels like a project that exists beyond the artist.

Gates's most revered works tend to begin, as he says, in the sphere of language, he keeps the hands-on nature of social, local-level craft thriving through his collaborators and performers. 'I have a sweet spot for the craftsman,' he

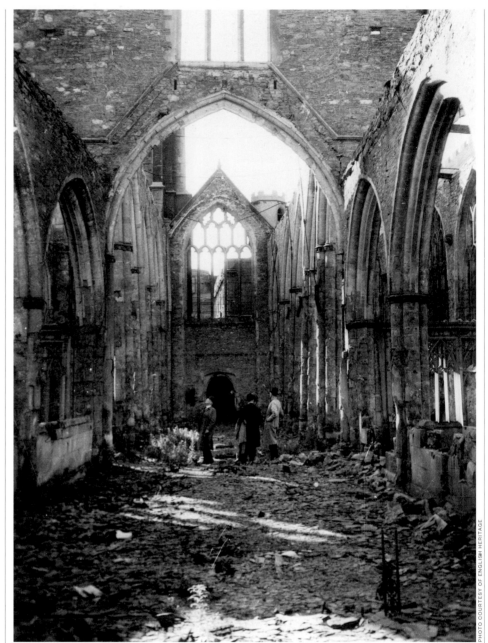

"HOW DO YOU TAKE A MOMENT TO INVEST IN THE CREATION OF SOMETHING SACRED?"

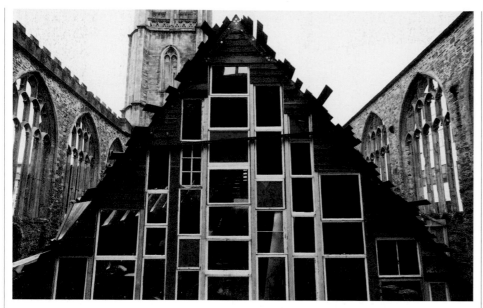

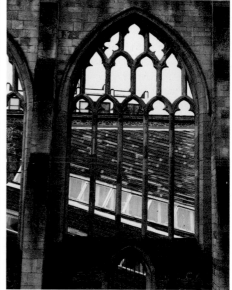

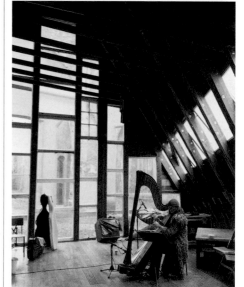

Sanctum took place between 29 October
and 21 November 2015, running 24 hours a day for 24 days.
It was housed in Bristol's Temple Church,
which was bombed in the Second World War and prior to
the event had been closed to the public for 75 years.

tells me. Indeed, while much of our discussion revolves around the conceptual nature of his own role in the project, *Sanctum* itself has a raw feel. From the flaking timber of the external structure to the invitation to handle lumps of raw clay mid-afternoon and the warm pits glowing in the corners, at times as an experience it's more akin to a folk festival than a contemporary art event.

'I asked: "Who are the builders?" There was all this amazing craft and guild stuff in Bristol, there were all these clay deposits that were here and we met these young boatmakers who were from a line of shipbuilders, who were using the same sheds that had been built for these complicated vessels that were moving around the world. We became very interested in them and in returning to these original things.'

'Initially, I thought we should have the highest calibre of people performing: "We want excellence and we want people to come out and hear excellence." Well, that's restrictive! By whose rubric of excellence? All of a sudden you realize that these are the hang-ups that we have that create the hierarchies of access. So you think: "No, let's just decide that people

must do the most excellent job that is possible in their capacity, everyone is invited and they should try to be as excellent as possible." And that feels good.'

Of course, the work does not just live within the artist, his collaborators and the performers, it is also about the public. But when work relies on people—not just on 'art-world' people, but on real, solid, public people—how does one reach them? When Gates calls, the art crowd comes running, but the real intention, it has always seemed, is to reach beyond that privileged sphere.

'In order to have a sophisticated enough invitation you need people who can go out and do the inviting. I think the challenges that museums have sometimes, or the challenge of culturally specific things, is that they already have a sense of who their audiences are and you use this word "targeted" and you target these audiences. But what if you lose the target?'

'There's no way that I, by myself, can do all that inviting. You need an arsenal of people who have tentacles. So there is that intentionality of invitation. It's not the architecture, it's not the artist that people know. Bristol said yes to this

Theaster Gates worked
with Bristol's MAYK to
commission over 1,000
Bristolian artists, musicians
and performers to produce
sound in *Sanctum*.
Photography by
Benjamin McMahon.

invitation and now there are all these amazing people who get to meet each other and participate. And it doesn't feel like they're participating towards my grand success.'

Over its 24 days, *Sanctum* called on more than a thousand local artists to create sound, in the loosest sense: from 1 a.m. drag shows to performance pottery and early morning calls to prayer. Gates himself appeared on opening night—having flown in directly from delivering a lecture in his role as professor in the Department of Visual Art and Director of Arts and Public Life at the University of Chicago—and left five days later.

It was Claire Doherty, from Bristol's Situations, an arts organization that focuses on new means of creating public art, who first brought Gates to the project. Speaking to me at the end of *Sanctum*'s run, she said: 'He had this initial vision and we worked very closely with him to put ideas in. He had very strong aesthetic control, which you can see, and then really it was once we agreed a set of principles about programming that he was very happy to let go. He kept in regular touch and we kept sending him movies from it and remarks. But he was like a theatre director, where once it's running he leaves it in our hands.'

Perhaps this new approach spells the beginning of a Gates franchise, as it were.

There has been discussion that *Sanctum* could move later this year to Essen in Germany, as part of the Ruhrtriennale. It is a difficult thing to imagine, *Sanctum* being—as every Gates project of this kind is—so locked in to the essence of its city of origin. It thrives on the nuances of place, and of breathing life into that specific space: the geographical, historical, cultural and social space of Bristol. How does he feel this kind of move would work? 'It's more like: How do you take a moment to invest in the creation of something sacred? Depending on how you define sacred—for me sacred has to do with people coming together to enact something for no other reason than to give pleasure to each other. Maybe *Sanctum* has this freedom, to be born in Bristol and then be an emissary of sacred light in other places. Maybe an expanded sense of site could mean that site is the location of an ideology or a set of ideals.'

Temple Church itself has now been closed again to visitors, and the physical structure has been removed. Gates hasn't been back to the city, but Doherty has been there throughout. As eyes on the ground, I wondered if this impact was ongoing. 'Interestingly, [the local theatre] Bristol Old Vic just announced that part of their 250th anniversary next year will be an open stage, where anyone who wants to perform, can. I think an interesting thing that's happening is the opening up of these cultural institutions. They just seem to have been given a bit of rocket fuel. I think in many ways, perhaps it's just a part of a renewed confidence in the city to do things differently.'

Gates's wider intention does certainly seem

"YOU DON'T HAVE TO COMPROMISE THE CONCEPTUAL RIGOUR TO MAKE ROOM FOR MORE PEOPLE"

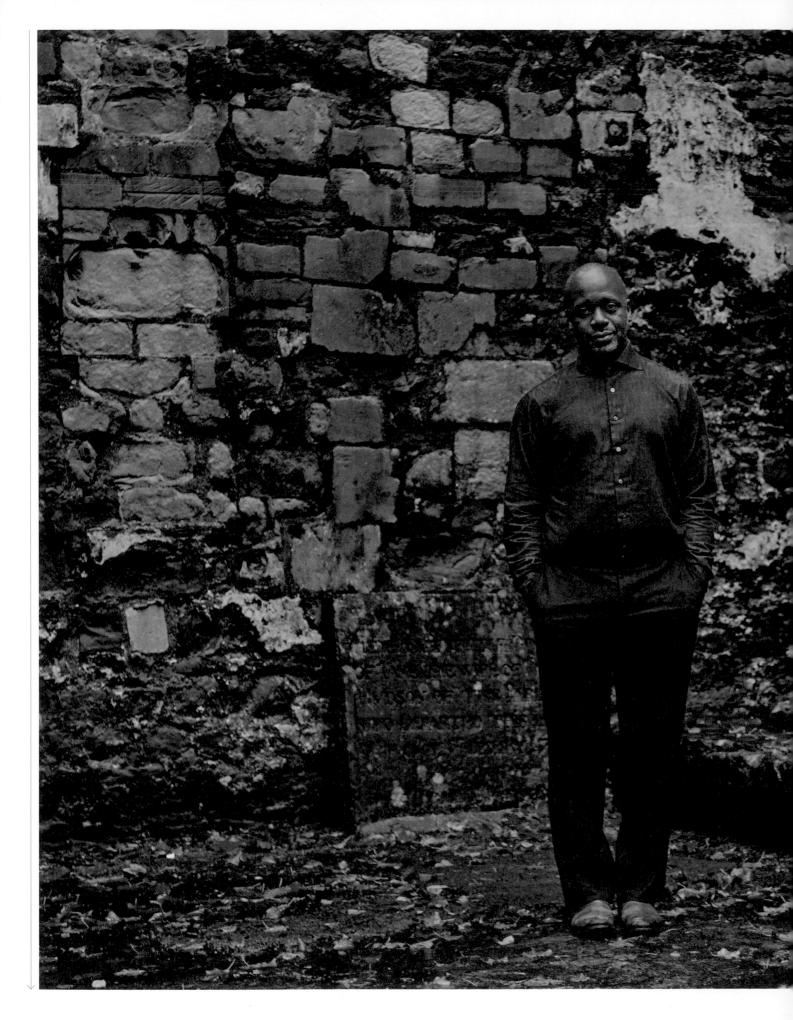

to be that of setting an example, something he does whenever he comes close to the contemporary art scene. He shared the prize booty of his 2015 £40,000 Artes Mundi win with his nine fellow shortlisted artists. When his practice involves a more typical understanding of physical artworks—paintings and sculptures—they are always wrapped up in a wider sense of humanity. His famous tar paintings—commanding in the manner of the best modernist painting, almost Rothko-esque in aura—are in fact the result of a working session with his ex-roofer father. They created the works together, using his father's old tar kettle. These humane, warm, loaded pieces are purchased as high art, and the proceeds are fed back into meaty, people-driven projects. In 2013 he pulled the marble tiles from the bathroom wall of a crumbling 1920s Chicago bank building—now the Stony Island Art Bank—and created *Bank Bond*, a series of $5,000 tiles, engraved with the phrase 'In art we trust'. The profits were reinvested into the $45m renovation of the building, which is currently used as a residency location for artists and scholars, as well as a site for artist commissions and exhibitions.

Does he feel that the art world is opening up to the possibility of a more meaningful exchange of values; one that prefers action to gesture? 'Well, I love to imagine that there are many art worlds, and this thing that we are seeing as THE art world—this complicated little ball of fire that we love to hit with a stick—is actually much broader, it's fatty, it's wonky. It actually doesn't know what it is. It doesn't know itself.

'Artists have always been engaged in interruptions that are broad and big and too ambitious. Maybe there's this core art world that will always think about master paintings and what happens in museums and the possibility of collecting great works, the market. These things will always, to some degree or other, be there. I think what artists are starting to demonstrate more and more is that there is room for a much broader and bigger art world. My hope is that what had been a small ball of fire would grow. And so maybe these are all just attempts that demonstrate that you don't have to compromise the conceptual rigour to make room for more people.'

Portrait by
Benjamin McMahon.

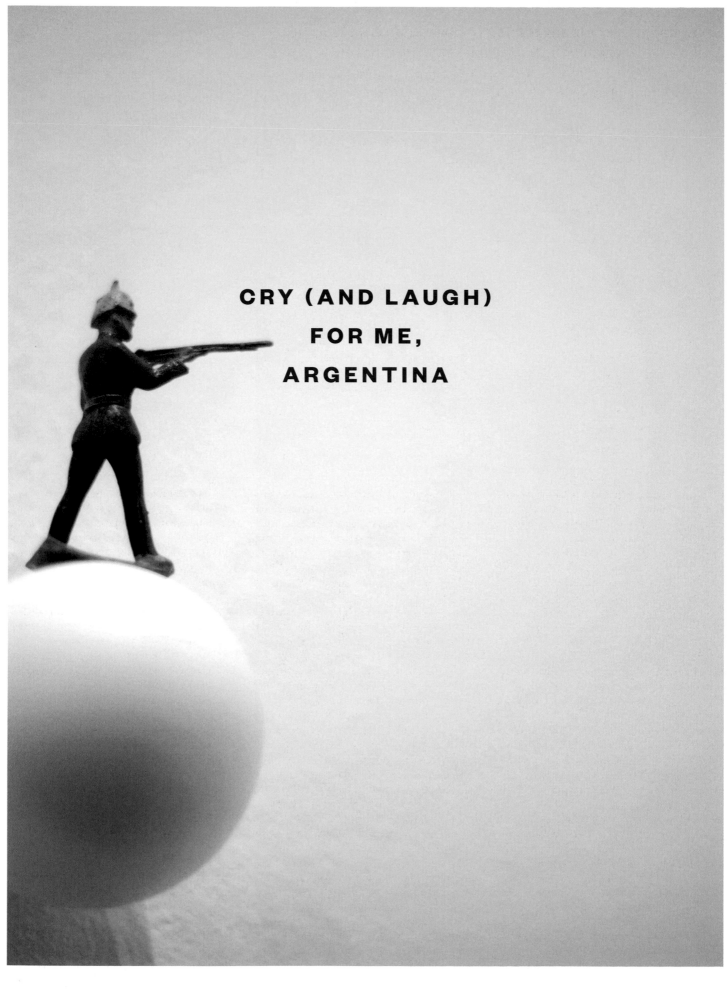

CRY (AND LAUGH)
FOR ME,
ARGENTINA

Conventional wisdom suggests that globalization is making the art world smaller and samier. But, following a visit to Buenos Aires and arteBA where the art on show makes her laugh and cry in equal measure, **KATYA TYLEVICH** begs to differ.

If I'm a fly on the wall, then I've landed among very good company. In their Buenos Aires home, Abel Guaglianone and Joaquín Rodríguez show off some of the 60-plus modern works on paper they own, including a Klimt sketch and a small Kandinsky ink. Contemporary Latin American artists and Argentine locals such as Fabián Burgos, Juan José Cambre and Mariano Ferrante also figure prominently in their collection.

Actually, they don't call it that. 'It's not really a collection, it's more a group of memories,' Guaglianone and Rodríguez tell me over the hum of their champagne-guzzling guests. 'Each one of the pieces is attached to a sensation, an occasion or emotion.'

On the eve of the opening of arteBA, the annual art fair, Guaglianone and Rodríguez are hosting a party to welcome collectors and gallerists from abroad and introduce them to local artists, some of whom are also represented in the couple's group of memories.

The pair are antique dealers, and their home, a spacious flat in BA's upscale Retiro neighbourhood, reflects the fact with its immaculate display of antique vases, chandeliers and furniture, which stay surprisingly unmolested, considering how many of BA's who's-who of art showed up tonight. The party goes on deep into early morning.

'It is a very interesting time in Buenos Aires for art,' they tell me. 'Public and private institutions are more active with interesting pro-

grammes. Artists have more spaces to show their work. Old galleries are moving to new spaces, and young spaces are becoming more professional.'

This is my second time to BA in under a year. As a visitor with no previous (mis)conceptions about the contemporary art climate in Buenos Aires, I come to view the city as impressively strong in its curatorial and cultural programming. At museums, galleries and art events, I exert little effort to come across exceptional artists whom I had never heard of before (initially, I blame myself for the ignorance, then realize that others outside of BA are also clueless). An unscientific scan of attendance rates at BA art gatherings suggests that my eagerness is not on account of tourist syndrome, but rather a way of fitting in. A strange, sculptural and humorously sexy choreographed performance by Osías Yanov (*VI Sesión en el Parlamento*) in the main public spaces of the Latin American Art Museum, MALBA, draws an audience to cover every inch of breathing space. A museum attendant has to push through bodies with his own in order to create a makeshift emergency-exit strategy.

In addition to MALBA and many other striking art spaces and institutions, I also visit the Museo de Arte Moderno de Buenos Aires (MAMBA), and Fundación Proa, Ruth Benzacar Galería de Arte and Galería Nora Fisch; and, of course, arteBA, whose attendance levels are so high there should be a claustrophobia notice on the door.

Although the presence of international galleries at arteBA is purposeful and demonstrated, the most exciting component for me is the strength of the local art and the extremely personal curation of many of the participating galleries. Perhaps knowing the strong expectations of local and international visitors (some collectors, some not), arteBA cannot take the risk of 'playing it safe' with something its audience has already seen—here or elsewhere. Whereas 'art' tourism for the purpose of attending fairs sometimes tends to reinforce the feeling that the art world is small (same faces, galleries, artists), my experience in Buenos Aires reminds me that it is actually quite large, with much left to be discovered.

I say as much to the new friends I make in BA. I tell them that I am discovering local artists I had not known about, that I am coming across exhibitions the drive and narrative of which I have not experienced before.

Most take the compliment for what it's intended to be: a compliment. They agree that BA has a rich art programme, which has seen improvements in recent years. But some take it as a veiled implication that BA is 'far' from the agreed-upon art hubs or norms. The implication is already on the tip of tongues, I don't need to put it there.

Okay, so the New York—London—Basel—Venice route typically doesn't include a layover in Buenos Aires. The city is geographically far from the art-market regulars. Art is bigger than geography, though, and so is the art market—or

Previous pages, left
Liliana Porter
Event V (detail)
2003/2015
Ruth Benzacar
Galería de Arte

This page, clockwise from top left
Mauricio Ianês
O Escritor
2013
Vermelho

Clemente Padín
*Correo del Sur
(Southern Post)*
2000
Henrique Faria Buenos
Aires Gallery

Ana Tiscornia
The Fact of the Matter II
2010
Galería del Paseo

Nicolás Ponton
Proyecto A—Arte
Contemporáneo

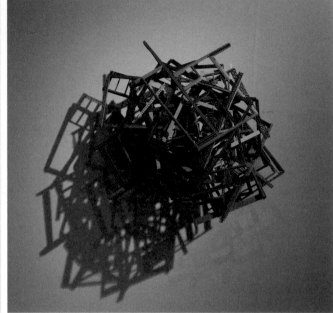

rather, art markets, which develop and transform owing to international differences in art climates. In regard to that, my new friends exchange sarcastic comments about the political climate of BA. In relation to the art market, high taxes and strenuous customs regulations for international art collectors give cause for local gallerists and others in the art field to get heartburn.

I ask Julia Converti, director of arteBA, to describe what, if any, antacid is in place. To me, at least, art activity seems quite vibrant in this city.

'Thanks to some of the shortcomings imposed by the political and socioeconomic context here, the art scene has developed its own specific type of artistic production and a wide range of self-managed independent projects,' Converti tells me, before rattling off some of the new leadership moving art forwards at cultural and contemporary arts institutions.

'The local scene is actually faced with a very important moment right now,' she continues. 'The quality of Argentine art production has always been extremely high, but it's only recently that we've seen a strengthened institutional framework to provide it with support, visibility, recognition, distribution and an international presence.'

My friend Tomás Powell, who is executive editor of the fashion/design/art/architecture magazine *Barzon*, and closely involved with arteBA, adds to Converti's observations. 'What's particular about Buenos Aires is that the art scene feels more rock and roll. There's an amazing amount of groupies, art fans, artists' friends of friends. Every art event ends in a bit of a party. There's a whole social life around artists.' Powell says that those supporting the arts within Argentina are also different from some of their counterparts abroad: 'The typical Argentine collector is generally very emotional and has a very personal connection with what they buy.'

I decide to do as the Romans do. I get emotional about the art I've experienced in BA and reach out to artist Fabio Kacero, whose midcareer survey *Detournalia* I saw at MAMBA in October 2014. The exhibition hit me like a bag of melons. Kacero's conceptual works, many of them playing with words, literature and notions of high vs low art (and nihilism, rejection and bored perversion), left me both deeply moved and in the grips of cynical laughter. How often does art make you actually laugh? How often does it stay with you for going on over a year, now?

To my surprise, Kacero answers me. I've heard he's not big on these kinds of things, but we spend an afternoon talking at a café near his home and studio. We talk about art, laugh about art criticism, and move on to life outside of art. Now that he's met me, Kacero says he can include my name in his artwork *CastK*, in which credits, like those that roll at the end of a film over a soaring soundtrack, are composed entirely of names of people whom the artist has met. I will add you to my list of credits also, I say. And I'll be sure to include location in the acknowledgements, too. Because, you know, it seems like a very important one.

*This year's arteBA will run 19–22 May,
www.arteba.org.*

JOURNAL

THE LAST BOHEMIANS?

A deep seriousness about the value and fragility of life and art connects the British artists **GILLIAN AYRES**, **JEFFERY CAMP**, **BASIL BEATTIE** and **JOHN MCLEAN**, part of a generation of painters that grew up during or just after World War II. Through the art world's other distractions and flirtations, they have all held onto a passion and belief in the romantic, philosophical and physical language of paint. Might they be art's last true bohemians? asks **SUE HUBBARD**.

These days the term 'bohemian' is a bit of a cliché in artistic circles. It probably emerged in France in the nineteenth century when artists and writers congregated in low-rent Romani neighbourhoods. Those with 'proper' jobs saw them as anti-establishment and inclined to free love. They stayed up too late, drank too much and rubbed shoulders with the marginalized. In 1894, George du Maurier's best-selling novel *Trilby*, about the fortunes of three expatriate English artists, their Irish model and two colourful central European musicians, who go off to live in the artists' quarter of Paris, helped to romanticize Bohemian culture in the UK.

But society and the art world have changed. Artists may still be hard-drinking and fun-loving but, with the enormous prices achieved in auction rooms and by multinational blue-chip galleries, the vision of the artist starving in a garret for the sake of his or her art seems quaintly outdated. They are now as likely to be appearing on TV shows as surviving on absinthe and a tin of sardines.

An earlier generation of British artists, still at work today and for whom painting has been their life's passion, started their careers in a world where there were very few galleries or collectors and hardly any art magazines, let alone an international jet-setting glitterati quaffing champagne at private views from SoHo to Shoreditch, platinum credit cards at the ready.

These are artists whose whole lives have been dedicated to an exploration of their chosen medium, to the search for authenticity, originality and imaginative truth. Artists who, against the prevailing trends of video, installation and increasingly assistant-produced art, have continued daily to get down and dirty in their studios in the ongoing belief that painting still has a voice through which to express our deepest human concerns amid the prevailing postmodern clamour.

GILLIAN AYRES

Just before D-Day, when Gillian Ayres was 14, the brother of a friend who'd been serving in the army arrived 'out of the desert' and took them both for a treat to a Knightsbridge hotel. Previously Head Boy at Winchester, he soon, as Ayres puts it, 'got bumped off'. She remembers thinking, then, in the midst of war, that art was all that human beings leave behind. It is something she still basically believes. In 1946, alarmed by Ayres's

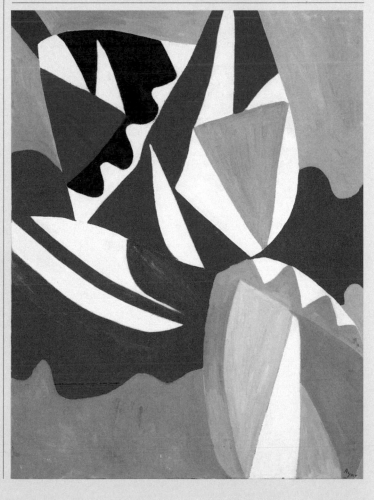

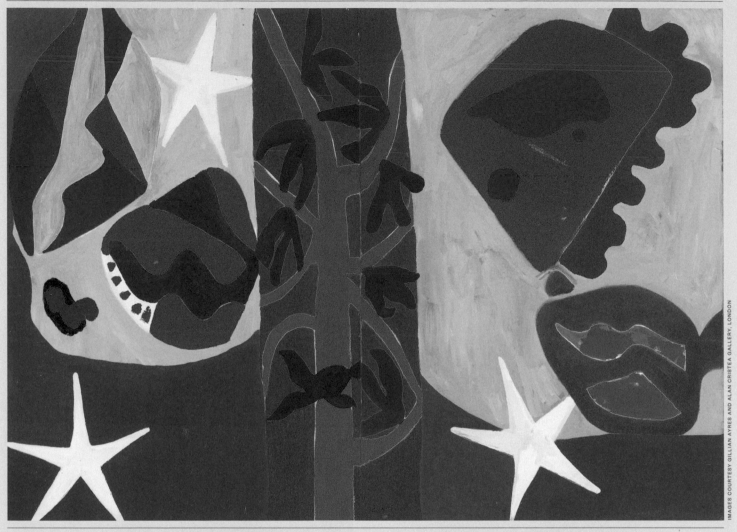

determination to go to art school, her headmistress warned her mother about the sort of men her daughter would meet there. Too young at 16 for the Slade, Ayres gained a place at Camberwell—though her nice parents would have preferred her to marry a nice doctor. She had no grant and though she received 30 shillings a week from her family her need of money to fund her voracious smoking habit led her to model (nude) for the Camera Club. She never told her parents. She was, she admits, pretty bloody-minded when young.

At Camberwell she rejected the prevailing Euston Road 'measuring thing' approach and found her tutor, William Coldstream, dictatorial—'it was dot and dash and measure.' So she began to attend Victor Pasmore's Saturday morning classes, where he talked of 'feelings' and embraced abstraction. In 1950, two months before her final examination, she walked out of Camberwell—'What should one have taken it for and for whom?'—and caught a train to Penzance and spent the summer working as a chambermaid. Back in London she turned down an allowance from her father to go to Paris and did a series of uninspiring jobs. An opportunity to work at the AIA gallery gave her the chance to meet some of the most original artists of her day and it was here that she began to find her own creative vision.

It's hard, now, to understand just how hostile the general public was to abstract art at the time. As Herbert Read wrote, it 'met

"THE ACT OF PAINTING IS AN ACT OF BELIEF"

with almost universal resistance in England'. But the revelation of Abstract Expressionism in the 1956 Tate exhibition *Modern Art in the United States* was a creative watershed. Ayres was elated by the energy of the Pollocks, de Koonings and Klines and determined that from then on she'd leave the traces of her painterly actions on the canvas and allow the paint to speak for itself.

Now into her 80s, she lives in a remote cottage in Cornwall with her ex-husband Henry Mundy and their son Sam—both painters—and numerous cats and dogs. Although no longer in the best of health, she paints most of her waking hours. Her recent show at Alan Cristea was a triumph of originality and invention. She recently told me: 'I love obscurity in modern art. I don't want a story. There are no rules about anything. I just go on doing what I do. I want to do nothing else.'

Arguably her 'formalist' works appear to deny any direct reference to the external world. Yet these life-affirming paintings continue to push against their own limits to speak, not only of a passion for paint, but of the light, lyricism and sensuality of the natural world. 'The act of painting,' Ayres says with total conviction, 'is an act of belief.'

JEFFERY CAMP

When I arrive at Jeffery Camp's home in Stockwell in London the walls are crowded with paintings. They are mostly by him but I spot a lovely little Euan Uglow lurking in their midst. His house may be an ordinary domestic terrace on the outside but inside it's a haven for the making of art. He paints in what for most people would be the front bedroom, which also serves as a sitting room. There's a huge-flat screen TV hunkered apologetically in the corner amid the brushes, rags, tubes of paint, old and new paintings and offcuts of wood that he uses to make his irregular-shaped paintings. There are also a couple of easels and some Arts & Crafts stools he tells

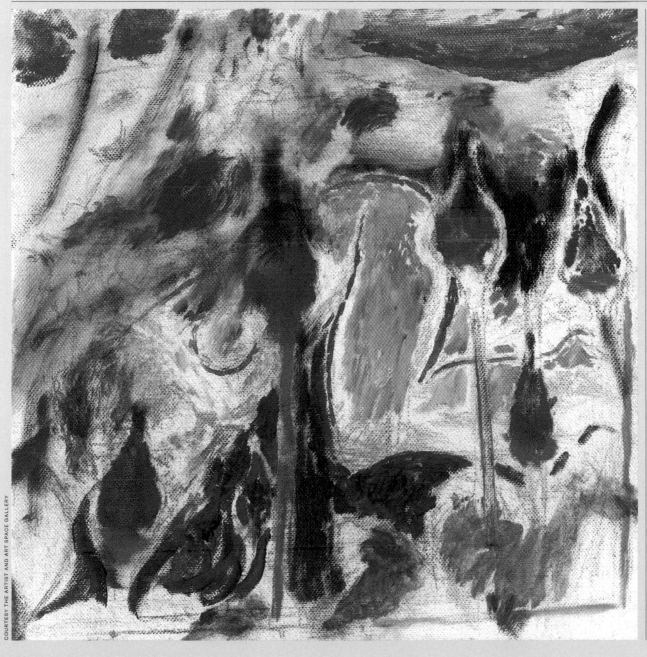

COURTESY THE ARTIST AND ART SPACE GALLERY

Opening page
Gillian Ayres
The Seesaw Sea
2014
Oil on canvas
122 x 91.5cm

Opposite, top
Gillian Ayres
The Dew Larks Sing
2014
Oil on canvas
(diptych)
99.5 x 140cm

Opposite, bottom
Gillian Ayres
Fiesole
2013
Woodcut in 21
colours from 3
walnut-veneered
blocks on Unryushi
Japanese 75gsm
paper
Paper 67.9 x 66.5cm
Image 59.5cm
(diameter)
Edition of 35

Left
Jeffery Camp
Sentinels
2011
Oil on canvas
30 x 30cm

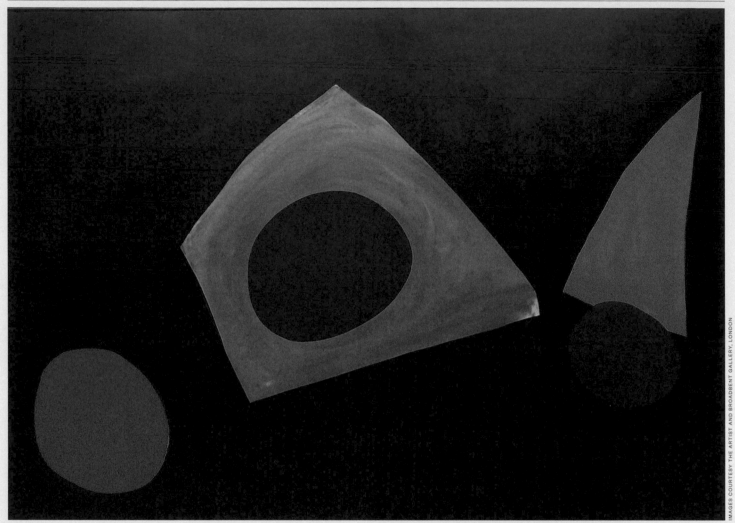

IMAGES COURTESY THE ARTIST AND BROADBENT GALLERY, LONDON

me were made by his father. Now in his 90s, he's wearing his familiar beret as he settles himself in a chair amid this organized chaos like an inscrutable, white-bearded sage. His wit is dry, his speech disconcertingly slow, as though he's deliberately making you wait for an answer. Just as when I first met him over 20 years ago there's a sense of mischief about him, as though he's enjoying the role of gnomic artist, leaving you tilting slightly vertiginously off the end of your question.

Camp grew up in Lowestoft where Benjamin Britten's father was his mother's dentist. At the art school next to the library, where he remembers reading the Kinsey report and books on El Greco and Rembrandt, Miss Varley showed him the ten stages of painting a

Russell Flint. She taught him, he says, everything, including book-binding, painting the figure and perspective.

Full of joyful, careless gusto, his work is impossible to categorize. It's as if Edward Ardizzone had interbred with William Blake, with a few genes from Franz Kline thrown in for good measure. There's a complex yet intuitive geometry to his paintings, with their dissolving figurative elements of people and coastal views. Colour is dabbed on with a series of small brushes, then pushed and teased across the surface. He has a huge knowledge of materials and has written several 'how-to books' on painting. Often, he tells me, he just destroys the image he's working on, laying it on the floor, then erasing it with turps. Washing it away allows

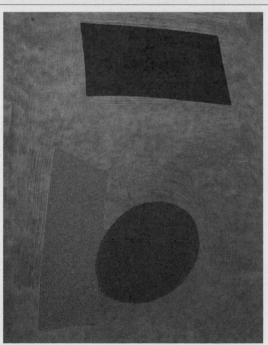

Opposite
Basil Beattie,
Smallness Stirs
1987
Oil on canvas
257 x 364cm

Above
John McLean
Cantabank1999
161 x 223cm

Left
John McLean
Capolavoro2000
66 x 50cm

for a greater freedom to move it around. He's been known to set off in the morning with a dozen or so odd-shaped bits of wood in a Sainsbury's carrier bag to go and paint. His light is luminous and there's a seamless symbiosis of figure and landscape that few other artists have been able to achieve. Whimsical, playful, yet formally serious, these are paintings that exude soul. Rainbows, lovers, seascapes: Jeffery Camp's lyrical, dissolving, jewel-like works capture an English sensibility with the palette of Bonnard.

BASIL BEATTIE

Basil Beattie's paintings are not easy. Physical, demanding, raw and, at times, disquieting, they confront the viewer with a series of ziggurats, tunnels and staircases

that apparently lead nowhere, painted with a deceptive ease and openness. The nervy edginess, the existential angst has always made him a 'difficult' artist, which, despite his being a tutor at Goldsmiths, means he has never quite fitted into the slick commercialism of the London art world. He might have been happier living in Germany where his work would have sat more comfortably with that of Kiefer and Baselitz than with British artists of his generation. His iconography, though essentially abstract, has its roots in the perceived world. His hieroglyphic images suggest a subterranean vocabulary concerned with the struggle of human existence. His horizons, like death, beckon and, Beckett-like, we have no choice but to go inexorably on

towards them.

There was little incentive in Basil Beattie's early life to become a painter. West Hartlepool where he grew up was a shipbuilding town, his father a signalman on the railways. There were no books at home, though his mother did visit London once. Going to the local secondary modern, he didn't know anyone who'd gone to the local art school, the building next to the bus station that fascinated him on his trips to the Odeon cinema on Saturday mornings. There, from the age of 15, he was to study everything from architecture to street design.

A place at the Royal Academy could only be taken up after the requisite two years of national service. It was ten years after the war and Beattie was stationed

in Cologne, still mutilated by bombing. It was there, in the museum, that he first encountered Picasso's *Guernica*. Prior to that his influences had been Walter Sickert and his heirs Ruskin Spear and Carel Weight. At the time Beattie says he knew nothing about American paintings: 'There weren't any publications and what I wanted to express was not clear. I felt very much on my own.'
Beattie was part of the first generation of working-class students. 'We tended to stick together. You could tell who we were. We were the only ones in jeans.' The 1961 Rothko exhibition at the Whitechapel curated by Bryan Robertson was seminal. 'I realized that Rothkos were not just arrangements of colour. That they had another dimension and were not simply

formal aesthetic judgements. There was something existential about them, something very different to the St Ives paintings I was used to seeing.' He tells me that he always knew he would never sell much. 'Now, at least I sell. The thing is,' he says, 'that when I set off on the business of making a painting I don't know how it is going to be. Meaning comes from the process of making. You have to be prepared to respond to ideas that you didn't have at the beginning of the journey, to learn from what you do.'

JOHN MCLEAN

The son of John Talbert McLean, a commercial artist and art teacher, John McLean was born in Liverpool but grew up in Scotland, largely in the Arbroath, famous for its smokies. At the age of 12 he learnt that he could impress by painting and earned his first commission. At 15 he travelled to Dundee to join the Communist Party and, as a teenager, developed a line in gritty Social Realism, painting Arbroath harbour with its fishwives. But it was a chance encounter with a catalogue in the autumn of 1960 from the *Situation* exhibition, which featured 20 abstract artists including Gillian Ayres, John Hoyland and the Dundee-raised William Turnbull, which 'opened up the future'.

Life for McLean in London in the '60s consisted of two attic rooms in Balham with a shared bathroom, living on a student grant and his wife Jan's salary as a fledgling maths teacher. To paint, McLean had to roll back the carpet on the linoleum floor. Ironically, despite having a thorough academic education like many of his heroes, such as Braque, as a painter he is essentially self-taught.

His precision and expressiveness are reflected in his resolutely abstract paintings. He is an extraordinarily sensitive colourist and has said that 'my pictures have no hidden meaning. To understand, all you have to do is look. Everything works only in relation to everything else... I like my pictures to be simple and direct.' There's a visual lyricism to his paintings, which are, as that other recently departed great colourist Bert Irvin said, 'blessed with a Matisse-like ability to dispose colour to dramatic and meaningful effect'. Dynamic and fluid, his shapes and vibrant areas of colour seem only momentarily to be fixed in their relational positions. He seems to draw with colour, weighing the subtle relationships between edge, weight and the position of his chosen forms. As his friend and contemporary the painter Geoff Rigden once said: 'He's an unlikely combination of Highland gillie and aesthete... I don't know anyone else who can skin and gut a deer and has his insights into painting.'

Above left
Basil Beattie
Step Up On
2013
Oil on canvas
213 x 198cm

Above right
Basil Beattie
Early Witness
1994
Oil on canvas
183 x 152cm

Art | Basel

Basel | June | 16–19 | 2016

ART&CULTURE

Win a feature commission to be
published in Elephant

Art Criticism Prize

Deadline: 1 September 2016

Judges:
Polly Staple (Chisenhale Gallery)
Roselee Goldberg (Founding Director and Curator of Performa)
Sam Thorne (Director of Nottingham Contemporary, a contributing editor
and columnist at frieze magazine, and a co-founder of Open School East)

artandculture.org.uk

BREESE | LITTLE

ARE YOU SMART ENOUGH TO JOIN MENASA?

You don't need a particularly high IQ to know that the Western art world has made a decisive turn of late, with a refocusing of interest on the countries of the MENASA (Middle East, North Africa and South Asia) area. There are few better barometers of this globalizing trend than Art Dubai. Ahead of this year's edition, **MOLLY TAYLOR** talks to fair director **ANTONIA CARVER**.

How did you first become interested in Middle Eastern art?
I studied social anthropology and art at university, but I first became interested in South Asian

How did you first become interested in Middle Eastern art?
I studied social anthropology and art at university, but I first became interested in South Asian art when I was living in Australia in the 1990s. There were so many artists with Asian backgrounds making really interesting work. I've always been interested in a pluralistic art scene and in understanding contemporary art as a global endeavour, rather than as something associated with power centres like London, Paris and New York. So working outside of those places is interesting for me.

How did you end up in Dubai?
In the early 2000s I started doing some work with Iranian artists and filmmakers and decided to move to Dubai. When I first arrived I did think, 'Hmm, have I just made a mistake?' You know, I thought there wasn't so much going on. But then as soon as I scratched the surface there was this scene that was bubbling up. There were so many interesting things going on in film; there was an active collective of artists around the great UAE conceptual pioneer Hassan Sharif and a generation of Dubaians who had gone elsewhere and then come back to the city with a resolve to change things. Artists were tackling

big questions in a playful, radical and experimental way, rather than being seen purely through the prism of identity politics. So that really was something—I felt very lucky to arrive at that moment in time.

The city must have changed a lot in the 15 years you've been there.
Radically. There was a lot happening then—there had been since the '70s actually—but in pockets, quite localized, with artists really doing things for themselves. What's really changed profoundly in those 15 years is the position of Dubai as a hub. The city is a meeting point for South Asia and the Middle East, and increasingly for various art scenes in parts of Africa as well.

What's also changed is the interest from the international art community: when Art Dubai first started in 2006–07, there were some museums and institutions that were interested but they were kind of here and there: often it was just down to the interest of the individual curator—someone like Venetia Porter at the British Museum. Now most major museums are engaged in this region, or at least engaged in a picture of the art world that is truly global.

What role does Art Dubai have in bringing the Western art scene over to the region?
I think Art Dubai has been quite a catalyst in terms of changing perceptions of this region and the kind of artists who are here, for several reasons. The fair shows work that's fresh and interesting by renowned artists but also by the artists of tomorrow. We put a lot into the not-for-profit side of the fair and try to be innovative in terms of how we programme talks like the Global Art Forum, and also with the way we commission artists and run residencies. We even set up an art school. The range of galleries [from 40 different countries] really draws in a fantastic range of museum directors and institutional leaders.

How do you make sure that regional and local work is represented?
We're very strategic about that. A third of the participating galleries are from the Middle East and South

COURTESY THE ARTIST AND PECHERSKY GALLERY

Asia, a third are from Europe and a third are from the rest of the world. In terms of the balance of artists, it's more like half of the artists are from MENASA because over the years a lot of the galleries have started to represent artists from this region, often actually finding them here—so that's another function of the fair!

Part of the brief to the contemporary galleries is to make sure they are helping to maintain that balance. We want to be constantly breaking new territories and accepting work from artists from places like Azerbaijan, Lagos, Delhi, Beirut. You know, that's our mandate as a fair and we're hyperaware of that. We want to present something very unique.

Do you think the art world in Dubai operates differently from London or New York or Paris, and if so, how?
The art scene here is obviously much younger—most of the

galleries have opened in the last decade. It's also incredibly multiethnic and international in flavour, so the gallery owners themselves come from Iran, Lebanon, Syria, different parts of Europe, India, Pakistan and the UAE as well. And I think there's more of a cohesive or team-like attitude here. It's very community-based. I think people have an emotional investment in what's happening in the art scene here because it's something that stands out in the region as wholly positive, really forward-looking and based around an acceptance or openness that's maybe becoming increasingly difficult elsewhere.

Being so immersed in the culture there, are you particularly attuned to the Eurocentricity of other fairs around the world?
There's definitely a big contrast and I actually hear this a lot from the fair's audience base. There are

quite a lot of people in the region for whom Art Dubai will be their first fair, and some of these people will say to me: 'I went to this fair elsewhere and I was amazed that everybody was very monocultural compared to Art Dubai.' There's obviously still a discrepancy: the level of representation of galleries from MENASA in major fairs in Europe and America is still really minuscule. But you know, that's the role of those fairs. It gives us even more of a reason to be who we are.

Western collectors are becoming more interested in the work of the region, in part due to fairs like Art Dubai. Do you think the type of work being produced has been influenced by this?
I think there was a period during the boom years in the mid-2000s—auction results were on steroids and the region was really opening up for the first time, particularly for artists from Iran, Syria, Egypt etc—when

there was a danger of some artists beginning to be market-led. But the number of artists who are a part of that auction-house world is actually very tiny. Key galleries also became much better at allowing artists to do things that were a little more experimental, or to go on residencies and take breaks. They really pushed their artists, as they should, into furthering their ideas rather than being market-led.

Now we're seeing more and more artists making what could be called political work, and collectors and critics coming from the West are particularly on the lookout for this. But at the same time there are many artists making work which is much more personal and intimate. Artists are also looking more at the history of art in this region and navigating how they relate to it.
I think that's because there are so many more museums, enabling a lot of contemporary artists to look

© CLINT MCCLEAN

back and reflect on their particular historical influences.

Art fairs can be a strange, sometimes overwhelming, environment for visitors. How do you plan the space in the fair in order to make it engaging?
Planning this takes up a huge amount of our time. I think when it comes down to it, we're driven to do things differently to other fairs. We think, 'How do we make this a great experience for people whether they've been to an art fair before or not?' A lot of visitors use it as their once-a-year museum-type experience because there's not so much on this scale regularly available for the public here. Then there are the people who go to endless fairs—how do we make it so that the galleries are delighted to be there? We break up the halls into smaller spaces in order to create moments of pause. We want to shake visitors up a bit and think,

right, you've never seen a gallery from Baku before, or met artists from Azerbaijan, so we're going to get you to stop at that booth and talk and have a new experience.

With the Global Art Forum, I bought in Shumon Basar to help figure out how we could make it so that people don't use it as a place to have a snooze. I'm sure we haven't been wholly successful—some people still doze off or check their Facebook there—but we plan the forum like a magazine because we're both from magazine backgrounds and it seems to work really well. We'll start with a news-in-brief and then move on to ten-minute talks followed by a longer-form piece or a panel discussion, followed by a short and snappy interview or a presentation, followed by music or a film. We also ask people to do polemics, where they get up and rant about something they care about.

Are there any cities in the region where the art scene is particularly interesting?
A place that's really doing incredible things right now is Beirut. All credit to the people driving the scene there because they've been relentlessly positive and worked incredibly hard to keep it going despite being right next to Syria, and despite having a lot of economic and political problems of their own. There's a really great programme going on at the Beirut Art Centre; the latest edition of HOME WORKS [a multidiscipli nary forum on cultural practice] just took place; then there was the opening of the Aïshti Foundation, which is a new, very glitzy private foundation that's opened alongside a shopping mall. So you have every degree of the art world there. It's fascinating. And long may it last.

Art Dubai 2016 runs 16–19 March. Tickets are available from artdubai.ae.

Opening page
Samanta Batra Mehta
The Edge of Memory: The Re-Telling of a Lost Narrative (Set of 43 Works)
2015

Opposite
Sasha Frolova
Antennas; Heart
2012

Above
Portrait of Antonia Carver by Clint McClean

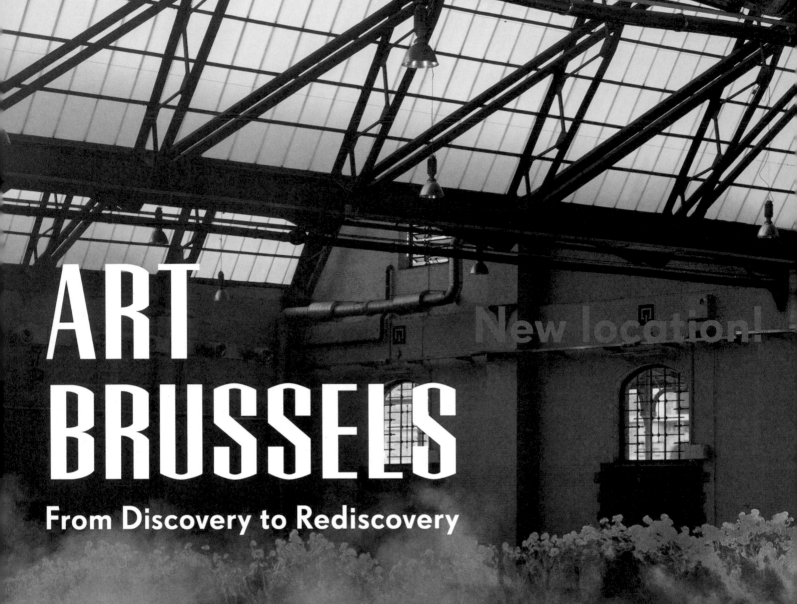

ART BRUSSELS

From Discovery to Rediscovery

New location!

Fri 22 April – Sun 24 April
Vernissage Thu 21 April

Tour & Taxis

www.artbrussels.com
Follow us 🐦 📘 📷
#artbrussels

 ING 🦁

10 IDEAS:
BEDWYR WILLIAMS

1

I WISH I'D RECORDED THE STUFF AROUND MY WORK INSTEAD OF JUST DOCUMENTING THE WORK ITSELF

The clothes, what the fashions were, the music people were listening to, what was on the news… When I look at my work from 2004–05 I can remember the work but I can't remember what was happening. I wish I had an ideas board in the same folder. Like, sometime in the early '00s artists would wear body warmers and baseball caps with worn-out jeans, and I remember hating that time, I hated it! Everyone looked like they were from a trailer park but they weren't, they were posh and stupid.

If I think of my career, it's almost defined by the time from 9/11 up to now and this Paris thing. Because I'm such an anxious person, I expect a terrorist attack every time I go to London—I literally run through the forecourt at Euston station to get out onto the street. I think that these events have informed my work, and I wish I'd paid more attention to what was going on around me at the time I was making it and been less anxious.

2

A LOT OF PEOPLE TALK ABOUT LEAVING LONDON BECAUSE OF MONEY

Some people get cross and say it's not true, people aren't leaving. But either way, I do think how amazing it would be if there were five or six cities in the UK you were genuinely excited about visiting.
Like, if you read the diaries of a famous dramatist in the '50s, they don't write as if they were out of the equation by being outside London. There was no shame in being busy in another city. Even as late as the '90s, when I went to college in London, London wasn't on the menu for a lot of people. There weren't a lot of young people moving there, most students

Bedwyr Williams is not—and has never been—a stand-up comedian. Nonetheless, in his text pieces, installations, sculptures and sweatshirts, the Welsh artist demonstrates that unique observational skill about the idiosyncrasies of mankind that is common to great comic raconteurs. Here, he shares his 10 Ideas about the UK and the art world with **Charlotte Jansen**.

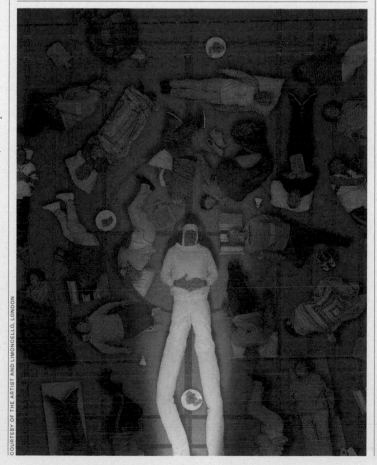

COURTESY OF THE ARTIST AND LIMONCELLO, LONDON

wanted to go to Manchester or Leeds. I suppose that might still probably be the case, but I think it's up to young people to stop being so sheep-like. I don't mean this to be anti-London, I like London a lot, but I love Liverpool, I love Glasgow, Edinburgh, Newcastle… I love visiting those places, they're all interesting places with interesting people. I like the fact that in Germany you have Cologne, Munich, Hamburg, you don't have this thing that you have to live in Berlin. Or in the US, you don't have to live in New York, LA, Austin – they're all places considered valid and interesting. I feel like we live on this small island with an amazing history of pop culture, entertainment, literature, all that, and the fact we've disconnected ourselves from the regions is ridiculous.

3

I MEASURE WHERE I AM IN THE ART WORLD BY HOW STUPID I FEEL

I mean how stupid I feel in myself. Like, I worry about the clever artists rolling their eyes when they see my name on the exhibition line-up. It's a catty, bitchy world, isn't it, and I think things are going well for me when I don't feel stupid when I walk into a room of artists. It's how confident I feel with these horrible jackals. It's a horrible world. Artists are horrible about each other. They are probably rolling their eyes as they read this now.

4

I'M GLAD WE'RE COMING OUT OF THIS WORTHY PERIOD WITH ART

All these fundraising print runs, and supporting artists, and blah-blah-blah—I'm not interested. I don't mean that in a survival-of-the-fittest way, it's just these preachy worthy artists on social media, I'm fed up of it. I want to hear artists being incisive and smart or stupid, not this communal quilt-making moaning.

5

ARTISTS DJING LEAVES ME COLD

I'm glad I can't DJ. I keep seeing dusty decks in galleries and I don't know what they are doing there. Although I have to say I love watching those people that were snooty to me earlier on in the evening dancing like dick-heads, that's my time then. There's something about artists and art writers talking about music that is so irritating and knowing it takes out all the fun out of listening to music.

6

IMPROVE THE RAIL NETWORK

There's a bright future for the UK if we had more props to work with. We could revolutionize the country with a good rail system. We're a very interesting country and we need to be joined up.

7

I WISH I COULD DO A REFRESHER OR POLISHING COURSE

I studied painting, and there was barely any theory. Most of the time, when I watch an ICA or Frieze talk, I don't know what the artists are talking about. It's like when a panel discussion starts off with a lethargic brainbox saying: 'I guess we should start with talking about blah-blah…' and straight away I don't know what they're talking about.

It's so far away from why I became an artist. I guess I want to know what they're talking about so I can dismiss it. At the moment I dismiss it and because I haven't gone out of my way to understand it it probably means I don't have the right to dismiss it. (People are rolling their eyes at this as well.)

8

I'D LIKE TO HOLD ART-WORLD BOFFINS UP TO SCRUTINY BY BOFFINS FROM OTHER FIELDS

Everyone cites and references these people, but you seldom get clever people from other fields with these art boffins. It's such a hermetically sealed world and it doesn't spill over into other popular intellectual circles. Maybe it's just for my own peace of mind, but I'd like to see them grilled by other clever people. This mumbo-jumbo art speak has been taken apart by a lot of clever people, but it still persists, it still exists. I'd like to see more cross-referencing with other clever people to see what they think, almost like an external invigilator.

9

ARTIST'S BOOKS ARE BECOMING BORING AND ANNOYING

I used to make them, and I used to like them, but now I see them on Instagram and I look at a picture of a plain grey book that uses a tiny font and that has 100 Likes, and I just think: How do the other people who have liked that know that it's good? There's so many of the bloody things.

10

I'M SUSPICIOUS OF ART-WORLD PEOPLE FROM OVERSEAS WHO PROFESS TO LOVE THE WORK OF BRITISH ARTISTS THAT CONTAINS A STRONG TEXT AND LANGUAGE ELEMENT

I can tell that these people don't speak English well enough to understand the nuance in the text. There's this airport English in the art world, this Euro English, and it's part of a phoney internationalism. People think they're interfacing with the work but I think they're lying—you need to know the language well to be able to understand when artists use text in their work. Not just English; this is true of any language.

That's why I always put subtitles on my work when I show it over-seas—to make sure it's under-stood. You have these curators with poor English who pretend to find it really funny and say they don't read the subtitles and I think: No, you didn't under-stand it. I'm sceptical of people like that. People I really love like Peter Cook or Tony Hancock, English comedians, didn't trans-late well into American. There's always a place for the local and the colloquial. I love the different shtick that different people from all different parts of the UK have, and if you show your work internationally, you shouldn't have to sand your rough edges off to make it fit.

Williams will have an exhibition at the Barbican's Curve Gallery in London in October.

COURTESY OF THE ARTIST AND LIMONCELLO, LONDON

Left and previous page
ECHT (stills)
2014
HD video

ENDITORIAL

LIKE A ROLLING APPLE BY MARC VALLI

How do you make a dent in the universe? How do you make a difference? How do you change the course of history, or the shape of things to come? In the heady days of Modernism, some seemed to think that art and architecture could do it. Then technology took over the stage.

Do we want to live in a world in which the way we see things, experience them, share and communicate them, and indeed relate among ourselves, is dictated by megalomaniacal geeks, frenzied sociopathic developers or overactive tech tyrants with booming laughs? Do we want our grandchildren to be studying the deeds of Steve Jobs, Jeff Bezos, Larry Page, Mark Zuckerberg and the next wave of Silicon Valley CEOs… Or do we think art still has a shot at influencing the way we live, think and feel?

Interestingly, the most ambitious (arguably the most talented) artist of this generation has a background in craft, in making things with his hands, in glazing and in pots. Gates—Theaster, not Bill—also clearly understands music. And cultural trends. And aesthetics. And people. And politics. Can such a creative force still rise above the fray, above the white noise, and make his voice heard over headphones and iTunes?

Interestingly, the man who possibly did most to shape the way we live now was an ardent fan of Bob Dylan, and of the libertarian, pre-digital spirit of the sixties. All through his career, right up to the launch of the first iPod and the iPhone, Steve Jobs remained a committed Dylan addict. What was Jobs dreaming of as he played bootleg tapes of 'A Hard Rain's A-Gonna Fall', over and over again, through his headphones?

The dream of a pre-digital world? A world in which feelings did still sound like vibrating chords, something strummed by human hands, even after Dylan's 'electric turn'? A world in which happening upon an idea didn't mean rushing to your legal department to make sure they filled out a patent? Of course, it is a bit hypocritical for me to be typing this on my MacBook while listening to music on my iPhone… But, and Jobs hinted at this continually: Apple would not have turned out the way it did without Dylan, or the Beatles, or the Stones, or even Janis Joplin, somewhere in the background of Jobs's head.

'Oh where have you been, my blue-eyed son…'

But then many a cuddly dictator would have said something of the sort. As has been grimly well documented, all dictators have a soft side, a penchant for over-sentimentality. And they love nothing better than loud music and big colour images, as they lull masses into submission, not just with music and images, but also with design and by making their lives easier. And faster. Aren't we all entranced by what Marinetti (talking of Fascist poetry) called 'the beauty of speed'? Jobs's Apple, Page's Google, Bezos's Amazon—all are totalitarian utopias come true. Headphones on, we shake our hips and dance our way into mass extinction. Our generation's unbound, ever-accelerating dive into the information age is a vertiginous, infinitely seductive leap into an abyss. We are astronauts floating away into outer space, iTunes playing in our helmets…

'Oh where have you been, my darling young one…'

Michael Craig-Martin is the poet of the Apple generation. His clean canvases and carefully articulated shapes (moulded with a touch of Jonathan Ive) and signature colours (hues of pink juxtaposed with reds and purples and electric greens and blues and all kinds of Apple colours) describe how our lives are now defined by the objects we surround ourselves with. Our lives are catalogue-like, hard-shelled biographies. In his latest Serpentine show, a mural presents a can opener, a sandal, an ice tray, a book, a cassette tape and a satchel fanning themselves out in a heady mixture of advertising and existentialism. Warhol meets *Toy Story*. In a corner of the last room, we are given a partial view of a MacBook screen, just like the one I am staring into, and the artist somehow manages to capture both the sense of infinite promise and universal void it has to offer. Headphone silence. Mirror-like, intimate, cold, Craig-Martin's beautiful objects highlight the seduction as much as the emptiness of our consumerist lives.

Can art still rescue us from the brink of this madness? Can artists such as Theaster Gates, titanic craftsman, visionary, activist, impresario, musician, help us reconnect with our lost humanity? Can art bring us back from that fluorescent nothingness, this bright new dimension of annihilation? Can a new generation of artists be brilliant enough to impose new frameworks, new horizons, new sensory markers, and help us reconnect with human thought? With human feeling? With sensation? With presence? With ourselves?

'Oh who did you meet, my blue-eyed son?'